Tariq Anwar was born in New Delhi to an Austrian mother, Edith Reich, and Indian father, Rafiq Anwar. At the age of five, following the separation of his parents, he returned, with his mother and elder sister, Farida, to live with his Austrian grandparents in Southall, England. His secondary education was at Walpole Grammar School, Ealing, and Sir John Cass College, Aldgate. Leaving college after only one year, he started a fifty-year career in the film and television industry. He has a brother, Peter, wife, Shirley, two children, Dominic and Gabrielle and four grandchildren: Willow, Hugo, Paisley and Storm.

To all those students who, in spite of this book, still want to become film editors; to all those monsters who made this book possible (you know who you are, or perhaps you don't?) and to Shirley, who kept the monsters at bay!

Tariq Anwar

MOVERS AND SHAKERS, THE MONSTER MAKERS

AUSTIN MACAULEY PUBLISHERS™

LONDON • CAMBRIDGE • NEW YORK • SHARJAH

A CIP catalogue record for this title is available from the British Library.

ISBN 9781788780339 (Paperback)
ISBN 9781788780346 (E-Book)

www.austinmacauley.com

First Published (2018)
Austin Macauley Publishers Ltd™
25 Canada Square
Canary Wharf
London
E14 5LQ

Acknowledgements

I would like to thank: John Hart, Bruno Coppola, Craig Sheffer, Barry Primus, Julie Arenal, Mark Adler, Robert Miller, Neal and Anita Slavin, Rand Marsh, Robert Neuer, Farideh Koohi-Kamali, Leila Farag, Saska Simpson, Scott Millan, Margaret Revell, Sergio Ferreira and of course Shirley, Dominic and Gabrielle Anwar for their support, suggestions and encouragement in the writing of this book.

This does not mean they necessarily share my views.

Preface

Every so often, an amorphous group of egocentric Machiavellian creatures closely related to the human species, ritually gather together in the name of art or making money, depending on your perspective, and indulge in an orgy of greed, duplicity, cowardice, nepotism, sycophancy, sadism and supremacy that would flatter the Borgias... and then disperse, only to repeat the whole process again...and again...and again. The Borgias scandals were the popular entertainment of the fifteenth century. Today, we have a different family intent on even larger audiences; the family of film.

Introduction

The Film Editor's role has never been understood by the general public nor, more alarmingly, by many in the industry. 'Cutting the naughty bits out' is the extent of their understanding, which, in a way, is actually true but oversimplifies the huge creative work that skilled editors regularly apply on all films, whether commercials, documentary or drama. The work of the actor, director of photography (DOP), designer, makeup etc., is plain for all to see and admire, but that of the editor? Cinematographers (DOPs), in particular, lead a charmed existence, seemingly immune from criticism for a failing film: how often do you hear that a film was poor but the photography was great, and how often do they singularly receive critical acclaim for the collective contribution of many others?

The editor's creative work is rarely appreciated, as it is assumed the finished film is as it was intended, but however much a film is pre-visualised, it always becomes something different when it is actually shot. When the editing is noticed, it is generally as a consequence of showy or fast cutting, which is often mistakenly regarded as 'good editing'.

Editors work very closely with directors and build a relationship of mutual respect, trust and loyalty, which can last many years: Ralph Rosenblum with Woody Allen, Thelma Schoonmaker with Martin Scorsese, Michael Kahn with Stephen Spielberg, Joel Cox with Clint Eastwood, Pietro Scalia with Ridley Scott and, further back, George Tomasini with Alfred Hitchcock. With long-term relationships comes an intuition of a director's wishes and a secure environment to be creative.

There are some directors who have a very controlling approach to editing and dictate which shots to use and when, what to delete and transpose, what temporary music to add etc., but in my experience, these are rare. The best directors allow their editors and others in the crew, the freedom of expression; freedom to make shot choices and structural decisions, to offer ideas and collaborate in

making the best of the material available. It is this closeness and loyalty (sometimes misjudged) to the director, and the desire to make the film he or she wants, that exposes the editor to the possibility of being replaced. If anyone is to be replaced for a 'problem' film, it should be the director, but that rarely happens. It's an executive failure more often than not that leads to these situations.

Many executive producers, particularly in the murkier depths of the independent sector, are ignorant of craft skills. They use their misplaced authority to voice ill-conceived thoughts as a basis for making bad creative decisions, which mostly impact on editors in post-production. One UK-based production house, wear it as a badge of honour to replace their editors, "we always fire the first editor and it never fails to make a better film, so we are right to do it." The entrance to this production house is a rabbit hole.

Respecting the 'office' of studio head, executive producer, producer and director is not only necessary (if you want continued employment) but also good manners. However, increasingly the persons holding that title deserve no respect at all. Editors, certainly in post-production, can consider themselves the director's right-hand man but should be aware that when Treasury Secretary Henry Morgenthau asked Franklin D Roosevelt, "Which hand am I?",
Roosevelt answered, "You are my right hand, but I keep my left under the table."

Self-preservation is a brake on displays of contempt, but releasing that brake at times is hugely therapeutic, provided you are prepared for the consequences!

This largely pointless and distressing process of replacing editors, which feeds paranoia and mistrust, reflects the inability of financiers and producers to read and understand scripts in the first place,
"Oh, is this the film we commissioned?"
"I read part of it all the way through."[1]
Films with problem scripts are green-lit too early, assuming the problems will disappear in post (they rarely do). Executives fail to monitor the rushes[2] and, when perceiving a problem months later

[1] Attributed to Samuel Goldwyn Sr.
[2] Prints from the processed negative – rushed for quick delivery (called dailies in America).

(based on audience reactions and the concern that they may not get their investment back), are unable to rectify the perceived problem themselves. They sometimes have a lack of respect for the directors they hire or are reluctant to admit that perhaps they have hired the wrong director. But they know best, because they are the highest in the food chain and they have the most power.

There's an old Hollywood adage: "In the beginning, there is a screenwriter. The screenwriter has a gun. When he turns the script in to the producer, the producer has the gun. Then, when the director is hired, the director has the gun. When he turns in the cut, the gun is passed to the studios. The studios then take the gun and shoot the writer, producer and director." But it doesn't end there, because there is also the entertaining merry-go-round of studio heads, who come and go and come back again, like fashion.

It was, and still is, a feudal world: Kings and Queens (Studio Execs), Princes and Princesses (Producers), Dukes and Duchesses (Directors), Barons (Heads of Department) all the way down to the serfs (assistants and the like). A hierarchy of demons, all too ready to send those that fall out of line to the Tower; consequently, deference abounds, and with that deference, comes an often-misplaced respect, born of fear.

A director is like an only child; the producer is his parent. Filmmaking is a team sport, and, increasingly, in these days of independent filmmaking, managing this team is a football team of producers. A football team of parents to an only child. So not only indulged by one parent but several parents. Common misconceptions about only children is that they are bossy, aggressive, selfish and spoilt, but in the film world, that is sometimes the case; perhaps given the nature of the job, understandable. Showered by attention, directors are enabled to behave as they wish, if not regards schedule and budgets, certainly regards their crew. Most handle this power with equilibrium, but some have a constant and insatiable need for obedience and flattery, and any signs of dissent and challenge to authority are met with accusations of disloyalty, unprofessionalism and sometimes dismissal.

To them and their patrons, knee-bending is the order of the day.

During the post-production process, everyone has an opinion and everyone becomes an editor. We are exposed to thoughts, good and bad (and sometimes ridiculous), and have to go through the

motions of addressing them knowing it's largely a waste of time. It is probably my own failing, but I find it irritating to work with notes that have a high level of abstraction: throw it up in the air; give scenes their own aesthetic and edit technique, their own colours; complicate the film language; give scenes a rhythmic genre reference. Or having to listen to tiresome film references, 'make it more like a blah, blah film', or delivered as a stream of consciousness with endless adjectives: 'make it brave/edgy/dark/light/funny/bold/kaleidoscopic'. 'Think Godard.' 'Think out of the box'. Think homicide! Complicating the language of editorial notes is an art perfected by executives (and some directors) who can then hide behind their generalities in the pretence of having said something worthwhile.

However, bad ideas do sometimes lead to something interesting, and it is this joy of discovery that makes editing so rewarding. After all, we editors have many technicians and artists, 'soldiers' and 'Chiefs of Staff' working long gruelling hours, often in inclement weather and under stressful conditions, to provide us with the material to have fun, and for the most part, we do have fun.

For the most part.

Director on set

Chapter 1

Based on a true story
Based on an untrue story
Based on a loosely based untrue story
Based on a story
Based on many stories

It is day and we are high above a desert, possibly in Algeria. In amongst the vast landforms constantly being shaped and reshaped by the wind, we locate a small group, perhaps a Bedouin family, taking respite from the heat and desert wind. On closer inspection, modern vehicles of different shapes and sizes become apparent, and closer still, we see that all but one of the faces of this group is white, albeit a slightly reddish white and the clothing, for the most part, western. The group are being very busy, doing stuff, the centre of their attention appearing to be a dark-skinned man in a sherwani (coat) and churidars (pants). He appears important and he is – he is a director and this is his film crew. A splinter film crew, not the army of technicians usually associated with the making of movies. They are here to make a contribution to the 'extras' part of the DVD that goes on sale following theatrical release. Handsome Indian director Satyajit Krish has the appearance of an aesthete, a refined looking man in his early forties, slight of build with an immaculately sculptured beard. He is in the process of doing a piece to camera. With him in this dramatic setting is the American, Filippo Costa, who doubles his Director of Photography duties (lighting) by operating the camera as well. This small unit also has an assistant director, clapper boy, sound recordist, makeup artist and Satyajit's blonde, decorative and gum-chewing assistant, Rebecca, doubling as continuity girl[3] for this small shoot, who is massaging his hands.

[3] More commonly called script supervisors today.

14

Satyajit sits posed in a casual sort of way, cross-legged on a stool, backlit by the sun, on a sand dune facing the camera. The assistant director is holding a vast umbrella to shade him from the heat whilst his face receives final touches of eyeliner and powder for the cheeks from the makeup artist. She then holds the mirror in front of him to admire her work, or rather just to admire himself, and on his approval, she moves out of shot. Rebecca and the assistant director leave with her. Satyajit gives himself a dramatic pause to compose himself, then, with the faintest of mouth movement, so as not to disturb the makeup, asks,

"Filippo?"

High up on a cherry picker[4] crane sits the exquisite Filippo, overexposed by the rays of the sun. In his early fifties and dressed in loose white designer pants and blousy double x white shirt, which billows in the desert breeze, Filippo poses to an indifferent audience below; they are all too pre-occupied in one way or another. His camera is focused on Satyajit. With his manicured white beard and long flowing white hair, Filippo looks every inch the god he believes himself to be. His eye closes in on the eyepiece of the camera. He replies,

"OK, Saty, whenever you're ready."

Saty, his eyes closed as in prayer, takes a deep breath, exhales then speaks again,

"Brian?"

Brian, the sound recordist, is seated some distance away at his cart, which carries the sound recording equipment. With some irritation, he puts down his tabloid newspaper and puts on his headphones; pressing a switch or two he shouts 'ready boss'. The assistant director takes this as his cue to shout 'turn over', the command for the camera to start, confirmed by Filippo, 'running' and for Brian to press record, 'sound speed'. The clapper boy moves in and announces,

"An Act of Courage, press promotional kit, shot one take twenty-four."

CLAP!

Following the clap, the clapper boy and assistant director move out of shot. Satyajit opens his eyes and declares with great moment,

[4] A film term for a crane supporting the camera.

"Action!"

The camera descends from up high, God returning to earth. Brian returns to his newspaper, the clapper boy to his iPod, the makeup woman to her makeup and Rebecca to her packet of Wrigley's. His master speaks,

"Ultimately this film is about courage, yah? The courage to question. And the courage to be questioned. To look into oneself and search for truth. And to doubt. Everybody says doubt is a bad thing, but this film is about the courage to doubt. I'm saying doubt is courage and to throw yourself into chaos is courageous. You throw yourself into chaos and start asking questions but to face these questions is very brave, yah? How far I can succeed with a film that costs this much and that's controlled by two studios and on which I don't have final cut, I'm not sure. If I fail, then I must be courageous enough to accept responsibility. After all, what is a man without courage, and what is an artist without courage? The courage to fail. Yah, that's very good...the courage to fail."

He smiles into camera, holds for a beat... then...
"Cut."

The image of Satyajit freezes. He is no longer in the desert but as seen on a monitor over a thousand miles away. As the monitor is switched off, the focus changes to the reflection of Ed Symonds, editor, watching.

I looked in awe through the projection box window (spyglass) down to the theatre below and there, if I pressed my head up against the glass squashing my nose and then twisting slightly to one side, I could just see the top of his head. Gregory Peck. I was working as a second assistant editor on a J Lee Thompson / Carl Forman Columbia production of a western, *Mackenna's Gold*. It was the late sixties. The projection box looked down onto the ADR theatre in Shepperton Studios. ADR stands for Automatic Dialogue Replacement but there's nothing automatic about it. Post-syncing is probably a more accurate description, but that term is rarely used now – it's the re-recording of dialogue in a controlled environment

because of extraneous noise at the time of shooting, or to improve performance. As a very lowly and very shy second assistant, I was reluctant to enter the theatre, although the very kindly supervising sound editor, Jean Henderson had tried to persuade me to come in and be introduced. I felt safer in the box looking down and got enough of a kick seeing the top of this genuine star's head through thick and quickly steaming glass, that meeting him in person seemed an unnecessary ordeal. I regret that now.

The studio had some scale to it then, with the huge (by British standards) back lot and sets from other productions, including Carol Reed's *Oliver*, which had recently finished filming. Today this back lot is a housing estate.

I had been to Shepperton Studios some years before. While still at school, I visited my father, the actor Rafiq Anwar, who had a role as a pilgrim leader in the 1965 film *Lord Jim*. Although impressed by the full-size boat floating in a gigantic tank of water being buffeted by strong winds provided by giant fans, and brief glimpses of Peter O'Toole and James Mason, I can't say that it was the cathartic moment that drove me to become part of the industry. My Jewish mother, having separated from my Muslim father many years earlier (not out of any religious conflict), exercised greater influence on me. I was, of course, encouraged along the science path and, with a local authority grant in hand, headed to Sir John Cass College in pursuit of a General Science degree in Pure and Applied Maths and Statistics. The college experience was short lived and I left after a year, applying for a second grant to go to The London School of Film Technique, for no other reason than I thought media studies (as it is now called) an easier academic option than calculus. Not surprisingly, a second grant was not forthcoming.

Editors wore suits to work in those days, and first assistants were (more often than not) career assistants, meaning that they had no ambition to become editors themselves. Digital technology was still 20 years ahead, so it was a world of white gloves, sellotape, chinagraphs (wax pencil), splicers, synchronisers, film bins and Moviolas.

As a second assistant I was largely responsible for synchronising the sound to the picture (rushes/dailies) in time for the daily (usually morning) theatre screenings attended by the director, producers and heads of department (HODs).

Syncing is primarily a mechanical operation, looking for the moment the clapper claps on picture and listening for the equivalent bang on the sound (provided by a magnetic stripe on a roll of film, which runs over a sound head) and locking them in sync, with the aid of a synchroniser.

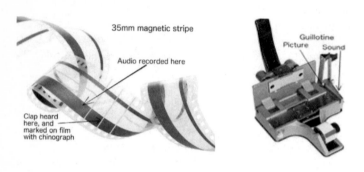

35 mm joiner

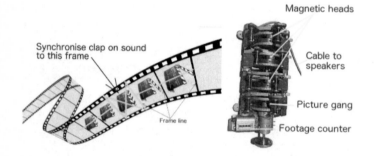

35 mm synchroniser

The shot and take number is identified both on picture and sound, making the process foolproof...mostly. These were scary moments for an assistant as it was all too easy to get the film image out of rack, by not cutting on the frame line (four sprocket holes to the frame on 35 mm, so 25% chance of misalignment in the joiner).

18

Or getting out of sync by missing a second clap[5], or by putting the wrong sound to the picture. In those days, much of the syncing was done by eye alone, with the occasional use of the Moviola magnifying screen to find a difficult to see clap. Sometimes there would be no clap at all, so then it became a matter of syncing the words to the actors' lips on the Moviola.

It was always a mad scramble to meet the deadline with no time to check one's work. I couldn't enjoy these screenings for fear of it going wrong and would sit in a room full of (to me), incredibly important people, praying I wouldn't be the centre of attention. On reflection, they were surprisingly forgiving of the occasional blunder.

The point of these screenings was to check the quality of the negative (laboratory reports might indicate over/under exposure, scratches, hair in the gate[6], etc.), check performances and to have the director choose preferred takes, give the editor his thoughts about a scene and for all the HODs to give themselves and each other a pat on the back.

Sometimes as a consequence of these screenings, reshoots were scheduled. It seemed to me from their regular over-effusive reactions and backslapping that getting an image on screen was somehow a miraculous event. With today's technology these group rushes screenings no longer happen, as rushes are viewed online by the various parties, individually on their laptops, iPads, iPhones, etc. Some miss the togetherness of the old way. But by the time I became an editor, and one with a leaning towards the anti-social, I found these screenings to be incredibly tedious.

[5] A second clap may be necessary because the first clap is out of picture or unclear visually. There would be two claps heard on the sound track however. So easy, for instance, to put the first heard clap to the second picture clap, putting the sound out of sync with the picture for the duration of the shot.

[6] As the film runs through the camera, debris sometimes collects in the gate – an opening where the film is exposed to light. This debris can take the form of minute dust particles or shards of broken off celluloid which appear on screen once the film has been processed and printed. As a precaution, camera assistants 'check the gate' after each shot by opening and inspecting it. If 'hairs' are visible, they are blown out and the shot retaken.

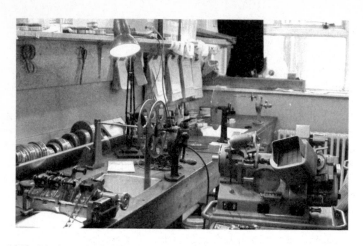

1968. Mackenna's Gold cutting room showing wooden bench with bins to catch the film, rewinds with spool and rewind plate further back, wooden troughs for picture and sound rolls, synchroniser and Moviola. Light under the synchroniser to help view image. Moviola screen marked to assign sound tracks when laying sound: left, centre, right etc.

A 'Horse' in the foreground, to hold rolls of film, and just beyond a film splicer. The mute picture can be seen on the first 'gang' or roller of the synchroniser, the other three 'gangs' have sound heads to pick up sound from the film with magnetic coating, when run through the 'gang' by turning the synchroniser wheel.

Film trim bin
(Picture courtesy of Patrick
Wilbraham)

Equally tedious were the largely clerical duties assistants performed: keeping a log of all the material, the breaking down (from the screened rushes rolls), of individual shots and takes, sometimes known as slates (identified on film by the clapper board and identified on the surface of the film itself, by a chinagraph pencil) and laying them out in order in a wooden trough for the editor to cut. The parts of the shot not used (trims) were then hung up on pins in a trim bin, each shot on its own pin.

These bins had to be constantly checked and reorganised on account of slapdash editors; a sadistic few of these editors deriving great pleasure in nullifying hours of work by the assistant by traversing the length of the horizontal support with a mischievous hand, flicking the film off the pins to land in a jumble into the bag below.

Then there was the laborious labelling of cans or boxes with camera tape, identifying slates in numerical order and then later for showing the identity of assembled reels known as cutting copy. Errands were run, and tea and coffee made. At all times, showing a smiley face to the first assistant and more importantly, to the editor. This was not always easy because I always had to be ready to enter the editor's inner sanctum at the bark of my name, 'Tarique!', to make joins for the editor, Bill Lenny; 'Tarique', a French pronunciation of my name, which still curiously persists in the USA. I was Lenny's second

assistant on *Cromwell*. I was ever so humble and had he said 'sit', I would have sat; 'fetch', and I would have fetched.

Bill rarely made a join during the assembly stage. He would view a shot on the Moviola, make in and out marks with the chinagraph (on both picture and sound, you could view them locked together or independently), remove the film from the Moviola, cut the selected pieces with a guillotine and paper clip them to the previous selections, winding them on to ever-growing, hedgehog-like spools, one for picture and the other for sound. When he wanted to screen his work, I would, with infinite care, remove the spools from his bench, rewind them to the front (they would be end out) and carefully start assembling the shots onto other spools, removing the clips and making sellotape joins with gloved hands. Heaven help me if I scratched the film in this process or even worse, allowed the paper clips to fall out, releasing the selected shots randomly into the bags hanging from the cutting table. The danger was ending end up with an edit, not of the editor's choosing but mine and receiving a clip of a different kind around the ear, which *would* be of the editor's choosing. Sometimes, presumably out of insecurity, he would want to review an edit decision there and then and I would be summoned from my room, "Tarique!", to make the join for him to look at on the Moviola. Once this had been accomplished, I would retreat backwards, reverentially bowing and scraping into the assistant's room. The first assistant, Lois Gray, an attractive, very well-endowed and motherly lady, understood my pain. She was very comforting.

The joined reels would then be taken into the screening room to look at. The courage of these early editors to cut sequences and screen them publicly without first checking their cuts needs admiring. It might well have been tosh, but I wouldn't have known as I didn't know much beyond the clerical stuff. As long as I hadn't made a cock-up in my joins, it had to be good. A great edit for me was one with no mishaps. Once passed the assembly stage, Bill found the force to make the joins himself.

Dimitri Tiomkin, the great Russian born Hollywood composer and Oscar winner for *High Noon, The High and Mighty* and *The Old Man and the Sea,* was Foreman's first choice for *Mackenna's Gold.* However, following a screening for his benefit (he slept through most of it, as did many others on seeing the film), Tiomkin was replaced by Quincy Jones. On Jones' arrival in London, I was asked

to bring him to the studio. Hall of Famer, Quincy Jones (composer, arranger, writer, record producer, musician, conductor, recipient of endless Grammy Awards and nominations, Oscar winner…etc.) and me, sharing a London cab. Now that was cool!

Probably, much more interesting than the film itself was a 'making of' type documentary (I never saw it), shot on 16 mm, which Columbia Pictures had commissioned through a scholarship given to a young filmmaker. His name was George Lucas.

Producers on set

Chapter 2

A dismal day in London, Soho. A warren of grubby streets that have been home to the UK film industry since the 1930s and the porn industry for even longer. In one of the many facility houses that have mushroomed in the area and service the industry, we discover Ed, the editor, seated in semi-darkness, facing a monitor. The monitor is one of many on the table in front of him along with a computer keyboard and small audio mixing desk. Speakers and hard drives complete the editing equipment commonly found in cutting rooms today. It is only five thirty in the afternoon, but in this winter gloom, it could be closer to midnight. Water cascades down the windows due to the heavy rain and a broken roof gutter, distorting the lights from the street five floors below, creating formless constantly changing shapes on the walls of the room. The monitors, similar to Ed, are in sleep mode waiting to be wakened. Ed, showing signs of life, touches the keyboard in front of him. The screens come alive. From one, a shot of a smiling Satyajit from the opening desert scene, stares back at him challenging him to smile back. He resists, releasing a big sigh and reaches for the bottle of indigestion tablets on the table supporting the computers. He takes one, swallows it without water, as the phone rings. He ignores it.

'Shall I get it...?'

Somewhere in the corridor his assistant Annie is calling,

'...before I go?'

'No, no, it's OK...go home, I think I know who it is. See you tomorrow.'

Annie leaves, the outer door closing after a cheery '"good night"'. Ed allows a few more rings, hoping it will stop, but cowardice gets the better of him, and he picks up the receiver,

'Hello?'

His worst fears are realised on hearing Satyajit's voice.

24

'So tell me, what have you been doing? Have you been having fun? Any miracles today?'

No niceties, just straight to the point.

'Stimulate me, Ed, I am ready for stimulation.'

Ed takes another pill from the bottle and swallows it with more difficulty this time. How to stimulate a man of pretentions? A thoughtful response,

Ed: *'I've been staring at a blank screen for several hours waiting for the film to reveal itself.'*

Satyajit: *'And did it?'*

That didn't have the desired effect. Failure to find the film puts Ed on the back foot.

Ed: *'No, but I had another go at the lake sequence. I now have twenty different permutations of the same scene. I think I may be blocked, I may need counselling.'*

Satyajit is in the back of a limo with his personal assistant, Rebecca, next to him. They are returning from Heathrow Airport, having just arrived from Algeria. She has an open box of exotic chocolates on her lap, selecting one to plop into his mouth.

Satyajit: *'I know, Ed, it's like choosing a candy from a candy box. Each candy looks as good as the next but there are subtle differences: Marzipan delight, cherry intensity, strawberry...'*

This could go on forever... Ed interrupts,

 'I need you to pick a candy, Satyajit.'

As the chilli vanilla nut crunch makes it way towards Satyajit's waiting mouth, he bars its progress by raising his hand.

Satyajit: *'Everyone looks to me for direction, but I feel I am more of an enabler. When I arrive on set and the actors ask me, "What do you want to do, Satyajit?" I reply, "What do you want to do?" It would be wrong to impose myself consciously on the growth of the movie and so to inhibit the imagination of the talented people around me. I'm a believer in the movie as a living organism, do you follow? It should be allowed to evolve. One has to be careful not to be a corrupting influence. I see myself as a simple gardener who has planted*

> cinematic seeds and stands back to watch them grow.'

Ed rises from the chair, seeds growing inside him by the minute, and carrying the phone, retreats across the room to lie down on the couch.

Satyajit: 'Do you remember when I shot that scene everybody on the set was crying? I decided to let the scene run and run and run. I couldn't bring myself to say "cut", I was so overcome with emotion...'

Satyajit's eyes begin to water at this memory. He is an emotional man. Rebecca mops the tears from his face with a tissue grabbed from a box on the parcel shelf behind her.

> 'The actors were so into it that I thought, "Why stop them?" I want to recapture that moment. In this cut, does that come across, the emotion?
> Does it work? Not over the top? The studios might say it is over the top. You must tell me if you don't like anything. You're the only person I can trust.'

Ed leaves the couch with phone in hand and takes in the view at the window. He looks down to the street below, the rush hour traffic strangely noiseless at this height. The rain continues to beat against the badly fitting sash window, rivulets of water finding their way through the gaps to the sill. He notices pieces of newspaper that have been stuffed between the frames to limit water access and vibration.

Ed responds:

> 'Well let's see. The film is at times theatrical. It's under-covered, with not enough close shots. Frequently underexposed with faces too dark. The dialogue is occasionally trite and it moves like a glacier and is still over five hours long. You could say it's an event movie with no event, Satyajit!
> Otherwise it's in great shape.'

Plop! The chilli vanilla crunch drops into place.

Satyajit: 'Have you seen Lawrence or Zhivago or Gandhi? That is what we are making here, an epic. There is a natural rhythm to the film which is defined by the story, and by its very nature, the story dictates

the manner in which it needs to be articulated, yah?'

Ed looks at the window seeing his own reflection. He shakes his head from side to side in that Indian kind of way, knowing that Satyajit will be doing the same in the taxi, which indeed he is. Satyajit continues:

'We need time to register all that is said and unsaid. Life is about those quiet moments when we retreat into ourselves to reflect and consider. The pauses I have asked you to put in are as important as the words that are spoken, do you follow? I tried to give you some close shots but Filippo wouldn't let me. The sun wasn't in the right place.'

Ed turns away from the window, his back to the lights from the street, to illustrate his next point:

Ed: 'Well, you know cinematographers... Everything backlit.'

Satyajit: 'He's a genius, Ed. Geniuses are difficult.'

Then reflecting on this point,

'People think I'm difficult.'

Ed jumps in with no hesitation:

'Not in the slightest, Satyajit.'

This slight doesn't register with Satyajit, who takes it as a compliment. With another shake of the head, he asks:

'Do you know Filippo's problem?'

Ed: 'Only one sun?'

Satyajit: 'Free floating anxiety.'

Ed: 'Oh, that sounds cool.'

Satyajit: 'No, not cool, Ed. Very uncool and very unpredictable. We had our differences, but in the end, I believe conflict brings out the best in us, don't you agree? Has anyone else seen this cut?'

Ed: 'Just Annie.'

Satyajit: 'And did she cry?'

Ed: 'She was so upset, Satyajit. I gave her the week off.'

Satyajit: 'Anyone else?'

Ed: 'Well, the window cleaner was in here when I played the scene back.'

Satyajit: 'And what did he think?'

Ed: *'He said the scene was reminiscent of the work of Claude Lelouch, in that the cynicism of his chosen subjects were dissipated by Gallic charm, a layer of chic, and a lot of modish references.'*

Ed turns once again to look down to the street below, to "reflect and consider". He can hear Satyajit still talking on the phone, his voice getting increasingly distant.

 'You know what I'm trying to do, Ed? I don't see this film as a simple tale of morality, it goes beyond that, it's a journey, a journey of discovery...'

Ed's mind is elsewhere. He tries to open the window to get a refreshing blast of cold air and rain, but the jammed newspaper prevents movement. He teases out a piece with his fingers, unfolds it and smoothing out the torn sheet realises it's an old Union newsletter, reading "BECTU at the Labour Party Conference..." He folds it back up and squeezes it into the gap, putting the Union to best use.

The Union – the Association of Cinematograph Technicians (later the Association of Cinematograph and Television Technicians, ACTT, and then later still the Broadcasting Entertainment Cinematograph and Theatre Union, BECTU) – was strong back then. In the 60s, you had to be a member to work. I got my 'ticket' (union card) when working for a small documentary company, Libertas, in Berners Street in the centre of London. Having failed the first year of a science degree at Sir John Cass College, and having failed to get a grant for the London School of Film Technique, and having failed to get onto a BBC training course, I responded to an Evening Standard advertisement for a driver and general dogsbody and surprisingly got the job.

I recall the BBC interview went badly. Having heard that it is advisable to dress one or two levels higher than the job you are going for, I wore green, low-waisted, bell-bottom flares (I had actually made myself) and flowered shirt; thinking a career in film and TV was definitely arty and that this 'look' would somehow compensate for a lack of academic qualifications.

Unfortunately, my two cloned balding bespectacled grey interviewers in grey suits were not impressed. My failure to have a

degree or read the Guardian (favoured reading of BBC management even then), were indications that I was totally unsuitable for training.

THIS IS THE BBC

Another question unrelated to my reading habits but actually related to editing had me wanting again. Two shots were described to me: one, a wide shot of a man entering a room and sitting down, the second a closer shot of the same action. At what point in the action would I cut from the first to the second? In hindsight, a stupid question, and I've no recollection of my answer but I obviously missed the cut.

At Libertas I valet parked clients' posh cars at meters, imagining myself 'Kookie', the cool, rock 'n' roll wise-cracking hair-combing fashion-conscious hipster portrayed by Eddie Byrnes in the American TV series, *77 Sunset Strip*. Sometimes I would be required to sit at the switchboard facing a bewildering array of holes, plugs and cables, invariably connecting calls to the wrong extension, which often solicited a cacophony of resigned distress, verging on screaming, from the floors above. Occasionally, I was asked to play at being a third assistant director. I would even get to keep the boss' Jaguar MK2, 0–60 in 12 secs dark blue saloon for the weekend. I cruised Soho, sunroof open and radio blaring, cigarette in mouth, one hand on the steering wheel the other around my new pregnant wife, Shirley. I was the man, Jack the Lad. I felt I really had made it in the industry. The reality was somewhat different.

Assistant directing on the floor was purgatory with even more screaming. The director screamed at the 1st assistant director and he screamed at the 2nd and they all screamed at me.

I was also required to pick up and return the talent (a term strangely reserved just for actors) and take them to the set.

On set, usually a busy London street, I was sequestered to keep the public from straying into camera shot, often pleading pathetically for them not to move, fearful of the 2nd assistant's blistering expletives in my ear. The expletives from the public, with

colourful variations on, "who the fuck do you think you are?" were the lesser of two evils. I lived with fear every day, good training for life in the fast lane later in my career.

Libertas' one cutting room had an editor, Peter Austen-Hunt and an assistant, Nick Keene. Thankfully, they took pity on me. When an opportunity arose to be a cutting room trainee, I jumped at it. There was no screaming in the cutting room. It was just so civilised in comparison with being on the floor (the film set), a bubble of blissful karma in a crazy ego-driven industry. The union 'ticket', destined for someone else in the company, came to me. I never found out exactly why, but I'd heard he'd been a naughty boy, and whatever he'd done wrong had nothing to do with me. Unlike the USA, union membership is no longer a requirement in the UK.

Ever encouraging, Peter gave me the first sequence I ever cut, a roller-coaster ride (mute – no sound) lasting about two minutes. Hoping to impress, I attacked it maniacally with twenty frame cuts, then ten, then five and so on, and then re-edited it once again with even more joins until the edit resembled a roll of gungy sellotape!

I tried to review my work on the unforgiving Moviola, but as I fed the roll into the gate, it would start and stop, start again and stop with the joins of each cut sticking, then jumping alarmingly until, eventually, it seized up. Out of panic, I accelerated the process by pressing down on the foot pedal, failing to use the handbrake lever. I watched the screen as the film suddenly leaped forward only to stall again and start to accumulate in one spot, frames overlapping (very creatively I might add); then, with the sprockets gauging into the film it started to shred.

Of course, it was unwatchable with shards of film landing on the floor, and in any event, I had failed to allow for negative cutting frames. Well, I didn't know! In the days of negative cutting, shots were joined with cement requiring a small overlap of negative.

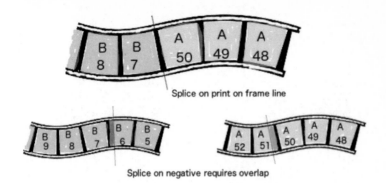

Splice on print on frame line

Splice on negative requires overlap

On 35 mm, two sprockets were required to be overlapped to make the join; this meant effectively losing a frame either side of a cut. So, if an edited shot finished on frame 50, returning to that shot on frame 51 would not be possible. When cutting print, you had to allow for these lost frames. With no fuss and some amusement, Peter and Nick had reprints made from the negative and I started again a little wiser. What gents they were.

On being made redundant a year later, I found work as a second assistant editor, through the Union unemployed register. Fortunately, there was an abundance of work and very few competing for it. My first feature film, a sort of horror, both in subject and content, was titled *Corruption*. In my ignorance, I remember being so impressed that Peter Newbrook, the DOP and producer on the film, also had a science degree. In reality, the BSC that followed his name referred to something else, British Society of Cameramen. The editor, Don Deacon and assistant, Maxine Julius, then went on to *Mackenna's Gold*. Don was one of the three associate editors on the film (along with Ray Poulton and John F. Link), and recommended me to the supervising editor, Bill Lenny. I assisted John F. Link, who came with the film from LA. Being impressionable, he instantly became my hero. Laid back, warm, great sense of humour (at times acidic), generous, encouraging, thoughtful and straight out of Hollywood!

1968, Mackenna's Gold
Long suffering-John F
Link with grumpy
assistant

John F Link at the Moviola

In later years, our paths would cross a couple of times when he tried and failed to get me on as one of the editors of a TV drama series, *Lace,* and when, even later, he edited a film, *If Looks Could Kill,* directed by Bill Dear and coincidentally co-starring my daughter, Gabrielle. Many years on from that I did end up working for Dear, editing a swash-buckling pilot, *Covington Cross.* During this time, Dear informed me, with some affection, that Johnny was actually a 'feisty son of a bitch'. What a role model! John's more notable credits are *Predator*, the first *Die Hard, The Hand That Rocks the Cradle* and *The Three Musketeers*.

That's how work came, through word of mouth. On finishing one film, I awaited the call for the next, being prepared to assist on the picture side or sound. I scratched a living, now having two young mouths, Dominic and Gabrielle, as well as a wife to feed. Several films came and went, some as notable as *The Asphyx* (about a psychic phenomenon of a blur appearing in photographs moments before a person dies), *Au Pair Girls* (not quite soft porn*), Crucible of Terror*, *She'll Follow You Anywh*ere and some even less notable! *Beware my Brethren* (based on the Plymouth Brethren) was my first experience of an editor being replaced. I was assisting John Colville, who had, as they say, artistic differences with the director, Robert Hartford-Davies. When a replacement, Alan Pattillo, was found, I had the dilemma of whether to stay or leave. Where did my loyalties

lie, with the production, or with the person who hired me? If I had had moral fibre, I would have supported the outgoing editor, irrespective of the fact that it would put me on the dole, but John encouraged me to stay and I did.

Director of Photography arriving on set

Chapter 3

A sunny day in London Town. Satyajit has brought the Algerian weather with him. His spacious and minimalist office is on the same floor as the cutting room and like the cutting room has windows overlooking the street. The weird and annoying sounds of cutting room activity permeate the walls of his room; lines of dialogue, music and effects being played forwards, backwards, pause, forwards, backwards, then backwards double speed and forward triple speed... Audio torture for anyone not directly involved.

Satyajit shares the room with Rebecca, who, with olive poised in her hand, drops it into Satyajit's mouth. The office walls are covered with Satyajit's Bollywood posters, one is upside down. There is a three-seater couch now occupied by the prone director and two desks, the sizes of which reflect the status of the occupants. Rebecca's desk is covered by many small bowls containing olives, Bombay Mix nuts and pumpkin seeds. Film magazines, scripts and a framed picture of himself with an Oscar in hand lie on Satyajit's desk along with a large bouquet of flowers with a card still attached, it reads, "Looking forward to our close collaboration in post, Walter and Abby."

The window blinds are half drawn and calming Indian music plays in the background. Incense burns. Rebecca continues to drip feed Satyajit's mouth from behind his head. On the floor, beside Satyajit, is the phone, it rings. Satyajit answers switching it to "speaker".

Satyajit: 'Hello?'

Katty: 'Satyajit, it's Katty.'

Satyajit: 'Katty?'

Katty: *'Your agent, remember? How's your schedule? The arts programme, "The Late Show" wants you as a guest at two next Thursday, their angle being "an Indian amongst the cowboys" that kind of thing. The exposure would be good, you*

know, face-time publicity. Keep you relevant. How do you feel about that?'

Satyajit indicates to Rebecca with a gesture to stop the feeding and start the hand massage. This frees his mouth to speak.

Satyajit: 'It's very short notice, Katty, I am very busy with my editor.'

Katty: 'So we should pass then...?'

Satyajit: 'No, no, no... I'm not saying that... Have you cleared it with our cowboys?'

Katty: 'We have their blessing, but if you can throw in a good word or two about our studio executives, I'm sure they would appreciate it. Abby's had a poor quarter and Walter's had a lot of negative press just recently: boorish, bullying, bum pinching, backstabbing things like that. Could do with some positive PR.'

Satyajit: 'Have you ever read "Towards the End of the Morning", Kitty?'

Katty: 'Katty.'

Satyajit: 'There's this character I strongly identify with, called Dyson.

He says, "It's not just excellence that leads to celebrity, but celebrity that leads to excellence".'

Satyajit rises from the couch and assumes various yoga positions, ending up upside down so that he can admire the inverted poster.

Satyajit: 'One makes one's reputation and one's reputation enables one to achieve conditions in which one can do good work. Freedom. Celebrity will buy me freedom.'

(Pause)

Katty responds:

'I take that as a yes. Got to go, I'll touch base later when it's confirmed... Must do lunch, bye.'

Katty hangs up before Satyajit can respond to the lunch invitation, Rebecca switches the speakerphone off. Satyajit rises and moves to the window, pulling the chord of the blind to fully open it. He stares out at the world – well a bit of it – before him.

Satyajit: *'The phenomenon of celebrity. You know Rebecca,*
I'm really just a poor boy from Bombay, celebrity
in itself does not interest me, it is purely a
question of what celebrity can achieve. I would
have a voice. I could influence opinion, fight
causes, be important...relevant. Imagine, in the
papers every day. "Maestro Krish says..." and
with pictures!
I must confess I would so like to be on the cover of
Newsweek.'

Rebecca: *'Awesome!'*

Satyajit becomes aware of his reflection in the window and
curls his hair with his finger.

Satyajit: *'Perhaps, I should have my hair cut?'*

I didn't learn a great deal about editing, I don't think you do as an assistant, but it was fun: not too much responsibility, great rates (£20 plus a week), time and a half overtime during the week and double at weekends, guaranteed days, long meal breaks (with penalties if not taken), meal allowances and an amusing drinking culture (particularly amongst the sound boys) which was tolerated because that's the way it had always been. Lunchtime pub visits were frequent; when in Soho, the Intrepid Fox on Wardour Street

was the favoured haunt for film techies during the day and early evening. At night, the pub (with a history dating back to the 1780s), was also the haunt of rock and rollers and years later, those seeking alternative music. Sadly, it was eventually closed down in 2006 to make way for flats. When at Shepperton Studios, the cutting crew of perhaps five or six,

crammed themselves into a grey 1275cc Mini Cooper 'S', driven at speed by its owner, sound editor Bill Taylor, arriving at The Three Horseshoes, where beers washed down a staple diet of ham, egg and chips.

With more time at hand, the venue changed to Walton for a leisurely curry, invariably followed by a siesta in the afternoon. Ever professional, we made up for lost hours in the evening...at time and a half! During sound dubbing, it wasn't uncommon to hear the occasional snore and burp in the theatre after lunch, and it was not coming from the sound track. Part of the assistants duties were to make sure their sound editors moments of hibernation went unnoticed (with a gentle nudge) particularly when the big boys were around.

By today's standards, sound mixing was archaic. A reel of picture accompanied by as many tracks of sound as was possible for the machine room to run (depending on the number of sound transports available) would be loaded up and run at normal speed and the mixers[7] (sometimes three or even four, having each been assigned certain categories: dialogue/effects/Foley[8]/music) would mix them without being able to stop. Stopping would mean aborting the recording and going back to the top. They would have charts written by the sound editors indicating where, in terms of footage, to expect tracks on the reel and what sound element was on the tracks. Below the screen in front of them, a footage counter would be displayed as a reference. These charts, mirroring the audio on the tracks and often written by the assistants, were a source of great pride, as artful as the track laying.

[7] more commonly known as dubbing mixers in the UK and re-recording mixers in the US.

[8] Foley – footsteps, clothes rustle, glass clinks, bangs, punches, etc., recorded live in a Foley theatre.

Dubbing chart as used on Reel 2 of Episode 3 of Ashendon, by sound editor, Keith Marriner. The first 6 tracks (green edge) exclusively for dialogue, tracks 7-11 background effects and further tracks for specific sound effects…

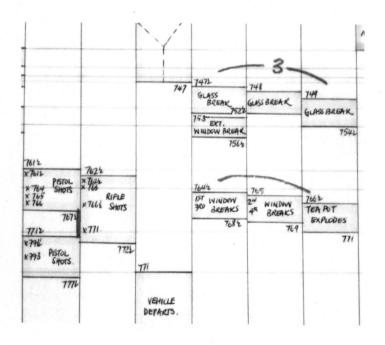

Closer on effects (FX) tracks

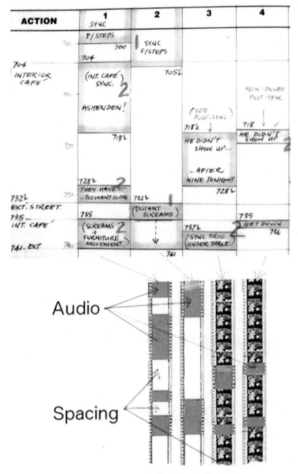

Audio

Spacing

Closer on dialogue tracks

The audio on magnetic coated film (sometimes striped, sometimes fully coated) was spliced into reels, separated by spacing, necessary to keep the audio in sync with the picture. This spacing would be either clear film or 'gash' film; 'gash' film being unwanted rolls of rushes or even old release prints acquired from the film laboratories. Sadly, some old classics found unexpected further use as 'gash'. There used to be quite a black market in supplying

spacing to productions providing further revenue for editors and assistants. With a roll (1000 ft.) fetching a few pounds, this could a lucrative trade on large productions like *Mackenna's Gold,* where some reels extended to well over one hundred tracks.

With only ten backroom transports available (one reel of sound per transport), a picture reel would have to be run many times with a different set of tracks loaded each time. When a technology called 'Rock and Roll' came in (early 1970s), it allowed the mixer to stop at any point and go back and then forward again, skilfully punching into record at a suitable point. A great advance but initially, the forward and backward movement was only at normal speed.

The many dialogue tracks would reduce to one or more dialogue pre-mixes[9] and, similarly, effects tracks to two or three effects premixes, Foley tracks and music tracks likewise until the number of pre-mixes matched the transports available and became manageable to make one pass for the final mixed sound. These premixes would also be on full-coat magnetic film which could accommodate more than one track, usually using three (commonly called triple tracks).

The final mix, made from all the premixes, would also be on this stock. This allowed for a simple 4 track stereo, left-centre-right and surround sound. This was then converted to an optical track negative and married to the picture negative, producing a married or ComOpt (combined optical) print.

Stereo optical track (L-R) on left of frame

[9] pre-mixes, also known as pre-dubs.

Mackenna's Gold being shot on 65 mm negative for a 70 mm print used a 4-track magnetic soundtrack, although the larger format facilitated a 6-track soundtrack on later films. A 70 mm film was too large to handle in editing, so a 35 mm squeezed image reduction print was made, an anamorphic lens being placed on the Moviola to read the image correctly.

And so, the days would pass. I had no ambitions to edit, it seemed way beyond my reach and I was enjoying what I was doing. My goal was simply to become a regularly employed first picture assistant.

The late sixties signalled the end of a golden period of UK filmmaking with the Americans pulling back from financing film production overseas. The industry was imploding. After months of unemployment, I took a short-term 'holiday relief' contract with the BBC. I intended to stay a few months but stayed 18 years.

Actress on set

Chapter 4

The cutting room has taken on a new meaning. It's late afternoon and Satyajit sits in the middle of the room having his hair cut by a small, rotund, white-coated barber, while simultaneously having his hands massaged by a kneeling Rebecca. The only thing missing is the punkah wallah (a manual fan operator). Satyajit is facing the monitors as Ed runs a sequence of the film's female interest, American actress Angel Hart in period costume, as she is being rowed on a lake. The period is early 1900s. She is in conversation (very English, English) with a gentleman, although the conversation is hard to follow because of crowd, aircraft and motorboat noises coming from the film soundtrack and the electronic razor in the cutting room.

Ed: 'Satyajit, these lines are inaudible. I had the sound boys try to filter out the background as much as they could but they feel, as I do, that it's worth having her re-do them.'

Ed turns for a response but none is forthcoming. He stops the playback, the frame freezing on a big close up of Angel, mouth open. From Satyajit's glazed expression, it's apparent this aesthete is on another planet.

The razor continues to whirr, hair floating in slow motion to the floor. Masked by the electronic buzzing noise but in the same pitch, Satyajit can be heard to be intoning. It's mesmerising and surreal.

Satyajit: 'Do you know, creativity comes out of meditation?'

He looks down at Rebecca.

Rebecca: 'Awesome.'

Satyajit: 'It's a question of controlling consciousness, fading it out.'

Satyajit gives Rebecca the other hand to rub.

Ed looks at Rebecca then back at Satyajit. A thought comes into his head, and in the spirit of controlling consciousness, he keeps the thought to himself...

'Satyajit Krish, mystical director...' *and building it into a full character assassination...*

'Interesting from a physiological point of view. Born with a film splicer in his handsome mouth but questionably without a spine. Typically, discovered 16 mm Bolex in the attic of his mud hut when he was three. Made his first feature film a year later. Curiously, risen from poverty to rupee fortune with a string of Bollywood failures but collecting the ultimate prize, an Oscar, for breaking new ground with a semi-autobiographical short film about the life cycle of a worm. Passive-aggressive, and in common with most directors, a victim of studio abuse. Charming, resilient and really hard to dislike, at least on a superficial level. Made of India rubber.'

Satyajit bounces back into this world.

Satyajit: *'If you feel we have to, we must do it. Technical reasons, not performance related, as long as she knows it's not performance related, not from my point of view at least. But if she thinks she could improve the performance, then she should, don't you agree? She should give us options, it is better to have options. Oh and make sure the dialect coach is with her.'*

It slowly dawns on Ed that he will be running the ADR session alone.

Ed: *'You will be there, won't you Satyajit, two, Thursday afternoon?'*

Satyajit: *'My friend...'*

Ed slightly panicked. Any sentence starting 'my friend' is the precursor for something unpleasant.

Ed: *'Only, actors don't like taking direction from editors...'*

Satyajit: *'Not only editors, my friend.'*

Satyajit laughs at this rare bit of self-effacement.

Ed: *'And she is given to cantanker, I don't feel equipped...'*

Satyajit: *'Ed, it's just technical, I don't need to be there... What is life without challenges? I shall be*

challenged in promoting the film on telly and finding nice things to say about our studio bosses...and you, challenged in overcoming your insecurities. I have every confidence in you. The experience will make us both better, more rounded people.'

Satyajit leans forward conspiratorially...

Satyajit: 'Besides, and just between you and me, I have to be mindful of my next project, and exposure is no bad thing. It will be in your interest too. I'm doing it for us. Where I go, you go; we are inseparable.'

Off Ed's look of increasing anxiety, Satyajit leans back closing his eyes.

'As I tell all my actors, you must learn to anchor yourself in the moment, play the part.'

Ed turns back to the screen, the big close up of Angel facing him in confrontation.

Satyajit: 'It will be broadcast live next Thursday evening, just in case you happen to be near a television set... Don't feel you and the gang have to watch, at 10 pm, only if you have nothing better to do... I'll wave to you.'

A commotion in the hallway heralds the entrance of Boyd Kirstner, associate producer of the film, who is with his underweight and pasty young assistant, Kelly. During production, the studio bosses have kept a low profile, leaving Boyd to act as minder on their behalf, but being well into post-production, he is aware of his lessening authority.

Boyd barks an order to Kelly, which can be heard by everyone in the building and beyond.

Boyd: 'Remind me to call Redford!'

They enter the room, blustering Boyd first, like Colonel Kilgore in Apocalypse Now, dressed in army fatigues. Then pack mule Kelly, laden with bags and pulling a large carry-on. Boyd seems oblivious to the barber scene in front of him.

Boyd: 'What's that smell, napalm?'

Annie, Ed's assistant, who has followed them in, answers:
"Incense."

Boyd: 'I like the smell of battle'.

He pauses letting that thought hang in the air.

> *'Just on my way to the airport, thought I'd drop in on the troops, only got a few minutes. How's it going, ready for the preview?'*

Satyajit rises from the barber's chair; discarding the white sheet, he attempts to embrace Boyd, but Boyd doesn't do hugs. Satyajit's arms hug air.

Satyajit: *'We're in great shape, just a few tweaks here and there. Would you like to see something, Boyd?'*

Boyd sits facing the monitors in full expectation of seeing something,

> *'No, no, no, I don't want to hold you up. Only time for a quick macchiato...'*

Ed taking this cue,

> *'Annie?'*

Anne: *'I'm on to it.'*

She starts to leave.

Boyd: *'And string cheese.'*

She stops, with an expression that says, 'Where to find string cheese in Dean Street?'

> *'With pastrami on rye.'*

Rolling her eyes, she leaves again. Kelly sets the bags down. The barber takes a seat at the back of the room. Boyd continues,

> *'I don't want to interrupt great work, but shoot me anything, anything at all that I can absorb and reflect on, on the plane. I hear good things about the last cut you sent them...'*

Satyajit beams, approval is what he's looking for...

> *'Oh good, what have you heard?'*

...but it's short lived, Boyd continues,

> *'Nothing, not a dicky-bird.'*

Satyajit's face drops, noticed by Boyd,

> *'Believe me, not hearing is a good thing, as good as a blessing from the Pope.'*

Satyajit and Ed look at each other.

> *'Ed, what should we show?'*

Ed is non-committal,

> *'Just run it from the top.'*

Boyd takes a deep whiff of incense,

> *'Boy that stuff is heady, must get me some Kelly.'*

Kelly takes note.

Satyajit resumes his seat in the barber's chair, Ed presses the **play** button, the film starts. Boyd's mobile phone rings, he answers,

'Brandy, what you got?'

Ed stops the film only for Boyd to gesticulate to carry on. He presses **play** once again but also pulls down the volume slightly, preferring to hear the phone conversation. Boyd is talking to some unfortunate secretary,

'It has to be the Four Seasons facing the ocean. Three nights, maybe four, and two rooms if not a suite, wrap around terrace and no higher than five floors and with a fax line and ISDN hook up and with one of those new flat screens and DVD player, surround sound and Nintendo 64. High speed internet, 100 megabytes no less and CD player...'

Kelly, desperate to please his master,

'Suite 401 faces the ocean, Boyd.'

'Get me suite 401, and tell them who I am.'

Boyd gets up and paces up and down, still talking to his secretary, occasionally looking at the film.

Ed, his thoughts to himself, reflects on who he is.

'Who he is of course is just a producer. Although no producer is really just. Boyd Kirstner is a small producer struggling to be a large producer. Middle management, which means an office overlooking the car park. Operated by a key in his back and permanently wound up by the papal office, the Studio. A screamer. Excitable. Knee jerk reaction to every problem. Loves his holidays and firing people. Consequently, works with a conveyor belt of punch bag assistants, his mobile phone grafted to his ear.

The most self-destructive quality in a producer is his choice of director.'

Boyd, still on the phone,

'Make sure there's a Maybach to meet me. Bye.'

He clicks his fingers to Kelly, who then picks up the bags,

'Gotta go guys, great job, the film's in great shape, love your work, it's...it's...it's a functioning, know what I mean? Functioning.'

Kelly exits, and as Boyd reaches the door, he turns to Satyajit,
> *'Let's do some paint ball when you get in?'*
He leaves just as Annie arrives with the drink and food order in a paper bag.
> *'Kelly, bring that with you.'*
The overburdened Kelly, with no hands free, has the handle of the bag placed in his mouth by Annie, then leaves.

I had no intention of staying at the BBC any length of time because, well…it was only television. And as we, in the movie world all know, television is not quite the ticket. If there is something disparaging to say about a picture 'look' or editing style, you say it's 'too TV'. It's a universal comment that needs no qualification to those in the know. It suggests the speaker is speaking from some higher place, some higher authority that can't be challenged. It is so tiresome. When, eventually, I did leave the BBC and in spite of a BAFTA award and many nominations to my name, I couldn't get a feature to cut because I was considered by financiers to be *only* a TV editor, an editor that can only cut for the small screen. That snobbery still exists today and that same sad thinking separates an editor's ability to cut different genres of film. A comedy editor can't cut drama, a drama editor can't cut action, an action editor can't cut a period film and so on. Director Sam Mendes invited me to cut his first Bond film, *Skyfall*. Producers Barbara Broccoli and Michael J Wilson invited me not to. That kind of thing.

My initial weeks at the BBC were spent at Lime Grove. Built by Gaumont Pictures in 1915, it is now sadly another housing estate. Similar fates have befallen neighbouring sites around Shepherds Bush: Television Centre, as we knew it, is no more, Woodstock Grove / Kensington House is now the site of a hotel, Television Film Studios (now Ealing Studios) a run-down shadow of its former self. These acts of vandalism to be rewarded, in time, with Knighthoods.

When I was there, Lime Grove was largely the centre for current affairs. I assisted several editors on a variety of documentaries and topical programmes working entirely on 16 mm film (like spaghetti after 35 mm). Having come from the feature world, I was amazed at the youth of all the editors and also their ambition and confidence. No career assistants here. Editing was a given (in time and if you behaved, just like the civil service) and for many others, just a stepping-stone for something better, directing or management. Whereas most people in the film industry worked their way up from lowly beginnings, taking years to achieve their goals, TV fast-tracked many into positions of authority. Many of the young editors I was working with had come straight from university, film schools or the BBC's own training course – the very course I had been rejected from before my 'Kookie' days.

Within no time, I found myself being given news items to edit (under loose supervision by the editor), or laying sound for

programmes such as the current affairs *Europa* or the war series documentary, *The Grand Strategy*. Editing news was particularly challenging as the material would come in (mid-afternoon) on reversal stock (like slides, both negative and positive) and would have to be cut, track laid, mixed in a dubbing theatre with a commentary and rushed up to telecine (a machine used to convert film into video) for broadcasting early evening. The film had to be handled with care with each editing decision being the final one; you couldn't have too many tape joins because of the 'roller coaster' effect. There would just be time to breathlessly race to telecine for transmission, negotiating a maze of corridors, through many doors, up and down clanging steel staircases in this factory-like building, delivering the finished film to the telecine operator and then retracing your steps back to the Lime Grove bar, to watch the item go out on the bar television along with my many half-cut colleagues. I didn't drink much but my colleagues did; the pressure needed releasing in some way. Exhilarating times.

My holiday relief contract expired and as the BBC had become less discerning than in my training course interview days, I was offered permanency. The feature industry was still in the doldrums, so I took what was offered and was placed with a drama editor Larry Toft at TFS in Ealing. Larry was very old school. Not always suited but always conservatively dressed. He cut on a Moviola, which was a museum item as picture synchronisers and Steenbecks had come in. He still worked with white gloves. He had been a Second World War bomber pilot and would happily stop work and reminisce in a quietly spoken voice.

The picture synchroniser had a bulb housing above the film that generated enormous heat, and it was advisable to lift this during periods of inactivity. Larry, fastidious about work as he was about appearance, always went through this ritual when he was about to embark on a story of one sort or another. Because my bench was adjacent to his, the light, when raised, shone directly into my face; I was a

rabbit caught in the lights of a car for an indeterminate length of time. I hope I never made him aware of my discomfort and his stories, sometimes repeated, were always interesting. He died during the writing of this book and at his funeral service it came to light (to me anyway) the extent of his heroism during the war. Just before his death, he was honoured in Poland for his bravery in dropping supplies to the Polish resistance.

Larry was always respectful to the many, many directors who came through the door but also very honest about their failings, expressing his thoughts with carefully chosen words. He had an analytical approach to editing with the facility to verbalise the thought process behind each cut – something I find difficult even now. He was painstaking about his work and encouraged me to 'have a go'. He would comment on my

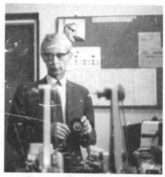

Larry Toft at the Moviola
(Picture courtesy of Chris Toft)

efforts, make suggestions and insist that I made the changes myself because that was the best way to learn, but only if I felt they were worthy of making.

He would also tell directors if they liked a sequence I had edited, that I was responsible for it; if they didn't like it, he wouldn't say anything.

There was a position of 'acting' editor at the BBC given to the more experienced assistants on a sort of trial basis. I did this on and off for about four years, regularly applying for the few (5-10) full editor positions that came up every year. For these positions, Boards were held and interviews given, chaired by the head of the editing department, a personnel officer and generally two others, perhaps a director or producer. I failed five of these boards over several years. This appalling failure rate at interviews I managed to exceed when I eventually left the BBC and freelanced for jobs. I just don't interview well. In my defence, the competition at the BBC was tough, with many talented would-be editors of the calibre of (now well established) Robin Sales, Clare Douglas and Jon Gregory. To follow later were Masahiro Hirakubo, Paul Tothill, Mark Day, Joe Walker, Francis Parker and others who have made their mark in the

feature world. Many more, who remained at the BBC until it fell apart, would have more than held their own in the freelance world had they chosen to leave. The BBC was, by far, the best training ground for editing and probably camera and sound too: the range of work, the collegiate atmosphere, the very open, humorous and sometimes hostile discussion of one's work over tea in the canteen, the security of knowing that whatever one did the chances of being fired were small. No endless line of producers, executive producers and financiers to negotiate, no test screenings and no focus groups. In those days, good audiences were hoped for but didn't drive the work.

I did eventually get 'made up' to editor and over the next 14

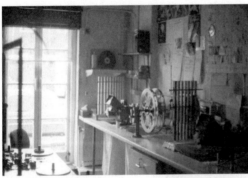

'S' block ground floor cutting rooms with newly laid carpet and exterior across car park

years or so, worked in a ground floor, cell-like 7' x 15' room in Ealing, which was shared with my assistant. This room also accommodated two cutting benches, two film bins and a 6-plate Steenbeck. It was cosy, particularly when we squeezed in a director and producer. Making it uncomfortable for them was not an intention but an unexpected bonus; they couldn't wait to leave. My room was smaller than most but the only one with French windows opening out to a narrow path running the length of the building, a low wall and car park beyond. The low wall provided a good place to lie back and contemplate my next cut; passers-by mistakenly thought I was sunbathing. It also gave me a back exit when needed.

There were two blocks of cutting rooms 'S' and 'T'. My block, 'S' block (housing the middle class of editors), had three floors with about ten rooms per floor, all to one side of a corridor, the other side leading to a sound stage, and then there was 'T' block (home of the upper class of editors) consisting of about six larger rooms on the third floor of a block with a view of Walpole park. The working class of editors would be those around Shepherd's Bush, no offence intended for those who worked there. The elitist editors in 'T' block, tended to cut the high end 'all film plays' (closest to feature films in television) whereas 'S' block editors would cut a mix of programmes from documentaries to light entertainment, drama series and serials. I distinguish 'all film' from 'not all film' because there were a lot of dramas and light entertainment programmes which had taped or live electronic studio content as well as film. My major claim to fame is being one of the many editors who supplied film inserts to the now cult *Dr Who*. Less cult for me were comedy shows like *Some Mothers Do 'Ave 'Em*, *Last of the Summer Wine*, *Terry and June,* and so on. Gradually, I progressed from inserts to all film drama series like *Shoestring*, *Bergerac* and *Chinese Detective*. These series were shared amongst several editors and a conveyor belt of different directors.

Chinese Detective had me and my assistant, Raj Kothari[10], in hysterics. Not serious drama, nor intended for laughs; it caused us to burst into giggles whenever we watched the cut. Very unprofessional, but sometimes the performances and dialogue

[10] Son of Motilal Kothari, who brought Louis Fischer's book, *The Life of Mahatma Gandhi*, to Richard Attenborough's attention. Attenborough dedicated the film 'Gandhi', to Motilal, Nehru and Mountbatten. Raj left the BBC to work on the film with editor John Bloom.

reduced us to tears, behaviour dismissed as childish by producer Terry Williams, who told us to grow up and left it at that. We attempted to curtail these involuntary titters when in the company of one particular up-and-coming director but failed miserably. During the review of his masterpiece, either Raj or I failed to suppress a chuckle, triggering the other to join in. When this happened, I temporarily halted the viewing, apologised to an extremely indignant director and promised to behave, but on continuing, we, Raj and I, feeding off each other's growing hysteria only made matters worse.

Raj blaming me for director abuse! (Picture courtesy of Raj Kothari)

The fashion-conscious director wasn't amused, declaring as he stepped to the door, that this was the worst experience he had had in a cutting room all his life and posing briefly in the doorway, so that we could admire his Armani look for the last time, left. His retribution was to bad-mouth me to the director of the next episode who introduced himself by saying 'shut the fuck up, and keep your opinions to yourself'. I didn't laugh or offer an opinion again for some time.

Better quality work came my way in the shape of *Tender is the Night, Fortunes of War, Oppenheimer, The Monocled Mutineer, Summer's Lease, Knockback* and many others, working with a host

of wonderful directors such as Barry Davis, James Cellan Jones, Robert Young, Martyn Friend, Piers Haggard, Jim O'Brien, Robert Knights, Moira Armstrong and producers Betty Willingale, Joe Waters, Richard Broke, Peter Goodchild, Mark Shivas, Sally Head, Colin Rogers, Kenith Trodd and many, many more.

Aphrodite Inheritance, a drama series produced and directed by Terry Williams was my first introduction to the delights of location editing (Cyprus), soon to be followed by Martyn Friend's, *Summer's Lease* in Tuscany. Martyn, with whom I had worked on *Bergerac*, cast my daughter, Gabrielle, which is the only time she and I have worked together on a drama; I was later to cut a documentary in which she appeared and directed.

'Summer's Lease' location editing in Vagliagli.
At last, control over my daughter
(Picture taken by assistant Leila Farag).

Fortunes of War had me travelling out to the then Yugoslavia, Greece and Egypt just to show the ebullient director Cellan Jones and crew, work in progress. The daunting seven-part series was made less so by the immensely warm, enthusiastic barefoot sandaled man, as eager to talk me through the history of Yugoslav ethnic divisions (as we walked around the streets of Ljubljana), as talk me through the edit; his voice having a huge dynamic range with

unexpected theatrical explosions as entertaining to me as to the locals.

Similarly, on *Tender is the Night*, I flew to Zurich carrying two large 16 mm cans of film (picture and sound), and hired a car for the two-hour drive to the location in Vulpera close to the Austrian border. To my surprise, we projected the film, about sixty minutes, to everyone including the actors Mary Steenburgen, Peter Strauss, Sean Young and John Heard, without director Robert Knights having seen a frame of the edit. It takes a brave director to 'go public', without putting his editorial mark on his film. It was generally well received, but the freedom given to me by the director was alarming to an already disgruntled Strauss ('do you mean, you cut this on your own?'), who found the whole BBC experience somewhat alienating. Robert and I had intended to have a *mano-a-mano* viewing before the screening but that didn't happen as he had other priorities.

Knight's beautiful and spirited French wife, Carole, was also on location and supposedly given to throwing his dinner out of the window if he returned late from filming. Of course, Carole might well have been put up to it by a budget-conscience and mischievous producer, Betty Willingale, trying to avoid crew overtime. Robert was, however, a brilliant tennis player, taking me apart with relative ease when time permitted in post-production. I believe he thought my editing was as functional and as pedestrian as my tennis.

The six-part *Tender is the Night* was one of the earliest BBC co-productions, a collaboration with the USA's Showtime. Up to this point, Drama Department did pretty much what it wanted, but a partnership of this kind did necessitate at least an outward appearance of a team effort. Prior to filming, Showtime made attempts to reduce the number of episodes to five. This was not an agreeable prospect for writer Dennis Potter, but producer Betty Willingale, taking her persuasive argument to New York, advised them otherwise, and six it remained. Showtime had some presence on set and a lesser one in post-production, but I don't recall them having a great creative influence on the series.

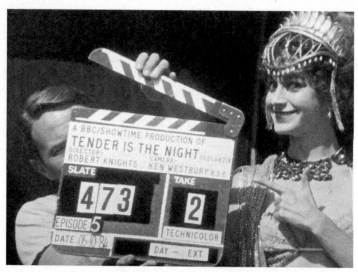

Sean Young fooling around.

Attempting, and failing, to strangle director Robert Knights, 'Tender is the Night'

State of the art BBC dubbing theatre 'B', with 'Tender is the Night' mixer Ken Haines

In due course, I wormed my way into the 'all film play', the most notable being *Caught on a Train*. Written by young, rising star Stephen Poliakoff and produced by the hugely successful and respected Kenith Trodd, it was the first time that I became aware of the 'politics' in film-making that was to be so apparent on my return to the feature world. I never felt either of them liked me particularly and thought me very much an 'S' block editor in their world of 'T' block technicians. I was cloth cap to their bowler. The cameramen, for instance, were Tony Pierce-Roberts, who left half way through filming to freelance with great success (*Room with a View, The Remains of the Day* etc.), and John Else (an extremely gifted and modest man), who took over from him. The director Peter Duffell was new to me and I to him but such was the way of the BBC there were no interviews just, "Peter, here's your editor!" Producers would sometimes make requests for editors but it usually happened behind closed doors.

Caught on a Train was a polished production: well written, shot and directed, and with wonderful performances from Peggy Ashcroft and Michael Kitchen. Peter was on location during most of the shoot, and I remained at Ealing. We spoke occasionally on the phone but I was left to assemble as I wished.

I laid a temp music track (in this case, the solo piano of jazz musician Keith Jarrett – Hourglass) something I have always done during assembly because it helps me with tone, emotion and rhythm, and is just fun. It gave the film a contemporary feel, a driving urgency to the story with beautiful right hand melodic improvisations complementing a repeated funky left hand line, which to me imitated the sounds of wheels across joined rails. It gave the film a sense of a journey which it was; a train trip from London to Vienna in which a business man Peter (Michael Kitchen), encounters an irritable lady, Frau Messner (Peggy Ashcroft). The atmosphere is claustrophobic, mostly taking place in a sleeper compartment, with one's affections constantly being displaced from one character to the other. It's very much a conversation piece between the two with other characters drifting in and out on the journey. Fortunately, Peter liked the assembly and loved the temp music (later buying the album) and hired innovative jazz composer/musician Mike Westbrook to write the score.

I would view the morning rushes (straight from the laboratories and mute at this stage) along with the Film Operations Manager, in

one of a bank of tiny screening rooms just to give the OK on the negative. Because of the volume of work coming through the BBC, rushes would sometimes be run at double speed. I would then pass on any concerns or praise to whoever asked. However, even giving praise can backfire. In one scene, the train is brought to a halt as a consequence of an alarm being pulled. The police arrive in numbers and there was, to my mind, a beautifully lit wide exterior night shot of the stationary train with police cars arriving and people getting off in the middle of nowhere. I commented as much to the FOM saying 'it looks like a feature'. This got passed down the line until it settled on the DOP Pierce-Roberts, who duly sent me an irate message back not to make comments like that. I think he or someone else took that to mean he was being too extravagant with lights.

During the initial editing and in Peter's absence, Poliakoff and Trodd would pay visits to the cutting room to see the progress of the film. It quickly became apparent from his negative comments about what he was seeing that Stephen's ambitions lay in directing and that Kenith, from his lack of humour and somewhat dark demeanour, took himself too seriously and was given to intrigue. Both had habits. Stephen fingered a grubby rolled up piece of something (perhaps a paper receipt) between his thumb and forefinger, and Kenith would play with his then longish black hair, fingers combing curls with a little flourish of the head at the end of each stroke and not at all in time with Jarrett's syncopated left hand. I fixated on their movements, irritated by their lack of timing but equally by their negative comments regarding the cut footage. Neither was particularly happy with what he was seeing. It was not directed at me (I may as well have not been there), but at Duffell's direction. I said nothing to either agree, or worse, to defend Peter. With 'keep your opinions to yourself' still ringing in my ear, I knew my place. At the end of these viewings, I was told to keep shtum. Their presence in the cutting room was as fictitious as mine. Another moral dilemma and another failure on my part, as I can't remember ever telling Peter of these clandestine visits. In any event, the film was a great success.

Shortly after, I was tempted to leave the Corporation when Peter offered me *The Far Pavilions*, which he was going to direct for Channel 4, but I was rejected by the freelance producers in favour of a feature editor. So, I stayed.

Chapter 5

Four figures stand in silence facing the lift doors. The lift is rising to the sixth floor of a sound facility, the location of the ADR theatre. The talent is Angel, the actress from the boat scene, who has been called in to do the dialogue replacement. Her eyes are shielded with the darkest of sunglasses, her expression none to friendly. Held tight to her somewhat inflated falsies is a magazine, the front cover of which has a picture of her with the same adversarial look. Her face is almost expressionless, expression having been removed by surgery but one can detect something simmering underneath the taught skin: Madam Etna about to explode. She is accompanied by her voice coach, Francie and assistant, Leslie, both pasty white, dressed all in black as though going to a funeral, their solemn expressions mirroring their mistress. Leslie carries a large bag of Whole Foods groceries. Squashed to the back of the lift behind the three women, somewhat dwarfed by their high heels and looking very uncomfortable, stands Ed. Angel can hold back no more and with small convulsions leading to bigger ones, explodes her bile, rather like a child would, not wanting to eat spinach.

'I...I...I...I hate looping[11]!'

Ed, with the heady sense of lift levitation, glances furtively at Angel, thinking, but not having the courage to say, 'Don't we all, darling!' He continues his thoughts; a response similar to Peter Sellers' expulsion of scented air in the Pink Panther lift crosses his mind? He decides not, then muses,

'Angel, new age, reconstructed, radical-free actress. Spoilt, petulant, immature.

Spiritually damaged, self-absorbed, fragile and not quite the sum of all her parts, some of her parts not being entirely hers.

[11] Another term for ADR. The picture and sound of the section requiring re-voicing, were joined into loops in the days of film.

Unreliable and, of course, grossly overpaid. Single figure IMDB STARmeter[12] reading for sure.'

She senses his negativity and turns to look at him. Ed, a somewhat sad STARmeter reading in the thousands, smiles back innocently.

The BBC newspaper Ariel, published weekly, had a diary section on the back page for anyone working there. It was too good an opportunity to miss, a brief account of the film editing process at TFS (Television Film Studios) from start to end. Most of it was published.

Author complete with 16 mm film headband

It takes about 20 mins from TFS to the Bush, that's about the same time it takes a BBC producer to discuss the emotional curve of

[12] Every time someone visits an Internet Movie Database (IMDb) page, (a database of over 3 million titles and 6 million people), they record that 'pageview'. It is the sum total of these pageviews that form the foundation of the STARmeter readings. The lower the STARmeter number, the higher the popularity.

a sync plop[13]. I'm on my way to a planning meeting for 'Play for Today'. We editors don't get invited to planning meetings as a rule, so to mark the occasion, I wear my best jeans and Film Department's ring of confidence. I enter a large conference room with tables laid out in a square, with what appears to be an army of people seated facing inward: Costume, Makeup, Design, Production and Film Department. I decide to sit with Film although Makeup look far prettier. The Head of Department makes the introductions followed by a stirring speech which blends beautifully with the House white served prior to launch. The two combine to give a feeling of well-being if not somnolence. I recall little else of the event other than meeting the director who regaled me on the untimely death of Hollywood Studio Tsar, Irving Thalberg. He further attempted to reference half a dozen obscure European films I'd never heard of, let alone seen, and the role of editor vis-à-vis character development and structural progression. He didn't seem impressed that my BBC cinema allowance encompassed only one film per year or that basically being an 'S' block editor, I had no idea what he was talking about.

My glazed expression conveyed a man in need of guidance, for then he informed me of his intention to send audio tapes back from location, indicating the manner in which he wanted the film cut. He was also half my age and twice as experienced. I return to Ealing with all my insecurities, inhale the musty autumnal air of my cutting room and, to bolster my self-esteem, arrange my own planning meeting with my assistant...to discuss the weekend. Feeling more confident, I start to read the script and send the ACTT some money. Several weeks into filming, the only cassettes being played are those of Stevie Wonder. No contact with production, apart from occasional visits to the rushes theatre by the producer. I haven't been introduced to him yet but as he doesn't ask what I'm doing there, I feel we have a pretty good working relationship. Notice hair on his nose. Cutting progresses nicely, I have more than 90 mins assembled and feel at peace with the world. Being well-directed, shot and performed, my job is made easier and I have time to acknowledge the crew's work with a toast in the Red Lion. If only I

[13] A sync plop is a 1 kHz tone heard two seconds before the first frame of picture. It coincides with the 'three' frame on the picture leader. It is used to confirm sync.

could send it for neg. cutting now before anyone else sees it and ruins it. Read a few more pages of script and send the ACTT more money. First contact with the director. He phones from location and asks if I've read Cecil B DeMille's autobiography? I also get a call from the producer's secretary; the producer is on his way over with the writer to look at the cutting copy. They arrive and we exchange grunts. I sit the pair near the viewing machine immediately in front of me and observe them observing the film. I find this more absorbing than the film itself. They seem to have a facility to rationalise which I can only describe as awesome, particularly when you consider we are still on the leader! The producer has also a habit of clicking his fingers, anticipating the cuts. The success rate is about one in five. Feeling terribly inadequate, I offer them coffee and my attractive assistant. The producer refuses the coffee. I notice the hair has grown an eighth of an inch. With that kind of growth, I reckon we could be dubbing with a measurement of half an inch. On the other hand, an active phase of development could play havoc with my schedules. I also consider that for him, every shot must have a hair in the gate. I'm still not sure he knows who I am or what I do. Filming over, the director spends long periods of time with me in the cutting room – doing the Times crossword and making phone calls to his agent. His initial reaction to the assembly was that it was cut too fast. I tried to explain about the Stevie Wonder cassettes but as he didn't understand, I went on to say, "To the formalist critic, such questions, however interesting they may be on the human level, remain irrelevant to the evaluation of a specific film."

He agreed, countering, "You can't make an omelette without breaking eggs." I wondered if he was quoting Kurosawa, because I detected a Japanese accent in his delivery, or was he simply trying to educate me on the making of omelettes? The thought hung there for some minutes as we sat there in silence enjoying this moment of closeness. I felt he understood my pain and I, his.

We have now reached the fine cut stage, the film having been shaped to the liking of the director, and his mother, brother, sister, wife, aunt and Uncle Tom Cobley and all. Although over-length, a viewing has been arranged for the producer and writer, for their seal of approval before the Head of Department sees it. I prepare for the inevitable stimulating discussion and intense argument that heralds these events, by hanging upside down in the film bin, wondering if anyone would notice. The producer doesn't like the titles. He wants

them reshot with his name on the front with the director, and, anyway, isn't the director's credit five frames longer than his? He also argues forcibly in words of no less than three syllables for cuts in text. These suggestions visibly upsetting the writer, who responds in words of four syllables. He further demands a re-voice of the leading artist. The director supports the producer, while not disagreeing with the writer by not saying anything at all, and I agree with the director! The writer now decides he doesn't like the hair on the producer's nose and refuses to talk to him unless he removes it. I consider that could cut my schedule by weeks! The director now decides the film isn't quite as fine cut as he thought and 'could still do with a bit of working on' – I contemplate hitting him with the synchroniser – and if the titles are going to be reshot, perhaps he should have a front and end credit. The producer considers that if the director is going to have a front and end credit, then perhaps he should too. The writer doesn't want a front or end credit but wants to be taken home. The producer refuses to take him unless he apologises for the hair remark. I reflect how lucky I am to be working with the cream of British television. The viewing with the Head of Department passes with an abundance of hot air and astonishing U-turns in argument but once all approved, sanity returns to the cutting room, while we prepare for dubbing and music recording. Continue to read the script and pay the ACTT. Dubbing proceeds pleasantly, with the usual paranoia over sync, bursts of temperament, machinery breakdowns and lapses into slumber. Dubbing has that effect. Meanwhile, the negative having been cut, is in the hands of the colour grader and prints produced to the satisfaction of everyone apart from the Mark 2 telecine machines which make their own changes. BAFTA. This is what we have been working towards, good critical reaction in the ever-so-rarified atmosphere of the Academy. After this, transmission is an anti-climax. There's the usual assortment of journalists, hangers on, groupies, Heads of Department and perhaps a Controller or two. Having not had an invitation that makes me a film gatecrasher, but then, I did bring the film. The writer is surrounded by pressmen, the producer, whom I've never seen so talkative – even asked me what I did for a living – is having pictures taken with the actors and the director is holding forth on Fellini's 'Otto e Mezzo', eight and a half to anyone else but soixante-neuf for all I care. Return to cutting room to finish the script (ah, now I get it!), and pay the ACTT.

Chapter 6

The ADR theatre is small, with a large screen at one end and a mixing console at the other. There's a small hospitality table along one wall with kettle, cups, tea, coffee etc., and a small fridge. The walls are covered with Bond posters, a none-too-subtle display of the mixer/recordist Ray's film-going preferences. Angel stands close to the microphone, still wearing her sunglasses.

> *'It's very dark in here Leslie, are there more lights?'*

Ray fusses around her, setting up the microphone positions, adjusting the lectern, trying some casual chit-chat really to himself.

> *'It'll be fine once we get going, don't you worry, luv. You just flown in from the States then, eh? Not affected by the hurricane? Isabel, wasn't it? How's that, not too close?'*

He tentatively fastens the neck mic to her blouse, his fumbling hands rising and falling with the movement of her fabricated breasts. With his face now in close proximity to her sunglasses, he is able to penetrate beneath the dark glass, just enough to feel the chill of her icy stare. If she were to speak, it would be to say, 'Have you quite finished?' He has. 'Now if you need anything else, luv, just ask. The lectern not too high is it, luv, OK? I could lower it. How about the chair would you prefer to stand, OK? That'll do it.'

Leslie, who has been unpacking her grocery bag of organic this and that, seems to be missing something, and directs her question to Ray, now returning from the front line to the security of his mixing desk.

> *'Do you have any natural caffeine-free herbal infusions?'*

Thrown by this but not stirred, our Ray replies,

> *'Only what's there Leslie, Tetley tea bags.'*

Leslie looks back at him disdainfully.

Having only just realised on account of her limited vision, that the director isn't present, the Angel speaks,

> *'Where's Satyajit?'*

It could be a bomb about to detonate. A moment of awkward silence.

Ed: 'He sent his apologies but he's at a screening.'

Angel, showing signs of stress, takes a moment to compute this new piece of information.

Angel: 'He's not here?'

Ed: 'No, he's at a screening.'

Angel: 'A screening?'

Delivered with force, both as a question and a statement. Had Ed been editing this scene, he would have been mightily impressed by the passion and, in James Lipton[14] speak, "the truth in her performance". He replayed it in his mind, 'A SCREENing?' If only she could bring that level of conviction to her work.

Angel: 'Medical I take it?'

Attempt at humour – not her best suit and consequently in need of multiple takes, but, sadly, this wasn't on film. This was real. Turning her attention to Leslie, and with softer tone, Angel continues,

'Darling, where's my corset?'

Leslie: 'Corset?' Panic-stricken, she looks at Ed.'

Ed: 'Corset? What corset?'

Francie: 'Angel was wearing a corset on the set, and she needs to put it on. She can't loop her voice without the corset.'

Ed: 'But we are only recording sound.'

Ed protests, but then, on seeing that argument isn't going to wash,

'We could buy one'

Leslie: 'She wants her corset, not any old corset, THE corset.'

Ed gets on the phone to Michael, the post-production supervisor.

This experience is becoming all too much for the talent: the absent director, the imagined hostility, the dark and claustrophobic room and no corset to boot.

'I feel faint' – Angel collapses onto a sofa.'

[14] *Presenter of "Inside the Actors Studio".*

Leslie: 'Oh my God, fetch some water, Glacier Mountain Natural Spring water...no ice but with a slice of lemon.'

Ray looks at Ed stumped, only to be saved by Francie,
 '*I might have the GMNS and a lemon.*'

She searches in her bag and pulls out bottled water. Angel drinks from the bottle and regains some composure. Then, in an effort to explain, she says:
 '*You don't understand, I need to connect with the character, I need <u>the</u> corset.*'

Leslie tries to comfort her,
 '*Of course darling, you must be so tired. It's been a very difficult day. Would you like to take your vitamins now?*'

Ed on the phone:
 '*Michael, I'm in ADR, we have an incident.*'

The BBC ran director's courses. These were largely for the long line of production personnel waiting their turn to take the hot seat on electronic based programmes. Very occasionally, they entertained someone from film department, film department not being considered a nursery for directors. With technicians having this working class image, who better then, to give voice to my short lived aspirations to direct than director Alan Clarke. Alan's work is hugely admired, not only for its variety, but also for his inventive use of the camera and his single-minded approach to dealing with difficult social issues. The three films I was involved in, dealt with drug abuse (*Christine*), interrogation abuse (*Psy-Warriors*) and trade abuse between the Eastern Bloc and the West (*Beloved Enemy*). *Christine* was the least challenging of any film I have cut, having only about 30 cuts in a fifty-minute film. Alan had recently discovered the Steadicam and used it mercilessly on *Christine*, following the girl walking from house to house on her drug delivery rounds. No musical score, very little dialogue, just walking, shooting up, sleeping, waking, walking, shooting up, sleeping...on and on for fifty minutes. On one level (editing) it was incredibly boring but on another (for the audience) very powerful, disturbing and real. Much of our discussion was on how long to hold each of

the Steadicam shots – lengths that varied from day to day. Although very serious about the subject matter of his films, he was never serious about himself, in fact quite the opposite, frequently joking about his indecision and the frustrations of working with him. He was very open, approachable and genuinely interested in the people around him and following a discussion about directing, he, like Larry Toft earlier, encouraged me to 'have a go'; using his very persuasive Liverpudlian powers to shoehorn me into a director's course. These courses were short, only a matter of weeks, made up of several exercises and largely pointless unless you were a production assistant with a guaranteed directing future. Subsequent to the course, I wasn't offered anything of any consequence to direct. In fact, I wasn't offered anything! Alan subsequently, also got me in to see Aubrey Singer, Controller of BBC 2 and I put forward an idea for a short film I had written, *The Bored*; a satire based on my many failed attempts at getting 'made up' to editor in the 'Boards'. Singer was enthusiastic and encouraging and put me in touch with arts producer Roger Mills. Roger was in the process of setting up *Ten on Two* (Ten shorts for BBC 2), so with Aubrey's backing (funding from somewhere?), I got to make it at Ealing. Shot over two days and with just two actors, John Savident and Jon Glover on a stylized set, it wasn't particularly demanding. John and Jon couldn't have been nicer to work with, and the crew were very helpful, but I found the floor experience so laborious (hours of boredom followed by moments of panic when you are called upon to answer questions or actually self-consciously direct), that I couldn't wait to get back in the cutting room to cut the material. I did have the luxury of seeing the first day's rushes, cutting them, discovering a cock-up or two, and then making amends on the second day. I did enjoy screening the finished cut to the director and writer, who were both delirious with joy and had no notes of any consequence (as they were both me), and Roger, bless him, had nothing to say either. I think this whole *Ten on Two* thing was a big distraction for him from more serious work. Had I showed him a film leader he would have approved it.

My conclusion from the experience was that the only benefit of becoming a director was to have control of the editing! Isn't that what drove George Lucas to direct from an early career as an editor? I have enormous patience to sit in front of a screen all day but doubt I have the patience to deal with temperamental actors and all the

egos on set, along with the enormous pressure of meeting schedules and pleasing the financiers and, as a consequence, delivering a film I no longer like. The only experience of directing I've had since has been with a second unit (horse, cart and cars) on a few films.

Passing through BBC Plays Department were many directors of Alan's standing: Stephen Frears, Richard Eyre, Alan Parker, Mike Leigh, Ken Loach, Martin Campbell, Danny Boyle and many others. In my BBC days, I only got to work with Alan Parker and then only briefly. It was also the only commercial I have ever cut, the BBC commercial *What has the BBC ever done for us?* It was a TV advert for the licence fee written by John Cleese based on his '*What have the Romans ever done for us?*', routine. Parker had already established himself in the feature industry and the commercials world, so he arrived back in Ealing as something of a celebrity. I think he was aware of his status and jokingly alluded to it along the lines of 'we're supposed to be the big boys, so we'd better not cock it up'. The 'we' was Alan Marshall, producer of many of his films, who also came along for the ride. Later, I was fortunate enough to work with Richard Eyre on two films and with Danny Boyle on what can only best be described as an extended short.

Designer on set

Chapter 7

The lights in the ADR theatre dim. Angel, having recovered her composure, stands at the lectern with the pages of lines to be replaced set before her. She is tightly wound up, now physically as well as emotionally, with the full body corset fastened on top of her clothes, trussed up like an upright mummy. She faces the large screen some twenty feet away, as do the others, who are all seated, waiting for the fun to commence. The screen lights up with the image of Angel's character, Charlotte, in period costume sitting in the boat. She sits across from her love interest, James, who is rowing as they talk. Her screen dialogue is occluded by extraneous sounds as heard in the cutting room. The lines to be replaced are: 'That's what I tell myself, then I bought a farm as far away from Kansas as possible.' This line and the image are repeated on a loop. A cue line appears across the screen from left to right as a visual guide to the start of the first word, "that's". Accompanying the line are three sound beeps, the imaginary fourth beep landing on "that's". The recordist, Ray, continues with explaining the process knowing she has heard this umpteen times before.

'Come in on the imaginary fourth beep. You've got headphones to hear the original dialogue if you want. Now if we could just do a sound check, perhaps you could just say the first line?'

No line is forthcoming, just a clearing of the throat.

'Great, that'll work for me.'

He hits **play**, *the picture runs and the line is heard albeit masked by noises.*

Angel is not about to pull for the team and is still wearing the sunglasses. A second eruption while still facing the screen:

'Why am I doing this?'

The gauntlet is down again. All heads swivel to look at Ed. Ray presses **stop**.

Ed: *'Because of the background noise?'*

Angel still faces the now blank screen, because the limited movement of the corset offers little alternative.

Angel: *'What noise, I don't hear any noise.'*

Ed: *'There are some non-period jumbo jets, ghetto blasters, power boats and the I-90 Freeway just off camera.'*

Angel turns, awkwardly, her feet swivelling in small increments to have her stiff body face her colleagues to look for support. Francie is the first to weaken,

> *'No, nothing, darling. I don't hear anything, absolutely nothing, could hear a pin drop it's so quiet.'*

Leslie joins in,

> *'Seems good to me, I heard what she said quite clearly, that's what I tell myself, then I bought a farm as far away from Kansas as possible.'*

Incited by them, Angel continues:

> *'You know guys, I've got to be honest with you. If I do this loop, you're going to use it, right?'*

Ed: *'That is the general idea.'*

That should just have been a thought, but having no firewall between thought and speech, his words were now in the room. Fearing a barrage of vitriol, Ed apologetically modifies his remark.

Ed: *'Only if we have to.'*

Fortunately, the talent is on a roll and oblivious to anything anyone has to say.

Angel: *'And I just don't think I can get that performance again, you know. This is so artificial, right? Can't you just do that filter stuff and get rid of those noises?*

> *I just can't get into the scene cold like this. I just can't do it.'*

Face off.

Ed knows you can't upset the talent because no one can upset the talent except another talent, so he waits, hoping this eruption will play itself out. It doesn't.

Silence.

Angel: *'Anyway, the beeps are funny!'*

Heads turn to Ray, now in the firing line.

Angel: *'The rhythm's wrong. Like, you know, instead of beep, beep, beep, I hear beep, beep...beep. How can I get the timing right with a beep, beep...beep?*

Leslie now remembers she felt the same:

'You know, I heard that too beep, beep...beep.'

And Francie too:

'Yes, very irregular beeps, very irregular.'

'I'm on to it,' says Ray, with a nudge, nudge, wink, wink in Ed's direction. Taking the role of appeaser, he fiddles with the settings without changing anything, announcing confidently, 'That should do it.'

Ed, anchoring himself in the moment, takes a different approach, one that Satyajit might adopt,

'Angel, I appreciate that finding the trail requires imagination and that imagination is not easily found in a sterile environment, but the trail that took you to the top of the mountain before is still there waiting for you. Try to engage that part of you that allowed you to soar to such amazing heights of...thespianism.'

Oh! 'Thespianism', such a clumsy word, it was so good until then. Ed immediately regrets saying it, but he does appear to have grabbed everyone's attention. Falling back on the more familiar territory of soccer quotes:

'In life, as in football, you won't go far unless you know where the goalposts are.'

Angel, Leslie and Francie are quite nonplussed. But Ray, firstly, nods in agreement, then joins in:

'Good players never want to sit on the bench as substitutes.'

Then wishing to share his soccer knowledge of the author:

'Marc Overmars.'

Blank looks.

'Ajax, Arsenal, Barcelona.'

Ed continues not to be outdone:

'Aim for the sky and you'll reach the ceiling. Aim for the ceiling and you'll stay on the floor.'

Ray counters:

'The first ninety minutes are the most important.'

Silence.

The women have momentarily turned to stone.

Angel removes her glasses, revealing further evidence of cosmetic activity and the darkest of eyes, all pupils, staring at Ed with hardly disguised contempt.

Francie, whose contribution has been minimal to date, decides it's time to give everyone the benefit of her expertise and move things along a bit.

'Angel, remember, think English. It's a "h"...wh<u>a</u>t, "h"...what.'

*Ray presses **play** and the loop comes around once more, beep, beep, beep...*

She misses her entry, her mind on goalposts and Marc Overmars when the loop comes around again, beep, beep, beep...

'That's what I tell myself.'

Angel says the line but, once again, mistimes her entry and gets out of sync with the picture thereafter.

Ed states the obvious,

'That's...out of...' *but is cut off.*

Angel: 'I know it is...I know it is! I'm sorry, I...just...it's about to come out. I'm just feeling I'm hitting a wall in this whole thing...so just...you know, it's about to come out. Do you know what I mean?'

It's gobbledygook, but Leslie and Francie show solidarity, nodding in perfect unison.

Angel: 'I don't know how you expect me to do this under these circumstances, goalposts ceilings and substitutes. I need to have some sort of beeps going on and I can't go into sentences like this and expect to jump one sentence and then do another thing and another thing without some sort of...some sort of guideline. I'm not a fucking magician here so...so...eh...asides the fact it's a very difficult emotional scene to do...eh...it's impossible, like, you know, under the technical aspects of how...how...how...we're working here. I'd be surprised...You know I do this really well. When I was on contract to Fox, I used to dub all the foreign versions, so I'm really good at this...but man...I...I...got to see somebody else*

*come in and work under…I don't understand how you can do this? There are no bells, no dot, dot, dot. There's a line that goes across and then I have things, after things, after things that there are spaces between and different emotions and different things, so what you really need to do…to do this properly is to break every one of these **fucking lines down**. Anyway, that's it.'*

Angel puts on her glasses, Leslie packs her bag and with Francie in tow, they flounce out, Angel still wearing the corset. Ray and Ed look at each other as the door closes and speak simultaneously,

'Lunch?'

Documentary editors don't get the respect they deserve. I don't mean in terms of the 'glamorous' awards shows, which largely serve to promote the industry and don't in any way reflect the 'Best' of anything (other than perhaps best of luck, marketing and promotion), but in terms of acknowledging the craft skills required specific to documentaries. You get hundreds hours of material dumped on your lap with the brief, make a film out of that! There may be a treatment of some kind, a general plan but the possible permutations within that are enormous. I'm not denying the director's contribution in all this, but so much is left to the editor. As in drama, story is everything, and in drama, the story is in the script. In documentary, the story is largely made in the cutting room.

For me, the viewing and assembly of rushes is a chore; like preparing a car for spraying. A necessary chore before the fun bit starts but the rewards are greater and more easily achieved with better preparation. In order to lessen the pain, I do tend to make quick decisions (not always the right ones), to shape a scene or event; choosing the shots I want, deciding the order and duration, and in the case of drama, what size of shot I want to use: close, medium or wide? In drama, I work with preferred takes until I am happy with the architecture of a scene and then review, swapping out takes for performance or continuity. I think it's important to get the first shot right because getting it wrong has a domino effect on subsequent shots, although inevitably the internal editing changes to

some degree as one progresses through the edit with new scenes being brought in: the end of one scene affecting the start of another. Whenever I present a cut to a director, I try to make it as finished as possible, that is finely cut and with sound effects and music, mindful of the proverb, "Never show unfinished work to a fool"

An editor's first presentation of an assembly is usually referred to as a rough cut, an insulting description in my view but one which remains throughout much of the post-production process (even with the director's input), until such time as it's deemed to be otherwise. Martin Scorsese subscribes to the view that, "If you don't get physically ill seeing your first rough cut, then something's wrong." Probably a reflection of a director's failings rather than a comment on an editor's work, but after weeks of careful crafting of the rushes (dailies), a negative response to the degree Scorsese is suggesting is soul destroying for an editor. Perhaps that's the point, suffering is necessary to elevate the ordinary to the sublime: the myth of suffering for one's art. Fortunately, I have worked with many directors who have managed to produce very good films without the traumas apparently suffered by Scorsese or if they have, they have thankfully kept it to themselves.

Today's digital technology (with no concerns about film stock usage and processing charges) has the movie world catching up with documentaries in terms of shooting ratios. A godsend for some feature directors who are now able to do their rehearsing on camera and to give themselves a greater range of performance to play with in post-production. Not infrequently, an actor's performance is built on selecting the best parts of different takes but if the range of performance across multiple takes (emotionally, rhythmically or in terms of physical continuity) is inconsistent then a 'built' performance can look an embarrassing mess, to the editor at least.

Good documentary directors have an edit script or a paper script, a plan laying out the route ahead; interviews would have been transcribed and pieces selected. As in drama, there are directors who are quite clear about what they want, are very hands on, sitting in the cutting room dictating each step and those who aren't, either out of laziness or inability or sometimes both. The worst kind will shoot hundreds of hours of interviews with no transcripts and with no idea of what he/she wants from the interviews, nor having a clear vision of what kind of film they are making. Consequently, weeks are wasted going down blind alleys. Some will arbitrarily order hours of

archive footage for the editor to watch and place within the film because they are supposedly too busy to do it themselves, supposedly working on an edit script quietly in the corner on their laptops but, in reality, surfing the web for party poppers. It will be left to the editor to find the story, in the director's mental and sometimes physical absence, which can be attributed to being unwell, dental appointments, meetings with executives or bank managers, working at home, depressed spouse, Liberty shopping, Waitrose shopping, heavy traffic, oversleeping, delayed public transport or alien invasion.

For some documentary directors, hijacking an editor's ideas as their own and expressing them as such to executives is *de rigueur*. Any concerns the editor has about schedules and lack of direction will be ignored and executives kept in the dark about the real situation through fabrication. When schedules fail to be met, the director will cover their ground by blaming the editor for being slow and then more than likely have them replaced, sometimes by a very junior and cheap 'in-house' editor to finish the job…badly.

Conversely, having a director with you all the time is inhibiting. Their continued presence is a distraction particularly during the assembly stage. It stifles the freedom to experiment because in the process you become aware, without anything being said, of a disapproving vibe from behind. A sigh, a fidget in the chair, a clearing of the throat… These may all be misinterpreted but they still make for a stifling environment.

Ideally, a director should know what he or she wants, is able to articulate it in simple language as opposed to the pretentious and then leave the editor alone to interpret the ideas, to then return, review the work, discuss and make suggestions, then once again leave the editor to his own devices. This process should continue until the later stages when the two work together for longer periods.

Most of the BBC editors now working in features would have been exposed to cutting many documentaries, as I was, and I believe this experience has been invaluable when working on feature films.

Cutting dialogue sequences well, is not as easy as it looks. Sometimes it should feel seamless, at other times unsettling, depending on what's trying to be achieved. This internal cutting of a dialogue scene, with continuity sometimes (but not always) a consideration, may be an obstacle to a documentary editor wishing to widen his horizons. But having the facility to see the wider

picture, to structure and perhaps restructure a narrative, to compress storytelling, use montages, sometimes ignore continuity – these are great assets to bring to feature editing. Unfortunately, the opportunity to do both nowadays is very rare. Generally speaking, you have to specialise in one genre or the other – it's hard enough for a TV drama editor to be accepted in the film world let alone one coming from documentaries. I consider some of my best work to have been on documentaries: working with Geoff Dunlop on *New York Emergency*, about the New York Police Emergency Department; John-Paul Davidson's *Opium Trail, Bhutan, Galahad of Everest* and just a few years ago *Down by the River*, about Hugh Laurie's love of the blues; DOP Philip Bonham Carter's first film, *Mark-Anthony Turnage* about the composer of the same name. Music, once again, has played a major part in the picture editing of these documentaries. It should be said that some editors and directors don't like to bring in a temp score so early in the process because it may hide flaws in the picture edit or influence the cutting rhythm in the wrong way. However, for important screenings, and particularly test screenings with an audience in the feature world, you have to have a temp score, one that in some way reflects the eventual composed music. Without it, a film could lack energy or feel devoid of emotion, and a test audience's response will be less positive, which will be reflected in their comments and approval rating.

If chosen well, the temp score can be a template for the composer, with the 'spotting' (in and out points) tried and accepted. Although a composer might be sketching ideas for the director to listen to during the latter stages of editing, he will wait until locked picture to commit to paper. Picture lock being a point at which no further picture changes can be made. It's a producer's way of trying to exercise some control over indulgent directors. Many directors prefer the terms 'soft lock' or 'latch lock', which still gives them the scope (or at least the hope) for changes. The composer's contribution is delivered towards the end of post-production followed by the sound mix, and Digital Intermediate (previously negative cutting and printing). DI is a process of electronically conforming the digital master material to match the cutting copy (the edit) via edit lists spewed out from the computer. In a subsequent process, the colour image is manipulated electronically. This replaces the photochemical grading process of days gone by.

Chapter 8

Night. A Soho pub, The Intrepid Fox, unusually deserted. Ed, Annie, supervising sound editor and union man Jim and his assistant Nigel, have gathered at one end of the bar along with ADR mixer Ray, to watch "The Late Show", on the big screen usually reserved for sporting events. The bartender Mick, comes over to the waiting group with the TV remote in hand:

Jim:	*'Quiet tonight, Mick?'*
Mick:	*'No football, the TV's yours,' he slides the remote along the bar, 'You all good then?'*
Jim:	*'Yeah good.'*
Nigel:	*'Can't complain.'*
Mick:	*'Ray?'*
Ray:	*'Good.'*
Mick:	*'Good.'*
Annie:	*(sarcastically) 'We're all good then.'*
Mick:	*'What will it be, fellas?'*
Jim:	*'I'll have a half please Mick, the usual.'*
Nigel:	*'I'll have the same, Mick, just a half.'*
Annie:	*'White wine and soda.'*
Ed:	*'Gin and tonic, Mick.'*

Michael, the Post Production Supervisor, enters the pub and approaches the motley group.

Michael: *'Quiet tonight, Mick?'*

Nigel, a sheepish assistant but feeling confidant to relay established information:

'Yeah, no football.'

Michael:	*'Rotten luck, Ed, too b...b...bad about Angel...'*
Jim:	*'Yeah, I heard about that.'*

Of course Jim had, he's the sound editor and knows he should be at ADR sessions. Ed moves the subject on to avoid confrontation, asking Michael:

'Did you get the corset back?'

Mick interrupts the conversation:

'I'm taking orders, Michael.'

Michael: 'Good, who's in the ch…ch…chair?

Ed: 'Oh, let me get these, it could be my last round.'

Michael: 'No, no this is my lob.'

The offer of a free drink to sound department ears is far too good not to take advantage of, Jim jumps in:

'Are you sure, Michael? In that case, make mine a pint then, Mick.'

Nigel: 'Me too, Mick, a pint.'

Mick: 'Two pints of the usual, gin and tonic, white wine and soda, and you, Michael?'

Michael's phone rings, he moves away:

Michael: 'Just give me a moment, Mick.'

Mick leaves, the drink orders in his head. Nigel and Jim have been together all day but strangely feel it necessary to fill the silence by checking on each other's well-being, the way comrades do.

Jim: 'All right, Nige?'

Nigel: 'Bearing up.'

Jim, not wishing to exclude Ray:

Jim: 'Ray?'

Ray: 'Not so bad, could do with a jar or two, how'd it go last night?'

Jim: 'Spent the whole of it under Blackfriars Bridge, it was f'ing freezing and wet. Got some good train tracks though.'

Ray: 'Yeah, what mic d'you use?'

Jim: 'I initially thought of using an M/S pair but in the end used a stereo ORTF. Much sharper'.

Nigel: 'ORTF. Great definition, sharper, noticeable difference.'

Ed observes the group affectionately, and to himself, considers them as an anthropologist would:

'Very strange species, the sound boys, like to drown their sorrows in sound speak, bits of this and bits of that and brown nectar; long suffering, dehydrated and woefully neglected…'

Jim is aware that Ed is looking at him and takes the opportunity to make his earlier grievance known:

Jim: 'I heard about the ADR, would have liked to have been there, Ed. A little out of order.'

Ed: 'Sorry Jim, the talent didn't want too many people in the room.'

Protest made, Jim backs down knowing his place:

Jim: 'Understood, boss.'

Ed continues his thoughts:

'Constantly at war with picture department but in the general scheme of things, harmless.'

Michael still on the phone but overhearing the conversation:

'Don't feel bad Ed. It wasn't your fault, we'll reschedule with the director p...p...present next time.'

Ed takes the remote and finds "The Late Show" channel.

Ed: 'You'll have to check his diary, he's working his way up to Strictly Come Dancing via appearances at Wimbledon, London Fashion Week and Celebrity Big Brother. No, I wasn't thinking about the ADR, I was thinking about the preview.'

Jim: 'Cheer up, boss, it will go down well.'

Nigel: 'Yes boss, great film, great editing.'

Michael returns having finished his call:

Michael: 'They've just c...c...confirmed the preview, Sherman Oaks, LA, end of the month. Be p...p...positive, think about the air miles.'

Mick: *(calling out)* 'Michael, made up your mind?'

Michael: 'I feel like a p...p...p...'

Ray: 'Peanut?'

Nigel: 'Prick?'

Jim: 'Producer.'

Ray: 'Prick Producer?'

Annie: 'Pedicure?'

Jim: 'Political pawn?'

Ed: 'Post Production Supervisor?'

Michael: 'P...p...pint of Pride, thanks, Mick.'

Mick: 'Nice one, on its way.'

Ed, to himself once more:

'Michael Hall, Post Production Supervisor, used to speak without a stammer but studio executive pressure re schedules and budgets changed all that.'

Jim: *'We're right behind you, boss. Any shenanigans, we're off the show.*

Solidarity, right, lads?'

No response.

'Lads?'

Ed catches sight of the programme starting:

Ed: *'Here we go.'*

On screen, the opening titles give way to presenter, Humphrey Barclay in close shot. Ed turns up the volume with the remote.

Barclay: *'My name is Humphrey Barclay, and welcome to "The Late Show". Our theme tonight, if there was one, is one of doing the unexpected: a writer known for children's books writes a psychological thriller, an artist who made her name in fine art turns to the abstract form and a director of Bollywood movies, with all its excesses in musical expression, takes on a genre of filmmaking alien to him. Good evening to you at home and good evening to our guests here tonight.'*

The camera pulls out wide to see the artist, Thamesmead Sharon and the author, Eton Arthur seated to one side of Dorking Barclay, with Bombay Satyajit to the other side. A low, highly glossed white table is in front of the group with a perfectly placed jug of water, four filled glasses, pile of books and a 35 mm cassette of film. Satyajit is not instantly recognisable, leant back in his chair, face towards the ceiling, with a pipe in his mouth and wearing spectacles. He has also forsaken his usual casual conservative attire for jeans, tee-shirt, loose Miami Vice Crockett jacket and baseball cap, which is worn fashionably the wrong way round. As Barclay gives longer introductions to Arthur and Sharon, barman Mick returns with the drinks.

Ray: *'Thanks, Mick.'*

Nigel: *'I don't see him.'*

Annie: *'That's him with the pipe...and the glasses...and jeans...and cap,'*

Jim: *'I didn't know he smoked.'*

| *Annie:* | 'He doesn't. It's a prop, like a comforter.' |
| *Jim:* | 'I had one until I was thirteen, a comforter. I called it Baa.' |

The group turn to look at him,

> 'It was a soft toy, a sheep...baaa.'
> 'Had it since I was a baby.'
> 'I took it everywhere with me.'

Jim digs a further hole for himself:

> 'Got a bit grubby over the years.'
> 'With its leg being in my mouth.'

| *Annie:* | 'Like a dummy would?' |

Their attentions return to the screen, Barclay continues:

> 'And our third guest, Satyajit Krish, Oscar winning director, actor, writer, producer and educator...'

Satyajit still with his head up in a thoughtful pose, takes a draw from the pipe. Not being practiced in the art of pipe smoking, Satyajit has failed to fill the bowl correctly and to tamp it down to the right compression. His first draw is a failure, he continues manfully; the studio director cruelly lingering on his efforts in close shot. Finally there is a sufficient passage of air to produce a glow in the tobacco, which then produces smoke in Satyajit's mouth. The suddenness of this event produces 'tongue bite'; he grimaces, exhaling but sensing the camera is on him, the grimace turns into a tortured smile. The smoke leaves the corner of his mouth, fogging his spectacles and making his eyes water, but then, rising unimpeded to the ceiling in a circular ring, like a Red Indian signal transmitting news of impending disaster.

> 'Who, on the face of it, seems an unlikely choice to helm a very Hollywood genre of film, the Western. But more of that later, first if I may turn to you,
> Arthur...'

But the camera is fixed on Satyajit pulling faces, unable to hide his discomfort.

Annie:	'Good God, what's he doing?'
Ed:	'Performance art.'
Jim:	'He's making a point.'
Annie:	'Which is...?'

Jim: *'It's a tribute to years of persecution of the Native American at the hands of the Euro-American.'*

Annie: *(Looking at Jim)* *'I can feel his pain.'*

The studio director at last cuts away to Arthur, but Jim has a further observation to make,

'No seriously, he has spoken to me about the second wave of genre deconstruction.'

Annie: *'Has He? What like in a dream? What are you talking about, Jim?'*

Jim: *'With reference to the films of Friedkin, Coppola, Bogdanovich and Hopper.'*

Nigel: *'That's interesting Jim, I didn't know that.'*

Ray: *'Yeah, I read about that somewhere.'*

Annie: *'What's that got to do with Indians?'*

Jim: *'It's a desire for change. He is using celebrity power to influence change. They are all doing it. He's aligning himself with the Indians. The caterpillar we know as Satyajit is metamorphisising into a butterfly. I read it as a protest.'*

Ray: *'I know you're a sound man Jim, but you do talk a lot of bollocks.'*

Their attention turns back to the screen.

Arthur: *'I actually found the transition fairly easy, perhaps because in my youth I was drawn to the likes of "Rebecca" and Anthony Berkeley's "Before the Fact", which actually became, and Satyajit would know this…*

The shot changes to Satyajit, now looking at camera and waving.

…Alfred Hitchcock's "Suspicion"…'

Annie: *'Oh God, is he drunk on lassi?'*

Jim: *'I think that's a racist comment.'*

Nigel: *'Who's he waving at?'*

Ed: *'I think that's meant for me.'*

Jim: *'Bibi Andersson smoked a pipe in Bergman's "Wild Strawberries".'*

Everyone looks at Jim with a mixture of hate and more hate.

Jim: *(backing off)* *'Just an observation.'*

Barclay: 'Sharon, if I may come to you. Having built your reputation on, technically, a two-dimensional art form, you have had the courage to move away into the sphere of three-dimensional art and specifically installation art. You have invited a great deal of adverse criticism, being at various times called tradition trashing, con artist and a sexually charged exploiter of ignorance.
How do you respond to that?'

Sharon: 'Frankly, I don't give a monkey's, Humphrey.'

Arthur: 'Hear, hear.'

Barclay: 'But surely, the personal abuse…'

Sharon: 'Yes, it's become very personal, Humphrey. It's hurtful. It's not just my art that has been trashed but my family, my very person…'

Satyajit's pipe has gone out. He pulls out a tobacco pouch and pick from his pocket with the intention of rebuilding the bowl; the rites of preparation in the trade. Totally preoccupied, he is not paying any attention to the other guests and what is being said.

'My art is very important to me, but I am a person, I am a human being, I have feelings.'

Barclay: 'Indeed you have and I have to say the art work before us…'

The image on screen widens to an arty top shot (from the ceiling), to see the highly glossed white table and the carefully placed objects: jug, glasses, books, film cassette and behind, the talent including Satyajit in his seat, still picking away at the bowl loosening the burnt tobacco and totally oblivious to what's being said.

…which "The Late Show" commissioned from Sharon for twenty thousand pounds…'

Sharon: 'Given to charity.'

Barclay: 'Indeed yes, generously given to charity…commissioned in recognition of this evening, exemplifying, if nothing else, a great deal of insight and feeling.
This amazing piece of work will be on display at the Tate Modern from next week…'

Satyajit to the horror of Barclay and Sharon reaches forward and taps the tobacco remnants of his pipe onto the table. Not once

but several times. The studio director dramatically cutting to close shots of the action,

Annie: 'Oh my God!'

Ed: 'What a shame, he didn't mean it.'

Satyajit stops emptying his bowl and becomes aware of the mess on the table, the silence and people looking at him. He sweeps some of the tobacco into the palm of his hand and not knowing where to put it, empties the contents into his pocket. Barclay tries to re-focus:

Barclay: 'Satyajit, if I may come to you, Sharon's work has been accused, in my opinion falsely, of being attention grabbing; an accusation, a consequence of being striking and sometimes bizarre in her approach to her art, do you think you have a very strong signature as a director?'

Ed: 'This will not be a simple answer.'

Their attention returns to the screen, a shot of Satyajit, as he places the pipe on the table and leans forward to take a sip of water. Sharon watches frozen, as her work of art is being dismantled. His spectacles fall into the glass producing creative splashes on the surface of the table, very Jackson Pollack. Removing them from the glass, the now dripping spectacles are placed on the table; the water making a dark soupy concoction with the remaining tobacco. He drinks from the glass, sliding it back onto the table producing black smears.

Ed: 'He's got great timing you have to give him that.'

Satyajit looks at the black soup on the table seeking inspiration, which he finds in the short piece of film exiting the cassette. He uses it to stir the mixture.

Satyajit: 'It's about DNA.'

The shot on screen is still wide; Sharon, wide eyed in shock, Humphrey and Arthur all ears.

Jim: 'Deoxyribonucleic acid.'

Ray: 'Oh for fuck's sake, Jim...'

Annie: 'Shut up, Jim.'

Satyajit: 'That is my approach. Putting the DNA of the story into my compositions and into my actors and into my crew.'

Annie: 'How dare he, I feel defiled!'

Satyajit:	*'The way I frame is incredibly personal and how I want the DNA of the story to be encoded in my compositions.'*
Ed:	*'You speak in tongues, Kemosabe.'*

Pleased with himself, Satyajit takes a moment for another sip and then crosses his legs, his swinging foot catching the edge of the table spilling water from the jug onto the table and floor. Sharon tenses her whole body, gripping the arms of the chair tightly and closing her eyes.

Barclay:	*'But coming as an outsider?'*
Satyajit:	*'Coming as an outsider, I take away the baggage of now and uncover a sense of the provisional present with all its uncertainty. I have a voice as an outsider, which experiences the familiar and unfamiliar differently.'*

Arthur nods as if he understands what Satyajit is talking about.

Arthur:	*'You're talking about the hindrance of knowledge?'*
Satyajit:	*'Yah! Yah! Exactly, the hindrance of knowledge. Do you know, I feel knowledge is a weight upon wisdom; and freeing yourself of knowledge allows you to go out of the mind into the universe and that is where you will find the truth. When I'm filming, I ask myself, 'What are you going to do today, Satyajit?' And do you know, you might be surprised to hear this, I have no idea.'*
Ed:	*'Anyone here surprised?'*

There is no answer in the pub.

Satyajit has that disarming smile, Barclay is at a loss to say anything, Arthur nods sagely and as for Sharon...rigamortis has set in. Satyajit remembering his obligation to agent Katty,

Satyajit:	*'But my producers, as insiders to my outsider, have been wonderfully supportive. Walter, for instance, I consider to be my brother and Abigail Spear, my sister. Walter is not at all as he has been depicted: he is not a bully, not intimidating, not uncouth, not a womaniser, not a brigand, not unscrupulous, devious nor conniving, nor controlling; not an opportunist, nor in any way petulant and vindictive, nor one for quick and*

cheap gratification. He's none of those things. He's a guy's guy. A mensch. Really. I love Walter, he is my very best friend. I love Abby too. On my films, everybody loves each other.'

The gang look away from the screen and group hug.

As the eighties moved into the nineties and beyond, there were changes afoot at the top. The 'good' Director General, Alasdair Milne, once a programme maker of great note, was replaced by the 'bad' Michael Checkland (later to be knighted Sir Michael Checkland), an accountant of equal note…in accounting. He, in turn, was replaced by the 'ugly' John Birt, a programme maker of lesser note (later to be knighted Sir John Birt and then even became Baron Birt) who was tasked with the modernisation of the BBC thereby continuing the demoralisation process of his predecessor. Then in came the multi-faceted Gregory 'Greg' Dyke (at the time of writing without an honour but no doubt will join the same conveyor belt as his predecessors sometime in the future) with his own particular style of 'cut the crap' leadership. The 'asphyx' was upon us all. I left about the same time as 'chequebook Checkland'. At grass-roots level, there was increasing discontent, not only with the quality of programme making but also with the changing environment. The cost-cutting and culling had begun. There were orders from above: "Thou shalt not smoke." Commonplace now but an outrage to smokers, me amongst them, at the time. Staff were being encouraged to leave with the offer of redundancy pay. Not all staff were offered an incentive to leave, just the ones they didn't want; rewarding the bad, a process of unnatural selection. I looked for a £ symbol daubed on the door of my room or out of curiosity, on others; waited in eager anticipation of jack-boots down the corridor late at night, the knock on the door, the offer of a handsome cheque and then being marched off the premises. It didn't happen for me. I took a video and stills of the studio, knowing it would never look like this again and after eighteen pretty good years, walked out the gate without redundancy pay and without a job.

I left the BBC in 1990, having already acquired an agent. Are agents any good? I guess some are, but are they worth the commission? No! I've had three in the UK and three in LA and

apart from my first agent finding me work on my foray back into the freelance world, I doubt if any have brought me work since. Not entirely their fault because of my predisposition for giving 'bad interview' when meeting new directors. They relay enquiries and put forward your name to up and coming productions (along with other names in their agency, so there's never a sense of being special), and then negotiate deals and contracts etc., but these days there are rarely negotiations. Most editors have their 'rate', which is set when working on a studio production, where rates are higher than the independent sector, but maintaining that rate is challenging. Take it or leave it is the attitude of apologetic independent producers falling back on the excuse of 'tight budgets'. The reality is that clients generally get their own jobs and then the agents step in and 'negotiate', getting 10-15% for their troubles. Agents are good listeners and therapists for those who need to offload perceived injustices, and act as a buffer between the client and a well-meaning but undesirable offer of a film. They take a lot of client lunches, so that's an opportunity to claw back some of the commission you've been paying them. Getting one is difficult, if you do get a response (!), the common line is, 'our books are full'; books are only full to people they don't want. The thrill of having an agent for many is short lived; in no time at all, you're no longer dealing with the agent but with their assistant or even the assistant to the assistant. Too many of my colleagues have been left in a vacuum after signing up and with no prospect of work, their agents become elusive, don't take calls and don't return them either. When contact is eventually made, it's always, 'we're really trying so hard for you, darling', delivered with a weariness suggesting they have really being doing just that. Agents are part-timers in the sense that, the part of time given to each client is small. In times of trouble, one shouldn't expect too much support; any grievance would have to be balanced with maintaining good working relationships with studios, producers and directors for the sake of other clients and future work.

Having said that, most of us have one. Maybe because it can be a lonely place when out of work, and they at least offer some hope of employment.

Louisa Stevenson at the then Prestige Talent Agency, was recommended to me, and me to her, by Pam Meager, a makeup artist at the BBC.

PTA and Louisa were subsequently swallowed up by a bigger agency, Peters Fraser & Dunlop, which then later still, separated into PFD and United Agents – a formation of disenchanted agents from PFD. I chose to stick with my then agent, Lynda Mamy at the new UA (Louisa having long retired, and her successor Vanessa Jones also retiring but then, to everyone's surprise, re-emerging at another agency altogether).

After a few weeks of unemployment, Louisa found me work on a Channel 4 TV series *The Orchid House*, a drama set in Antigua which was directed by Horace Ové and produced by Malcolm Craddock, both loveable characters. Horace, so loveable that when I felt the need to throw a 16 mm joiner at him, he neither hit me nor fired me, he just ducked.

In the spirit of collaboration, it was my way of offering him the opportunity to take over the edit, because nothing I was doing was pleasing him.

Or, perhaps I was buying into the philosophy that a director's suffering is good for his art. He picked the joiner off the floor and gave it back to me, grinning like a Trinidadian cat. Horace liked to provoke. Known for being the first black British filmmaker to direct a feature-length movie, Ové was no stranger to controversy with documentary films like his black and white *vérité* style *Baldwin's Nigger,* about writer James Baldwin's visit to the UK accompanied by comedian Dick Gregory, and his first feature film, *Pressure,* which was banned for two years by its own financiers, the British Film Institute. *Pressure*, which told the story of a black teenager joining the Black Power movement, depicted police brutality to such a degree, that it unnerved the film's backers to the extent of delaying release.

Ové's introduction to the film world was on Elizabeth Taylor's *Cleopatra,* being cast as a Roman soldier as a consequence of, as he put it, "There being a shortage of tanned people in England at the time." For the same reason, I was cast as one of the wise men in my primary school nativity play, a role I repeated year after year, until the tanned population in my neck of the woods, Southall, grew.

Possibly, the demand for my role was so great that the Southall tanned population grew to over 55% of its total. Sadly, for Horace though, Elizabeth found the weather in England too cold for her liking, so the whole circus of actors and technicians relocated to sunny Rome where there was an ample supply of tanned men, his role as soldier being diminished to slave.

Unfortunately, not having the same clout as Elizabeth, I didn't make it out to the Caribbean but remained at Shepperton Studios during the shoot. Post-shoot we moved into cutting rooms above Berwick Street market in the heart of Soho, owned by sound editor and part-time jazz drummer, Brian Blamey, who had worked on such classic films as *A Clockwork Orange,* and the far less classic *Au Pair Girls,* where we first met. Brian and I worked on three further films until the digital technology hastened his retirement.

Entrance to the building was through Tyler's Court, a narrow passage connecting Berwick Street to Wardour Street, which was used as a urinal by the night people. Every morning, I held my breath for a full forty seconds as I turned off Berwick Street, side stepped pools of urine, fumbled with the door lock, praying the keys wouldn't fall, only opening my mouth on closing the door behind me and reaching the top of the first flight of stairs.

Orchid House gave me the opportunity to introduce my 23-year-old son Dominic to the industry; he came on as my second assistant, the first assistant being a colleague of mine from the *Mackenna's Gold* days, Tony Bray. Dominic was horrified at the archaic nature of film editing and thought electronic editing was the only way to go. Both Tony and I scoffed, as Luddites do, and said that was the most ridiculous thing ever and would never catch on. Dominic stayed with me on four more projects: *Covington Cross* (the American pilot mentioned earlier), *Under Suspicion (*my first feature film courtesy of TV and theatre producer, Brian Eastman), *Galahad of Everest* (Drama Doc. with JP Davidson once again) and *Hostage* (a TV movie, directed by gentleman Robert Young, with whom I had worked at the BBC).

Dominic left the industry, scornful of its hierarchical nature and took to building dreams of another kind, kit cars and then later, inventing a method of transferring nuclear energy via a circuit, to free electrons and protons, thereby reducing the coulomb barrier. The coulomb barrier being further reduced by muon catalysis prior to collision with protons.

The result being fusion. Obviously!

Brian Eastman is one of the few producers I have worked with who actually understands all the film crafts: something of a mixed blessing because, as sound editor Chris Ackland once informed me, "There is no wool-pulling over his eyes"; not, of course, that anyone from sound department would ever entertain such ideas.

Having produced many shows for television, Eastman respected the work of television technicians and wasn't prejudiced against them when it came to making a theatrical film. For TV established Ackland (Brian's suggestion for supervising sound editor on *Under Suspicion*), this was also an opportunity to gain acceptance into the feature film fraternity, so for the both of us, Eastman was a bit of a godsend.

Eastman chose the sound editor for my first feature film, for which I was grateful. In recent years, producers and directors have done the same, for which I am less grateful. In the glorious years between, I was able to choose my sound crew or to put it another way, the people I wanted to work with. This change is partly due to the growth of low budget independent films and Post Production Supervisors. PPS's are a relatively new breed in the industry, taking away the long held position of post supervising from the editor. Their rise has been quick and their increasing power alarming. Their job is to ensure that the post-production process runs smoothly, that budgets are adhered to and deadlines met. They are co-ordinators and facilitators, liaising with the producer, director, editor, sound editor and accountant. Their increased power, and unpopularity, comes from their association with producers and the consequent 'special relationship'. On small independents, the producers invariably have their PPS on board before anyone else; they together determine the post-production budget for a film and work out the best way to achieve that budget. This means that even before an editor has been chosen, package deals with 'sound houses' have already been set up. No longer is it always possible for an editor to choose who he wants, unless, of course, his choices are prepared to work within the PPS 'package'; it's become a case of the tail wagging the dog. Their status, in the UK at least, has grown out of all proportion to their creative contribution to a film, so much so that some now appear on main credits; possibly buying their credit in return for some sort of 'package' deal of their own, but buying credits is not something new to the industry.

Directors too, increasingly exercise their power in unilaterally determining the sound team, bringing on people they have worked with before. Admirable on the face of it but in reality, an undermining of an editor's authority. It is the picture editor who works most closely with the sound editors and re-recording engineers (mixers) and not the director.

Sound editors start work sometime towards the end of the director's cut and are generally instructed by the picture editor, both verbally and by the template of the edited tracks. As with composers, supervising sound editors have 'spotting' sessions with the director and editor, only instead of an esoteric discussion about music, it is a more mundane conversation about atmospheres, effects, Foley and dialogue; directors approaching the first chore much more readily than the second.

Sound editors bring innovation, imagination, patience and enormous skill to their craft, particularly in dealing with poor original sound; plundering unused takes for usable dialogue, re-syncing the lines to the selected shot, applying filters to reduce intrusive noises, finding and using 'fill'[15] where necessary. The work of effects editors is most apparent and appreciated on action/sci-fi films but much of their brilliant, subtle work gets unnoticed; similarly the work of Foley editors. They re-record every action not covered in production and improve on sounds already there; also, movement under dialogue has to be recreated for dubbed foreign versions of films. Similarly, the effects editor will provide a full atmospheric background, leaving a foreign buyer with just the need to add voices in their own language.

Their credit position, towards the end of the end roller (because post-production follows production), is symbolic of their sense of being bottom-feeders. They have to continuously adjust to a changing schedule: either being put under extreme pressure working unreasonable hours to meet deadlines or suddenly, being put on hiatus. They have to accommodate the whims of editors, directors and, to a lesser extent, producers; be answerable to post-production supervisors; and, at all times, present an obliging outward appearance while, no doubt, harbouring homicidal thoughts.

[15] Fill or filler. Atmosphere extracted from within a shot where no dialogue is spoken. Used, for instance, to replace an unwanted noise with atmosphere from the same shot, or to give an extension to the end of a shot to allow for a fade into the next shot, thereby giving a smooth transition.

Fortunately for me, I have survived any malevolence from my sound crews and recently completed my ninth film with Ackland.

Equally battered and bruised are dubbing mixers. Trying to make sense of the hundreds of tracks presented to them, they inhabit cinema-sized rooms, desk-bound for hours on end. The desk in their case, a control panel befitting Starship Enterprise.

Mixing 'Libertador' at 424 dubbing stage with re-recording mixer, Jonathan Wales

It can be a very loud place, particularly on sci-fi or action-packed movies; irritating for neighbouring theatres requiring a more delicate environment.

The protocol in dubbing theatres is interesting: where to sit and whose voice to listen to? There are usually four choices of seating: in front of the mixing desk, at the mixing desk, behind the mixing desk and behind, behind the mixing desk. The latter being luxurious armchairs and couches, designed like Venus Flytraps, for visiting producers and executives to sink into and hopefully disappear.

The prime position for those wanting control is in the seat next to the mixer, a position of intimacy and authority (Captain Kirk to Commander Uhura), where the mixer's ear is within whispering range. During the mixing process, which can take many weeks, this

captain position is seamlessly occupied, vacated and occupied again; the closer to the end game the more important the occupant.

As to the voice, well that is ultimately the director's, although prior to his arrival (at the tail end of proceedings), it is the property of the various sound editors: dialogue editor, Foley editor, FX and music editors. Later, control is ceded to the picture editor; he or she being privy to what is likely to please the director most and thereby, in theory, making the director's contribution merely a stamp of approval. Of course, it doesn't work like that. A possible scenario is as follows: a morning session where the supervising sound editor mixes a reel to his and the re-recording mixer's satisfaction, an afternoon session where the picture editor comes in an undoes the sound editor's and re-recording mixer's work to his satisfaction, and an evening session where the director comes in and undoes everyone's work to his satisfaction.

A worse scenario is when the segue between sessions is accompanied by temper tantrums; the picture editor balling out the sound editor for not doing what he wanted, the director balling out the picture editor for the same reason.

The mixer's role in all this is to offer opinion and suggestion in a calm reasoned voice, keeping a level head when all those around them are losing theirs. Almost uniquely in post (editors increasingly falling into this category because of the digital age), they perform live to an audience and are continuously being judged; constantly being asked to change things by the sound editors, then the picture editors, then the directors, then the producers. They too keep their true council without any outward appearance of psychological disorder, and that is to say nothing of their creative contribution and sensitivity, using sounds (and sometimes not!) to tell a story, not

necessarily literal to the images on film. Add to that, the time constraints on mixing a film and the pressure that imposes (most likely by the post-production supervisor), being a re-recording mixer is not for the neurotic, bad tempered and controlling. Having said that, there are some mixers who exhibit those traits ... except when the director is around! The best of mixing, like editing, is rarely noticed or appreciated.

To give some sense of how challenged a mixer can be, when working on *Cousin Bette* at Twickenham Studios, Dean Humphries at the behest of director Des McAnuff, made a possible world record of 1740 passes over the same spot! I was there.

At least my body was!

Dean Humphries mixing Cousin Bette.

Twickenham has always been my preferred mixing facility, because of their accomplished mixers, past and present: Dean Humphries, Craig Irving and Tim Cavagin but also for the intimacy of the studio. Their theatres being host to many award-winning films and to many fiercely fought table tennis and cricket matches as well; a throwback to the pre-digital age when reel changes necessitated a ten to fifteen minute pause and an opportunity for serfs to duel (and usually beat) the knights.

I had hoped *Under Suspicion*, released by the then-Columbia Pictures, would be my breakthrough moment into cutting features,

but it didn't happen, and I returned to working in television, as did Chris. A year or so later, I came close to editing another feature for Robert Young when he was offered *Splitting Heirs,* but his request for me failed to persuade his producers, who preferred, once again, to have someone with more feature film experience. Instead, I was offered *Galahad of Everest* (a dramatized documentary about Brian Blessed's failed attempt to climb Mount Everest) which turned out to be significant for me, because the producer Stephen Evans, was partly instrumental in my being hired for *The Madness of King George* two years later.

Script Supervisor on set

Chapter 9

Incense wafts from one room to another bringing a kind of spirituality to the creative process of editing. If not spiritual, then at least psychedelic. Scenes are playing on the monitor in Ed's cutting room, Ravi Shankar providing the temp music; the audio level is set lower than normal to allow for chat. Satyajit, sitting barefoot with his legs up on table seems totally engrossed. Ed, next to him, adjusts the sound, sliding the faders of the mixing consul with aroma-filled feeling. It's all going terribly well; they have been watching without stopping for some fifteen minutes and no notes, a good sign that the director is in his happy place. Annie wafts in with two takeout coffees, places them on the table and whispers, to Satyajit, with more than a hint of mischief:

'Great show last night, Satyajit.' To which he responds with a tight-lipped benevolent smile; Lord Krishna be praised. She wafts out, respectful of great minds at work; slightly more intoxicated then when she first entered.

*Satyajit, lifting his feet off the table, takes a closer look, moving his head up to the monitor screen as though inspecting for screen imperfections. He strokes his beard thoughtfully. This could be trouble, but Ed plays on, focusing on Satyajit's reflected expression on screen rather than the film, hoping to read his thoughts. The sequence comes to an end and Ed presses the **stop** button. Satyajit doesn't react, he still stares at the screen with great interest. Ed, in anticipation of an adverse comment lays a pre-emptive strike, always a good policy for an editor to appear ahead of the game:*

'Still a bit slow, I think there are several repeated moments that we could look at again, perhaps delete some dialogue? And there would be something to be gained by moving the lake scene forward, don't you think?'

Ed waits, both in expectation of insightful comment but also with the concern that he is inviting hours of work, which may follow a few negative remarks.

Dragging himself away from his reflection on the screen, he turns to Ed:

 'Ed...' *(long pause),*

 'What do you do when women keep ringing you?'

Not at all the response Ed was expecting. Ed looks at him blankly.

 'Tell me, what do you do when women keep ringing you?'

Still no response.

 'Come on you can tell me, man to man?'

Ed opens his mouth but nothing comes out.

 'Really? Women don't ring you?'

 'Not as a rule no. My ex-wife yes, but not women.'

Satyajit looks back at his reflection on screen,

 'You know why women don't you ring you, Ed? Because you are not as good-looking as me!'

Ed opens his mouth again and then closes it, as a fish might do. Satyajit continues:

 'Do you think I'm good-looking? Tell me honestly?'

 'Well, I don't fancy you, my grandmother might.'

 'Huh, Ed's always joking.'

Ed looks at his own reflection off the screen to confirm his apparent physical failings. Satyajit, also looking at the screen:

 'Do you think this is a good film?'

Ed converses with Satyajit's reflection:

 'Well...it's not a bad film.'

 'I think so too, we've made some big leaps in the past few days; a silk purse. How much time have we lost?'

 'Five minutes or so.'

 'Five minutes...very good.'

Responding to Ed's silence, Satyajit turns away from the screen to face Ed:

 'You want more?'

Ed turns to look at him:

 'I know they will want cuts.'

Satyajit considers for a moment and then a moment longer.

 'This is the film I want to make.'

 'OK, well if you're happy.'

'Do you like the music?'

'I like the pieces I put in.'

'You don't like the Indian music?'

'It's a little weird hearing Ravi Shankar in Monument Valley. There's no reference for that music in the film, the only reference for it is you.'

'You are being far too conservative. You don't think they will like it?'

'In all honesty, it won't matter. Whatever we put in, Walter will change it'.

'Do you think Walter and Abby will be happy?'

'What, with the film? If the scores are good, they will be happy.'

'If not?'

'Abby will let you live but Walter will put you in a bagel along with the lox, and eat you.'

(Pause)

'It's OK to be in touch with your unhappiness, Ed'

'Did I say I was unhappy?'

'It tells you when something is wrong. I have such anxieties…sleepless nights…panic attacks. I have this fear of everyone hating my film and that no one will employ me again; insecurity is my shadow. You don't have insecurities, do you, Ed?'

'Of course I do.'

'Of course you do but you hide your insecurities well…in cynicism.'

Ouch, that hurt!

A phone can be heard ringing down the corridor, followed by a pickup and muted conversation. Satyajit regaining his composure asks:

'Let's have some lunch?'

'Anywhere particular?'

'No, but not inside. Outside, on the pavement. I would like to be seen.'

It was around this time, the early 1990s, when there was increasing pressure to move to digital editing and prove my son

right. I, like many other editors was reluctant to change. Some editors at the BBC couldn't adapt and chose early retirement instead. I was offered *Harnessing Peacocks*, a film which re-connected me with director James Cellan Jones and the classy producers Betty Willingale, Colin Rogers and Georgina Abrahams, but on the understanding that it would be cut on Lightworks.

There were two digital systems on offer: the first to market was Avid, devised by computer geeks in the USA, while in the UK ex-film editors developed Lightworks. Over the last twenty plus years, Avid has grown in popularity, largely through its greater facility to deal with visual effects, while Lightworks, through lack of development, courted oblivion. In my view, Avid, and the cheaper newer boys, Final Cut Pro and Adobe Premier are clumsy tools, over-complicated and slow, hopeless in editing sound and generally not much better than iMovie. Whereas, Lightworks simplifies editing operations to a minimum and has all the feel of cutting on film. That being said, I have had great difficulty persuading productions in the UK to use it because it costs more to rent and in the US it's got to the point where the mention of the name solicits the response, 'What's Lightworks?' There are also very few Lightworks trained assistants left.

On *Harnessing Peacocks,* my fears about the new technology were lessened by having a Lightworks editor sit with me for the first two weeks of production. Crashing was a common occurrence and the lack of storage space a problem, having continually to 'consolidate' material, that is discarding material not used in the cut in order to make space for new footage; a problem when re-visiting scenes that have had original material removed, necessitating the re-loading of that material. But soon, I came to love the added control the digital age was giving me: I could make infinite versions of a sequence without unpeeling and remaking joins and access each version instantly, lay up as many sound tracks as I wished during assembly as opposed to laying just two; manipulate the picture image by resizing or flopping or zooming in and out, colour grade as well, have automated control of sound levels, access any part of a cut at the press of a button rather than having to wait while spooling forward and back. It also meant an editor could 'set up shop' with greater ease not having to have all the film paraphernalia (cutting benches, Steenbeck, bins, shelves, cans, boxes, etc.), to deal with and with that, have less of an obstacle to edit on location.

The location editing for *Peacocks* was in the lounge of my hotel bungalow in Combe Martin, Devon; the unit taking over the whole complex for a few weeks. It was a heavenly three-second commute to work during the day, and at night, when I was so inclined, I could roll out of bed and continue editing in pyjamas. 'Jimmy' Cellan Jones, when time allowed, usually at weekends, would always make his presence felt. The exuberant and loud bear of a man was as entertaining as ever and the friendships forged with him and the producers still exist today. Other 'friendships' of lesser longevity were forged in Combe Martin, as they tend to be on location, with the swimming pool allegedly being used by some of the crew for recreation of the breast stroke variety: used prophylactics being discovered floating on the water the next day. The pool had to be drained.

Following *Harnessing Peacocks,* I worked again with the ever-loyal Robert Young, on the first of two films for HBO. The title of the first, *Doomsday Gun* refers to the super gun being built for Saddam Hussein by munitions engineer Dr Gerald Bull (Frank Langella). It was a high quality film, with a great cast: Alan Arkin, Kevin Spacey and Michael Kitchen, and was a product of the New York arm of HBO, run by Colin Callender. *Doomsday Gun* was my first experience of the executive conference call. The film was being made in London and Callender was in New York. We would courier cuts of the film to him (no internet then) and wait for the call a few days later. It wasn't something to look forward to, as Colin always had plenty to say. It was never a discussion but a monologue, lasting over an hour with the lavish use of the word 'visceral'. Just the occasional 'uh huh' or 'that's interesting' response from our end was enough to keep Colin satisfied that we were listening, which, of course Robert was.

The second production, *Fatherland* directed by Chris Menaul, took me to Los Angeles and to the first of several sackings.

Chapter 10

Soho streets are not ideal for alfresco dining: passing traffic is very close with vehicle exhausts polluting the air and the food being consumed, tables are squished together to allow for pedestrian movement on narrow pavements, it is also noisy. The weather today is equally unwelcoming but stoics, Satyajit and Ed, brave the conditions to occupy a table in full view of anyone wishing to look. Satyajit eats but makes himself available for recognition by constantly looking up in hopeful expectation. Two people pass by and smile towards the table. Satyajit returns the smiles, with an expression that says, 'Yes, it's me last night on telly.'

Passers-by: *'Hi, Ed, OK?'*

 'Hey, Ed.'

Ed acknowledges cutting room colleagues,

 'Good, thanks.'

Disappointed but not deterred, Satyajit continues to make eye contact with passing male pedestrian traffic receiving some smiles in return.

Satyajit: *'I think he recognised me from the show.'*

Ed follows Satyajit's eye line,

Ed: *'I'm really not so sure, Satyajit.'*

Satyajit understands,

Satyajit: *'Oh! Do you think...?*

Satyajit takes a few bites of food,

Satyajit: *'So you enjoyed my little programme, Ed?'*

Ed: *'I told you already, it was...memorable.'*

Satyajit: *'How many watched do you think?'*

Ed: *'Well, at least...'*

Ed counts those present at the pub.

Ed: *'Five that I know of.'*

Satyajit: *'Millions?'*

Ed: *'Yes, of course.'*

Satyajit:	*'There was no preparation in what I said, everything on the spur of the moment. I felt so at home...with celebrity. Not nervous at all. The others were nervous, particularly that girl. I think she was deeply anxious, but I came across well?'*
Ed:	*'Yes, as I said...memorable.'*
Satyajit:	*'Memorable, but not too mannered?'*
Ed:	*'Not at all, you're a total natural. You should give up directing and just talk about it. You talk about it really well.'*
Satyajit:	*'Really?'*
Ed:	*'Really.'*
Manu:	*'Saturgy? Oh my goodness?'*

Attention, at last. Four Indian gentlemen pass on the street, Manu, Wasim, Dev and Iqbal. Satyajit stands, as does Ed; they all shake hands.

Satyajit:	*'Manu, my good friend and Wasim, so good to see you, Iqbal...Dev...this is Ed, my editor. These are my producer friends from home.'*

Pleasantries are exchanged. Satyajit waits expectantly for praise for last night's performance, it isn't forthcoming.

Satyajit:	*'Well, boys?'*
Manu:	*'We've just come from the cutting room, the girl said you were at lunch.'*
Satyajit:	*'Well?'*
Iqbal:	*'We thought we'd just pop in.'*
Satyajit:	*'No, what did you think?'*
Manu:	*'Think?'*
Satyajit:	*'You know, my TV show.'*
Wasim:	*'Oh yes, exactly, we popped by to wish you luck.'*

Satyajit's face registers disappointment.

Satyajit:	*'It was last night.'*
Dev:	*'You were on television last night, Saturgy?'*
Satyajit:	*'Yes, I told Manu it would be on last night.'*
Manu:	*'I thought it was tonight.'*
Wasim:	*'Oh if you had told me I would have watched it. You didn't watch it. Manu?'*
Manu:	*'No, I thought you said it was tonight.'*
Satyajit:	*'I said it was last night.'*
Manu:	*'If I'd known I would have watched it.'*

Dev:	*'Me too.'*
Manu:	*'Were you good?'*
Ed:	*'He was memorable.'*
Manu:	*'Memorable!'*
Iqbal:	*'If only we had known.'*
Satyajit:	*'You did know.'*
Iqbal:	*'Manu didn't tell me.'*
Manu:	*'I thought it was tonight.'*

A short embarrassing moment.

Wasim:	*'Anyway, how is your film?'*
Satyajit:	*'I am still working on it.'*
Ed:	*'Satyajit's made a silk purse from my sow's ear.'*

Ed's sarcasm is lost on everyone,

Iqbal:	*'Why not show it to us, Satyajit?'*
Satyajit:	*'Show it?'*
Manu:	*'Yes. For us, good idea.'*

Satyajit thinks, then warms to the idea.

Satyajit:	*'Like a test screening?'*
Wasim:	*'Exactly.'*

◆

Test screenings serve two purposes: to judge an audience response to the film, 'what you don't know can kill you' and if necessary re-cut it, but also to gain information about aspects of the film that might be useful for marketing.

The latter is often used to disguise the need for the former, 'oh it's just for marketing really, how best to pitch our campaign', when dealing with recalcitrant directors. It can also be misused by mendacious producers to reinforce their criticisms of a director's work, 'see, the audience is telling us it doesn't work'.

In one recent scenario for a UK-based independent film company (with the rabbit hole entrance), a sample audience of just twenty people (of which only 18 showed up) were recruited to pass judgement on a perceived problem film; a ridiculously low sample and statistically null and void, as most recruited audience number somewhere between 200 to 500. To add insult, industry people – directors and the like – made up part of the audience, like inviting jackals to feast on a wounded animal. The filmmakers, namely the director and editor, were excluded from the event, once again

exhibiting the deviousness of the producers. In their common view, twenty people was enough to 'glean some valuable data, which reinforces the fact that the film, in its present form, needs a lot more work'. Objections to the rigged event were met with, "We cannot ignore the common threads of the feedback. If we do, it's at our own folly. I also feel that it is somewhat dismissive of the hard work gone into staging the screening and the detailed analysis of the feedback, just because we don't like the general negative result." The producer less concerned about the many months of hard work gone into making the film than the few weeks in setting up a test screening for just twenty people.

For productions with a slightly more honest approach, the selected audience aren't quite random but skewed in favour of the genre of film being tested, with recruiters taking to the streets, local to the test preview cinema, asking, 'what kind of films do you like?' and 'would you be interested in a free ticket on such and such night?' The demographic, age, sex, and class of the audience and later the focus group is also a consideration. After the screening, questionnaires are handed out to the audience, to be answered and later collected and collated. A quick 'exit poll' is taken on the night with research staff feverishly working out a rough approval rating to hand over at the end of the focus group.

Overnight, the responses are analysed in more detail and a substantial document produced for the studio executives. A pre-selected group of around twenty remain in the theatre after the screening to form the focus group, with a professional moderator, skilled at extracting good and, particularly in my experience at least, bad opinions from the participants. Apart from questions like: 'who was your favourite character?', 'what was your favourite scene?', 'how would you rate the pace?' etc., are questions relating to the 'five-point scale' of 'excellent', 'very good', 'good', 'fair', 'poor'. If a film tests well, it is because it had an approval rating of above 80%, that is 80% of the test audience chose either of the top two boxes, 'excellent' and 'very good'. Anything from 50-60% is a cause for concern.

Fatherland (a 'what if' film about Hitler winning the war) was cause for concern when tested in LA. It was also cause for concern before testing. The initial edit took place at Twickenham Studios but the move into Soho, London, resulted in the worst computer crash I have experienced. It was still relatively early days of digital editing

and crashes not unusual, but the magnitude of this one led to an editor's worst nightmare, that of having to reconstitute the cut. In my case over a week's work had been lost.

Having finished the 'director's cut', my assistant, Tracey Wadmore-Smith and I, armed with work permits, relocated to HBO headquarters in Century City, Los Angeles. Director Chris Menaul remained in England because he was in pre-production on another film; his participation in the editing process pretty much at an end. I later heard he was a little put out that I didn't keep him up to date with HBO shenanigans, which was an oversight of mine, but there was no intention to exclude him, as initially there was nothing to report, and when there was, it was to tell him I had been fired.

After a brief 'how d'you do?' with führer Bob Cooper, the amiable dynamo and founder of HBO Pictures, we set up shop. HBO occupied the top floors of one of the Century City twin towers, and we occupied a windowless storeroom on the highest floor. The room was partitioned off into three separate rooms, like cages, which stored all the office junk from the plush floor-to-ceiling glass suites below. We made our cutting room in one of the cages. Apart from occasional visits by Ilene Kahn, the producer, we were pretty much forgotten about in our aerie. Ilene was the Grace Poole to our Mrs Rochester in Jane Eyre, occasionally bringing us bits of gossip, news and refreshments. Being a smoker back then, a puff necessitated travelling down 44 floors to the piazza below.

A week or so after our arrival, we were invited down to the executive floor, to join Bob's staff in celebrating his birthday. Good old Bob was the general sentiment of the 'bussed in' workers; 'for he's a jolly good fellow' was sung by all, us included. Small in stature, a whisker above 5'4", but big in authority, Bob ruled. On first sight, concerns of seeing double were allayed on discovering a Madame Tussaud's like copy of himself in his office. That may be an exaggeration born of a distant memory; a blow-up look-a-like doll or cardboard cut-out is probably more accurate. His executives were tough too. I recall being in Richard Waltzer's (Executive Vice President) office when he was lambasting some minion on the phone, to either get the subject of the call to shape up or to fire him. Richard, who then had a penchant for spectacular ties, may well have been justified in this tirade, but the ruthlessness of it was a bit alarming. It was just so un-English! But this was Hollywood, or

more accurately Century City. Perhaps, I would be at the receiving end of a similar conversation in the future.

Meanwhile, I was given an open-top Miata sports to get around in and nice accommodation in Westwood. There was little pressure at work and plenty of time to watch the 1994 World Cup, the endless news coverage of OJ Simpson and also to find a lawyer to start the lengthy Green Card process. The American producer, Ilene Kahn, was very pleasant, though, having little input at work, she graciously invited us to dinner at her home. Good old Bob didn't seem to take much interest in the film, so I fiddled with this and that until eventually, he arranged an in-house screening for executives and staff. The outcome of the screening was that the film wasn't quite as good as they had hoped, but it could be as good with a different editor. I had no idea what their problem was, only that there was a problem. Initially, Ilene brought in one of her editors to sit with me and make suggestions, but as that didn't work – owing largely to my US Border Control Officer welcome – the inevitable happened.

It was left to her to break the news, "Tarique, we're going to have to let you go. It's not personal, you understand. We all think you've done a wonderful job."

It's just, darling, not wonderful enough!

"Bob feels the film needs a fresh approach, a fresh eye."

When a film is perceived to be in trouble, that is, not to the liking of the financiers (studios) the 'fresh eye' (high up in the vocabulary of executives) is called upon to rectify the problem – the 'fresh eye' being another editor. This is not uncommon and when this happens, some directors and producers, out of self-preservation, disappear into the shadows, muttering words like, 'I tried my best', 'there was nothing I could do' or the Nuremberg defence, 'I was following orders'. If one were to be charitable, these reactions are understandable, because of the need to maintain good working relationships with the studio in terms of future funding (producers) and acceptance (directors). In any event, why sacrifice possibly years of work, just to save an editor? And who knows, the film might just improve with a more objective view. The reality is that the 'fresh eye' is there not solely to replace the editor but to side-line the director. The 'fresh eye' has allegiance to the Crown and through the Crown greater authority than the outgoing editor, and so can ignore the obstructive director.

Like the Eurythmics, I had that sinking feeling: a feeling of inadequacy, a feeling of failure, a feeling of being a pariah, a feeling of injustice, rejection and anger but largely a feeling of being ever so sorry for myself. So many emotions that take root in the head and just won't go away, day or night. 'Don't take it personally!' There is nothing you can do, just a week's severance pay and out, tail between your legs; the stigma of 'being let go'. I felt my work was about to be violated. I wanted to punch the air out of Bob's blow-up doll. Like some drama queen, I needed time to grieve, become comprehensively tragic, perhaps retreat into the Topanga Mountains, join the hippies and find myself.

Fortunately for me, this self-pitying didn't last long, as within a day or two, I received a call from my then UK agent, Vanessa Jones, telling me there had been an enquiry from the producers of *The Madness of King George III* – the III was later supposedly dropped by Samuel Goldwyn Jnr., who felt American audiences would think this was a sequel to *The Madness of King George II*.

The enquiry had come from Stephen Evans (*Galahad of Everest* producer) who was producing the film with David Parfitt for the Samuel Goldwyn Company and Renaissance Films. They had already started filming, so there was pressure for first-time film director, Nick Hytner, to approve someone quickly. After a very brief chat with him on the phone, the disappointment of the previous days disappeared and I was on a flight back to London and Shepperton Studios. Tracey remained behind to assist my replacement, the highly accomplished Dennis Virkler, who being Avid trained couldn't operate the Lightworks and had Tracey 'pushing buttons' for him. Sometime later, he thoughtfully phoned to commiserate on my departure. Later still, he rejected the offer of an editing credit.

Runner on set

Chapter 11

A mini screening is taking place in a small preview theatre in Soho. The smell of curry permeates the air. A makeshift buffet table in the front is decked with various Indian culinary delights. Ed peers through the projection room spyglass window into the theatre and all appears well, although the 'test' group are more pre-occupied with the food than the film itself. Before returning to the theatre, Ed leaves a plate of food for the projectionist, absorbed in a game of patience on his laptop. On re-entering the theatre, Ed waits at the door for his eyes to adjust to the light, then, picking a poppadum off the table, takes a seat near the front next to Satyajit. Behind them a few rows back are: Wasim, Manu, Iqbal and Dev. Satyajit's head slightly turned away from the screen, is watching for all their reactions and not watching the film. Jim, Nigel, Annie and Rebecca make up the audience at the back. On screen is the sequence we saw earlier, our two leading characters in a boat. Sitar and tabla accompany the scene, disguising the aircraft noise and motorboats to some extent. The viewing continues. The curry is eaten.

Dev: 'Satyajit, the curry is very good, is that coriander in the chicken? One pinch, if I'm not mistaken.'

Iqbal: 'And half a teaspoon of turmeric, I think.'

Wasim: 'And pressed garlic. Did you know the record for the longest string of garlic is 123 feet?'

Jim: 'That was the old record, I think it's now 200 feet.'

Wasim turns to the intrusive voice from the back:

Wasim: '200 feet, imagine that!'

Dev: 'It's a very good antibiotic I hear.'

Manu: 'Is it from The Red Fort?'

Iqbal: 'No, no, it's the Palms of Goa. Definitely the Palms of Goa, I can tell it's in the turmeric.'

Annie: 'Palms of Goa it is.'

Iqbal now turns to look behind:

Iqbal: 'I knew it'

Wasim: 'You get a very good deal at the Palms. The lunchtime special, any amount you can eat for five pounds.'

Dev: 'Would that be for two courses or three, Wasim?'

Wasim: 'Seven pounds for three courses.'

The scene on screen changes to our two leading characters making love. This draws their attention away from the food. Wasim smiles broadly, Satyajit notices.

Wasim: 'I like the girl, who is she?'

Manu: 'That's Angel Hart, isn't that right, Satyajit?'

Satyajit: 'Yes, Angel.'

Dev: 'I prefer the boy.'

Iqbal: 'Very good performances, very good, no Manu?'

Wasim: 'Excellent photography, who is the cameraman?'

Satyajit: 'Filippo Costa.'

Iqbal: 'Very exotic name. From Venezuela?'

Ed: 'Two sun, Arizona.'

Satyajit: 'He's from LA, Iqbal.'

Manu: 'Excellent design and makeup.'

Iqbal: 'Most excellent.'

Wasim: 'Music has a lot of muscle.'

Dev: 'So does the boy.'

Iqbal: 'She's a big girl, very accommodating breasts.'

Wasim: 'Very good, very good. Like the curry, tastefully done, Satyajit.'

Satyajit: 'Manu, what do you think? You'd like jig, jig with her, no?' (Laughs)

Heads are turned away from the screen to look at Satyajit.

Satyajit: 'No, no, keep looking, keep looking.'

Heads are turned back as they watch deep thrusting.

'In the story, she's fucking for King and Country.'

Dev: 'No, no, she's fucking out of self-interest.'

Manu: 'Isn't that the point of fucking?'

Wasim: 'As long as you remember to fuck down. What you must avoid, Satagy, is fucking up.'

(Laughter)

Iqbal: 'Hey, Satagy, do you remember?'

'If I could be just anything a brick I'd like to be...'

The men get up and sing together,
> *'FOR BRICKS GET LAID IN EVERY WAY*
> *IN ONE'S AND TWO'S AND THREE'S.*
> *THEY GET LAID WHEN STANDING UP*
> *AND GET LAID WHEN LYING DOWN.*
> *GET LAID WITH ANY COLOUR.*
> *BLACK, BLUE, WHITE, GREY OR BROWN*
> *BRICKS COME IN DIFFERENT SIZES*
> *WITH TEXTURES COARSE AND FINE*
> *THEY LIKE TO DO IT FACE TO FACE*
> *AND SOMETIMES SIXTY-NINE.*
> *THEY CAN BE LAID IN PRIVATE OR*
> *LAID FOR ALL TO SEE.*
> *YES IF I COULD BE JUST ANYTHING.*
> *A BRICK I'D LIKE TO BE.'*

Annie, watching from behind and quietly to herself.
> *'Was that a brick or a prick?'*

Madness was to be my penultimate edit on film. I arrived with a backlog of material to cut, some of which had already been assembled by first assistant, Chris Lloyd. It was only a couple of years since I'd been in a film cutting room but it already felt Dickensian. I met Hytner, already a star of the theatre but a novice to film, and started an on-off collaboration, which has lasted nearly twenty years. We recently completed our fifth film together, *The Lady in the Van*. I'm sure it would have been twice that number but for his slight aberration of running The National Theatre for over a decade. Along the way, he collected a Knighthood, an honour, as I pointed out to him, due to my skilful editing of the Royals in *Madness*. He confirmed as much in an email to me:

"Tariq – Definitely down to you! Holding Mr Pitt's backwards walk several seconds longer than apparently necessary – thereby demonstrating the meaning of deference. They never forgot it at Buckingham Palace."

Apart from the brilliant cast, led by Nigel Hawthorne and Helen Mirren, Evans and Parfitt had assembled an exceptional crew in all departments, particularly Andrew Dunn (DOP) and Ken Adam (Designer). Given the wonderful performances, ample imaginative

coverage, an Alan Bennett script of his play (already a success in the theatre) and a gifted director with a clear vision, even a studio executive could have cut it! The studio executive in this instance was Samuel Goldwyn Jnr., a Hollywood royal with absolutely no inclination to edit but every inclination to encourage, enthuse and, so I heard, avoid a restaurant bill. I found him and David Parfitt (I already knew Stephen Evans) a total delight to work with.

Thankfully, both Parfitt and Evans were, and are, in the mould of Brian Eastman; enlightened producers willing to give opportunities to 'new' technicians and directors, irrespective of their lack of feature length credits. I owe them and particularly Nick Hytner a great deal of debt for my career in films.

Hytner had directed the play in the theatre, and was the only choice to direct the screen version, although with it being his first film and only my second, we were both on trial regarding future cinematic work. He was, like Sam Mendes later, a very quick learner, both on the floor and in the cutting room. He loved the editing process and the discovery that, unlike the theatre, so much could be re-imagined and re-worked after the event, and that an audience's point of view could be constantly controlled by shot selection. Although relinquishing this control to somebody else, initially at least during the assembly stage, must have been alarming, at no time did he make me feel insecure about my decisions; on the contrary, he was enquiring, keen to learn through observation and questioning.

I have always been reluctant to explain why I have chosen to cut in a certain way, partly because most of the time I don't know myself, and partly because when I do try to explain it sounds pretentious, certainly self-conscious but more than often, inarticulate. Usually, one can get by with 'it just felt right', but that sounds so bereft of thought to someone you might be trying to impress, that supportive reasoning is often advisable. Giving the thought processes behind a decision, invites an opposing argument for negating that decision, which could be equally valid; or sound more valid if vocalised by someone with the gift of the gab and greater reasoning powers. This intellectual approach, or over-thinking, can lead to a confused state of mind and time-consuming misadventures. Too much decision-making angst can also be counterproductive during the assembly process as well; it can lead to a kind of paralysis of thought and action. I think it's better not to

think too much and give way to intuition, then be prepared to post-rationalise if required. Editing is largely an intuitive art.

The film came together very quickly and Goldwyn, keen to meet the Oscar deadline, brought the post-production schedule forward. The first of two test screenings in LA went reasonably well, although Tom Rothman, Goldwyn's executive, requested changes based on the audience reaction. The next day I was in a cutting room nervously applying those changes for the second screening scheduled the same evening; I was momentarily back in BBC's Lime Grove preparing a news item for transmission.

Fortunately, it went well, and the scores went up a little with Rothman giving us a ringing endorsement of our efforts: "You guys have delivered, it's up to us now to tell the audience how good it is."

He was true to his word, the reaction to the film on release being better than expected, winning many nominations and awards; Nigel Hawthorne missing out on the much coveted Oscar, which went to *Forest Gump's* Tom Hanks.

Shirley, my loose cannon of a wife, was outraged at this miscarriage of award and many years later, gave voice to her anger to the writer of *Forest Gump*, the much-respected Eric Roth. We were in Malibu, as one is, enjoying coffee at the Country Mart Coffee Bean, while our grandchildren played on the swings. Eric (who had written *The Good Shepherd*, a film I was to work on in 2006) was also there and joined us. In conversation, he mentioned the upcoming Award season and his nomination for writing the screenplay of *Benjamin Button*, which he recommended we see, "If you liked *Forest Gump*, you'll like *Benjamin Button*." Shirley, in total ignorance of Eric's status and curriculum vitae, declared,

"I hated *Forest Gump*!" I wanted to slide into the Malibu sand, but Eric, almost apologetically and hiding any hurt, confessed to having written *Gump*. Shirley then went on to explain it actually wasn't the film she hated but the fact that Hanks had beaten Hawthorne to the Oscar. It was one of those embarrassing moments that you'd wish would end but seemingly doesn't because the thought of it still makes me cringe now.

Had *Madness* been a failure I would have been a failure too; my feature aspirations curtailed for who knows how long? But Nick had conjured up the double whammy of success at the box office and with the critics, so his next film wouldn't be far away, particularly as one of his greatest fans, Rothman, President of Worldwide

Production at Goldwyn Films at the start of *Madness*, was now a bigger fish in a bigger pond, President of Fox Searchlight.

Makeup on set

Chapter 12

An overcast and wet day in Sherman Oaks, Los Angeles. Electricity is in the air both inside and out. Sheltered from the elements in the foyer of a multiplex, are small groups of film people in forced conversation, just waiting nervously. 'SPECIAL SCREENING' signs direct a selected audience to an assigned theatre, being helped on their journey by the staff of a research company, handsomely paid to stage these events. This is the first testing of 'An Act of Courage' and two groups of filmmakers are awaiting the arrival of studio heads Walter Weisman and Abigail Spear.

The larger group, in a loose arrangement of a circle, face inwards. Tom Schmitzer, Walter's New York executive and Pierre Alonso his European executive, stand in close proximity and are having animated conversations on their mobile phones, possibly with each other. Abby's studio executive John Mayer, tall and lean, a giraffe amongst sheep stands by Satyajit, his agent Katty and diminutive composer Franco Totti. Producer Boyd Kirstner is in a group of his own made up of his many assistants including lead assistant Rocky; his previous assistant Kelly having succumbed to disorders affecting mood, thinking and behaviour. Boyd barks an order to be heard by everyone,

'Remind me to call Affleck!'

His assistants, in unison, all take note.

Ed sidles up to this group but not quite making the circle stands at the periphery. He's a stride short and observes Boyd who has started to pace up and down being followed by his pet Rocky. Boyd is on the phone to the same unfortunate secretary of an earlier scene,

Boyd: 'Go to Barneys get me something for Bubble's birthday, $3000 give or take and keep the receipts. Then send her twenty-four red roses…but

check her age first, and fifty-five blue violets, no,
make that forty-five. Write on the card...'
Boyd turns away from Rocky and dictates quietly:

"*Roses are red, Violets are blue, my howitzer's ready, I hope*
you will be too.
Love you, babe."

Raising his voice once more:
> *'Then take the car in for servicing and get me on*
> *the red-eye to New York tomorrow night, seat 1A.*
> *Pick up the kids from school and take them to*
> *their mother. Get her something from Macy's, no*
> *make that Century 21, $200 give or take. Call*
> *Stallone, tell him I loved...'*

Ed moves away to eavesdrop on the other group,
Franco: *'I'm thinking bowed psalteries.'*
No one asked Franco what he was thinking, but he volunteers it
anyway. Satyajit suddenly realises he's talking to him.
Franco: *'For a long time, I've been thinking bowed*
> *psalteries. In fact, ever since I read the script*
> *psalteries sang to me. Can you imagine the*
> *possibilities, the musical canvass? I think we*
> *should move away from the conventional or*
> *orchestral, throw in a luth or errabab and a*
> *mandole, why not?'*

Satyajit would have difficulty understanding him under normal
circumstances but his mind is elsewhere, which is registered by the
look on the deflated composer's face. He continues,
> *'Or perhaps not.'*

Franco moves away despondent, observed by Ed.
> 'Oscar winning Franco Totti. Affectionately
> known as that tosser Totti, usually by other
> composers. But then, this is an industry where you
> just don't admire the competition. English born
> and bred, although you'd never know it from his
> affected French accent. Real name Archie
> Boothroyd, but he quickly realised a European
> name could be more beneficial.'

Ed continues to observe the characters around him from behind, warming to his role as commentator.

'Tom Schmitzer, executive producer, but don't be fooled by the title. Exec Producer credits are handed out like peerages to party benefactors. It is said that the average Hollywood film has just over 10 producer credits (3.2 producers, 4.4 executive producers, 1.2 co-producers, 0.8 associate producers and 0.4 other types of producer*).* Schmitzer is sort of senior management. Key to the executive bathroom. All designer dressed down and undetermined sexuality. Acerbic wit, smart arse, socialite. Has the ear of Walter. Dangerous and not to be messed with. Pierre Alonso, Exec. Producer and Walter's mouthpiece in UK. Forms double act with Tom. Enjoy each other's company like mischievous schoolgirls at the back of a classroom, constantly gossiping and scheming.'

Katty sidles up to Satyajit.

Katty: *'Satyajit.'*

Satyajit looks at her as he would a stranger.

 'Remember? Your agent.'

He smiles in acknowledgement. Ed moves within earshot…

 'Now Satyajit, if this goes well, take the credit. If not, find someone to blame.'

Satyajit: *'I'll say it's work in progress, I'm still looking for my film.'*

Katty: *'That's good, I like that, looking for your film.'*

She continues talking; Ed, distancing her speech to allow for thought:

'One of the great mysteries in filmmaking is how often films get lost. There should be a search engine for directors looking for their films, and as for agents, they are in varying degrees, smug, clinically detached, vindictive, tactless and pragmatic. Slide from enthusiasm through complacency to apathy with the ease of a mosquito drawing blood. They are magical; now you see them, now you don't. Followers of baseball, for they're forever 'touching base' with their clients.'

Katty: *'So be nice to Abby and Walter, let's touch base later.'*

She moves away.

Ed's reverie is broken by Pierre, who relays information received on the phone:

'They are still thirty minutes away.'

Boyd, now off the phone, reacts to this news:

'I'll need string cheese in twenty-seven minutes, and a macchiato to follow. Todd, you make the first run, Chris, the second. Let's do a time check,'

The assistants all look at their watches,

'I make it 6.15 and twenty seconds.'

They all concur,

'Check.'

I have worked more with John-Paul Davidson (JP) than any other director.

A prolific filmmaker and the most travelled and connected man I know; he's been the mainstay of my documentary work, and through introduction to Stephen Evans (*Galahad of Everest*), partly responsible for kick starting my moribund feature career. The two, JP and Stephen, came together once again to give me my third film, *Gentlemen Don't Eat Poets*, JP's big-screen directorial debut. Also producing was Trudie Styler.

For JP, this wasn't a make-or-break venture into the feature world; for him, it was purely a case of showing he could do it and if further film work came his way, great, and if not, too bad. I didn't see this as a lack of ambition on his part, more a healthy attitude towards work and a degree of ambivalence towards the movie industry. Secure in his own field of documentaries and constantly in demand, directing a film offered a challenge that wasn't the be-all and end-all. Contentment is hard to achieve in an industry rife with rivalry, resentment and envy, where one is continually comparing oneself with others but JP has come closest to achieving it.

Just as well in a way, because *Poets* was largely panned. A quirky black comedy about aristocrats Alan Bates and Theresa Russell having their lives taken over by weird, below-stairs couple Sting and Trudie Styler, produced comments such as:

"A schizophrenic film, providing at best, lukewarm entertainment value."
Pat Kramer, Box Office.

"It is not well-made – grease on the camera, poor set-ups, stiff direction and editing that betrays panic."
Derek Malcolm, Guardian.

"A bog of boredom."
Nigel Floyd, Time Out.

Each to his own and painful reading at the time, but thankfully, as films are released long after the event of making them, the damage of such comments is not only somewhat diluted but on re-reading, marginally amusing.

Some years earlier, Trudie had enlisted JP in the making of a surprise, very tongue in cheek 40th birthday film for husband Sting. I was paid for editing the film but in addition, and to my surprise, received a gift from Ms Styler, delivered by chauffer, of a bottle of wine from Harrods. I am no connoisseur of wine, so reading Petrus didn't mean anything to me. It was just a bottle of red. I discarded the box and the bottle remained unopened for several weeks. On being invited to an anniversary party and having nothing to take, I immediately thought of the Petrus, but thought (sadly, I know) it would look better in the original box, which I had discarded. I rang Harrods to see if they could help but, not surprisingly, they couldn't; however, out of curiosity and in really bad taste, I asked the price of the wine. On being told it was well over two hundred pounds, the bottle remained in our possession and we took a bottle from Somerfield's instead. That kind of generosity from Styler was to be repeated time and time again on future joint ventures (charity films

and re-cuts) with gifts ranging from Eames furniture to farm produce from their farms in Wiltshire and Tuscany.

Being only as good as your last film (in terms of box office/critical success), I was in danger of losing my tenuous hold on features but thankfully, Hytner came to my rescue once again. He'd been asked to direct *The Crucible*, a film based on Arthur Miller's play, which was being jointly produced by Arthur's son, Robert Miller and David Picker, ex-Head of United Artists, Columbia Pictures and Lorimar. Twentieth Century Fox Searchlight (Tom Rothman) was financing the film.

Rothman was later to be involved with *Lady in the Van* in his then new role, resurrecting Sony TriStar Productions. Having had an astonishingly successful eighteen years at Fox, ending up as Chairman and CEO of Fox Filmed Entertainment, he was unceremoniously evicted from office by Rupert Murdoch to make room for his highly competitive sons, out-of-work James Rupert Jacob, late of News of the World infamy and Lachlan Murdoch.

During the *Van* production, however, Tom moved into the hot seat at Sony as a consequence of Amy Pascal's departure; the company almost rendered inoperable by paranoia, as a result of their own hacking scandal.

The *Crucible* film unit took over Hog Island in Massachusetts, building the set of Salem village; Daniel Day-Lewis participating in the build of Proctor's house reportedly using 17^{th} century tools. Day-Lewis' creative process has been well and, for him, tiresomely documented; immersing himself physically, psychologically and emotionally into his characters. Weirdly, I have been asked at editing workshops whether I do something similar before each film, somehow absorb myself into the story for better understanding of characters. Registering the disappointment in the face of the questioner, I felt less of an editor for saying 'no'. Bizarre, the thought of becoming a method editor, it somehow doesn't have the same ring when applied to editing, suggesting something negative, mechanical, programmed and unfeeling.

Filming on Hog Island entailed making a short return ferry trip every day to reach the location. The organisation for such a large scale operation, the responsibility of the assistant directors and production managers, has to be admired; actors, light and sound crew, support staff, catering and small vehicles all moved efficiently across the water and in time for camera 'turn over'. Add organising

trucks, trailers, buses and limousines when on dry land, along with arranging street permits and re-scheduling for bad weather, it's a logistical nightmare.

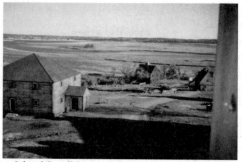

Hog Island Crucible *set – photo, courtesy of Stacy Marr*

The assistant directors' work used to be recognised at the Oscars, but sadly no more. Perhaps their craft isn't considered creative enough for consideration because their creativity is lumped in with the director, designer and photographer. Perhaps their contributions are difficult to compare but actually no more so than other crafts.

Warnings on the island were given about the danger of Lyme disease, a bacterial infection caused by the bite of an infected deer tick. Fortunately, the cutting rooms, along with the production offices, were set up some miles away on the mainland, in an annexe of the disused Danvers State Insane Asylum.

Danvers State Hospital, 1893 (Wikipedia-public domain) Now (with the same façade), a luxury apartment block.

Appropriately, Danvers Asylum was on the site of the former home of the infamous Judge Hawthorne, who acted as a Judge in the Salem witch trials. It is said that this site may have played a bigger role in the witch trials than Salem itself. The theory being that the contamination of local crops – such as rye, wheat and barley – by a fungus that caused ergot poisoning, may have brought on hallucinations that led to the witch phenomena. The main building, a huge gothic-like structure with spires, stood in splendid isolation atop a small hill – like the Bates' house in Psycho, only many times bigger. It had been vacated and boarded up about four years before, in 1992, and left to decay and rot. Its spookiness was recognised by director Brad Anderson, who chose the abandoned building as his location for the horror film, *Session9*. Set apart from the main building but connected by a labyrinth of underground tunnels was the annexe, where the production set up base.

The annex – home to production offices and cutting rooms
(Picture courtesy of Stacy Marr)

Production took the ground and first floors and we, typically, had the basement; cutting rooms don't need windows apparently! Some of the tunnels that led to the main building were still accessible from the basement and constantly expressed drafts of musty air and eerie noises into our door-less rooms. In return, the sounds of possessed hysterical girls were sucked back up to the main building, courtesy of Wynona Ryder and her willing accomplices; ghoulishly echoing down the black forbidding holes,

Danvers tunnel – no place to be at night. (Photo courtesy of Tom Kirsch)

screams that perhaps gave voice to the tormented souls trapped within its walls. Thoughts of shock treatment and lobotomies, which were carried out on a regular basis, obviously preyed on the mind!

For recreation, we set up a ping-pong table in one of the empty rooms adjacent to the cutting room, which was fine during the day, but late at night when working alone, it was quite unnerving, being difficult to separate the sounds from the speakers with noises from outside. Was that a bat hitting a ball? Has it bounced off the table onto the floor? Is it rolling along the corridor towards me? What's that appearing in the doorway?

The post-production took place entirely in New York, where Hytner had set up a second home; a sign I hopefully took to be a commitment to making films in America. With my newly acquired Green Card, I was happy to have this potential source of employment in the States, although as time progressed, Nick's disenchantment with the industry would increase.

First Assistant Director on set

122

Chapter 13

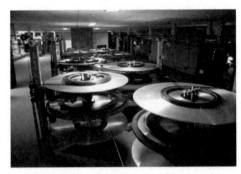

Projection booth, showing reels of film on platters
(Picture courtesy of Brad Miller, www.film-tech.com)

The projection box of the multiplex looks like the machine room of a battle ship. Banks of grey projectors are lined up on both sides of a large room, sending images down to the theatres below, through windows made from high-grade glass, designed to minimise loss of light. It's noisy, with the clattering of film passing through the projector gates and with the muffled soundtracks of some of the theatres being relayed through small speakers. The atmosphere is balmy, the heat coming off the carbon arc projector lamps capable of producing several thousand degrees at source. Large horizontal platters loaded with joined reels release the film from the outside and via a number of pulleys, feed into the projector and then back from the projectors on to the platters on the inside, so that it's ready to run again for the next screening. In effect an enormous loop. This negates the need to do 'changeovers' from one projector to the other and to rewind the film to the front for the next screening. The film has been brought over, in two thousand foot cans (twenty minutes running time), by Ed, Annie and Michael, and is currently being joined by Annie prior to the screening. After the screening,

Annie will unjoin the film and return it to the cans. With finished films, the sound is imprinted onto the film itself and read by a sound head in the projector. With films on test, the sound is separate and requires separate joining and unjoining; a separate sound projector is also required, thereby doubling the risk of failure.

This operation is being run by Howey, the chief projectionist, and Marlene his assistant. Howey and Ed are looking through the spyglass down to the theatre below

Howey: *'OK. So you've got the volume control taped to your seat, see...down there?*

Ed inches forward to look down to the theatre below.

It's set about right, on seven, so you shouldn't need to touch it. Word of advice, don't let the director anywhere near the dial.'

They move away from the window as Annie joins them. Howey observes their anxiety:

'You both look anxious but don't worry, usually it's fine. I say usually because I have had some breaks, you know, right in the middle of the screening. Kerbam! The worst is when the film gets caught, here in the gate of the projector.'
(He points)
'And burns up and the synchronisation goes, you know. The picture is like up here and the sound down there.'

He attempts a visual illustration of 'out of sync' with grotesque facial expressions and weird sounds.

'And there's nothing you can do about it but stop the machine and then it's over to you guys, the editors, to put it right, you know what I mean? You have to put it right with an impatient audience down there and the studio big wigs lookin' on. Not that I want to make you nervous, you understand. There was this time when we were running that film with the man who was in one of those Bond pictures though it wasn't a Bond movie, had a funny accent like yours. Marlene what was the name of the movie we ran

in here a few years back with the man who was in those Bond movies and the editors joined the reels out of order...?'

◆

Following *The Crucible* was *Wings of the Do*ve, produced by Renaissance Films (Stephen Evans and David Parfitt again) and Miramax. On reflection, I got off very lightly on *Wings*, because Miramax meant Harvey Weinstein, a man notorious for being very hands on in post-production and having a predisposition for recycling the creative pool. Once, supposedly turning on his own staff with, 'You're fired', 'You're fired', 'You're fired', and with a little more feeling, 'And you're fucking fired'. It is difficult to be neutral about Harvey.

Our first meeting was in the stairwell of a Venice Palazzo, where the film was being edited by me, with the help of my first assistant Liz Green; the rushes being sent to London for syncing, digitising onto hard drives and returned to Venice by my other assistant Saska Simpson and trainee, Katya Jezzard.

The cutting room Palazzo...

now the 5-star hotel, Ca'Delgrado

Harvey was doing the state visit to location that executives do, the cutting rooms being, as is usual, part of the to do list. He was accompanied by a coterie of Miramax domestiques (producers and pandering staff).

My introduction was made slightly easier by him having already met my actress daughter, "So you're Gabi's father?" With my movie-editing career still in its infancy, I was only too happy to have some favourable connection (albeit a tenuous one), with this significant movie mogul. For a man with a reputation for boorishness, bullying and temper tantrums attributed to low glucose levels and poor nutrition, I was very happy to shamelessly ingratiate myself along the lines of 'such a pleasure to meet you'; almost kneeling at the feet of this imposing man, as one would with a man not only above one's station, but also appropriately on the stair above. He was surprisingly jovial, perhaps as a consequence of a successful tryst; rumours of his sexual misdemeanours had reached most industry ears. Sadly, my only qualms were about impressing him and furthering my career.

However, the connection with my daughter wouldn't have saved me from oblivion (it didn't on *The Four Feathers*) and I suspect it was the skilful sidestepping of incoming tackles from behind by the director, Iain Softley, like me a lover of soccer, that avoided my early exit from the game. Iain was resolute about the kind of film he wanted made and released, and managed Harvey extraordinarily well; like flexible steel conduit – bending but holding firm. He had enormous resilience, patience and that great sense of ironic British humour, all pre-requisites in dealing with Harvey (along with a substantial skin), as did both Evans and Parfitt.

I recall going to a post-mortem after a test screening in New York, and being warned by Iain not to look Bob Weinstein, Harvey's brother, in the eye. He didn't like it I was being told. Iain might well have been winding me up, but as Bob ran Dimension Films, the horror wing of Miramax, I was not about to take any chances. I tried to avoid all eye contact but surreptitiously glanced at him when I thought he wasn't looking. Fortunately, he didn't speak much at that meeting and never to me, so my resolve wasn't really tested.

We (the Brits) all thought the test screening went reasonably well, but Harvey felt it needed saving and he was the man to do it.

We worked on his notes back in London, then sent him a new cut (VHS tape), only to have it returned (VHS tape), re-cut by his scissor-hand editors (mercenaries of the Papal Household), operating from his trademark 'Butchers Shop' in New York.

Bearing in mind these edits of the film had a complete sound track mixed-in, any re-edits within music sequences looked and sounded horrific (like the effect of TV channel hopping), even if the intention was sometimes good.

We went through this excruciating and sometimes entertaining process for weeks before eventually being able to lock picture. Some of Harvey's notes were taken on board and a new ending manufactured; Merton (Linus Roache) returning to Venice after Millie's (Alison Elliott) death accompanied by a new Millie voice-over, "I believe in you..." Less bleak than the scripted ending of Kate (Helena Bonham Carter) and Merton's failed relationship.

The material for Merton's return was actually a deleted scene, his first arrival in Venice. It was considered redundant and remained on the cutting room floor until a reason found for reinstating it.

I had survived my first encounter with Harvey, Iain's choice of composer, Ed Shearmur, wasn't so lucky. His score worked brilliantly, but, not surprisingly, Harvey disapproved of it. He threw it out and hired Gabriel Yared, who had recently collected an Oscar for another Miramax project, *An English Patient*; it should be said that Harvey, like many in the industry, is a dedicated follower of fashion, riding the coattails of success when the opportunity presents itself. The cutting room was put on a four-week hiatus while Yared wrote his score. In the end, Harvey didn't like it any more than Shearmur's, so we reverted to Shearmur's original submission. At least Weinstein acknowledged that he was wrong.

The good and bad Harvey was to continue to be in my working life for years to come, not that there was anything special in our relationship, it's just that he's been a huge presence for many in this industry.

Chapter 14

A large limo is driving on the very busy 405 on its way to the Sherman Oaks Galleria. Sitting in the back are Walter Weisman and two ladies, his wife Annette and mother-in-law, Golda. The driver sits with the window divide up and is in communication with Pierre, announcing their progress as they approach the multiplex. Next to the driver sits Walter's female assistant, Paisley. Walter is eating an All Day Value Subway sandwich with one hand, dropping crumbs and bits of meat, tomato and lettuce onto his stained clothes, which show evidence of previous encounters with Starbucks, Fat Sal's Pizza and possibly remnants of The Waverly Inn. He has a cell phone in the other hand and is as forceful as ever,

'Fuck the story, just tell me who's attached... She's not a star, she's a fucking corporation. I don't want to deal with a fucking corporation.'

He ends the call and shouts through the glass divide at his driver,

'Find out where Abby is, I don't want to arrive before her.'

The camera holds on Walter, feasting. We hear Ed's voice,

'Walter is a major minor Studio boss, a modern Medici, a papal like patron of the arts. A bruiser with a large appetite for food and intimidating people. Skilful exponent of industry kriegspiel and an avid participant in the celebrity lovefest. Small jet at his disposal. Fearsome. Avoid close proximity while eating for fear of life-threatening projectiles.

Walter lowers the divide to talk to Paisley.

'P, what the fuck happened at BAFTA?'

Paisley: 'I'm so sorry Walter, it was...'

Walter: 'The fucking cameras couldn't see me...'

Paisley: 'I know, it was just...'

Walter:	*'I told you to get me a seat behind Hanks, so that when the cameras were on him, I would be in shot…'*
Paisley:	*'I was told by allocations…'*
Walter:	*'I don't want fucking excuses, you buried me amongst the fucking technicians, who wants to be behind some fucking technician for God's sake?* *No camera is going to be on a fucking technician.* *How the fuck did that happen? Kiss your retirement package good bye.'*
Paisley:	*'We don't have a retirement package,* *Walter.'*
Walter:	*'Don't get cute with me, if we had a retirement package, you wouldn't be getting it, farshtinkener!'*
Paisley:	*'It won't happen again.'*
Walter:	*'You better fucking believe it or I'll make an amphibious landing on your fucking head.'*
Paisley:	*'I'm sorry, Walter, it really won't happen again. I wouldn't want that to…'* *But the divide closes on her.*
Annette:	*'Now don't get over excited, Walter.'*
Walter:	*'Behind a fucking technician, can you believe it?'*
Golda:	*'I think we heard, Walter.'*
Walter:	*'Farshtinkener!'*
Golda:	*'Walter?'*
Walter:	*'What?'*
Golda:	*'What's an amphibious landing on the head?'*

◆

"Stand in line!" "Stand in line!"
"Go over there!" "Over there, you heard me!"
"Sir! Sir! Sir! Go to the back of line!"
"Do I need to say it again? Back of the line!"
"Don't cross the line!" "Don't cross the line!"
"Step back, sir!" "Step back!"
"Wait till you are called!" "Wait. Till. You. Are. Called. Sir."

The Object of My Affection (a drama-comedy starring Jennifer Aniston and Paul Rudd), brought me back to work with Nick Hytner

again in New York. My hopes that Nick's commitment to the US would bring me work there were being fulfilled. The initial excitement though, was quickly dulled by Homeland Security and their very unique brand of welcome at US airports generally and LAX specifically.

Standing in line is a softening up process for further humiliation at the booth by a Customs and Border Patrol officer

I now had my Green Card but as my wife didn't, it caused consternation and concern, which continued for many years.

"How come you have a Green Card and she doesn't?"

"She doesn't want one."

"Does she intend to work?"

"No, she's been retired ten years."

"How long is she staying?"

"Three months."

"Three months? And you tell me, she's not going to work?"

"That's right."

'This is very irregular. Sir, sir, please don't touch the desk."

"I wasn't..."

"Step back from the desk, sir."

"How far back?"

"How long have you been out of the country?"

"Five or six months."

"Five or six months, huh? Which is it, five or six months?"

"Probably six months."

"And you tell me she doesn't intend to work?"

But then, there is a hierarchy here not dissimilar to the film industry, so bringing experience to bear, a display of supplication and submissiveness...

"No sir, she just loves being in this wonderful country: the wonderful people, the wonderful scenery, the weather, the food, the NRA."

Solicits.

"Welcome home, sir."

Oh for a bucket of homeland water!

Also through experience, I had discovered that argument or reasoning was counterproductive, with a CBP response,

'Are you talking or are you listening?'

And humour the kiss of death,

"Sir, step over there."

'There' meant a secondary interview in a side office with an equally unpleasant, boorish, bored and bullying officer with even more attitude.

On one occasion, on crossing from Canada at Buffalo, 'step over there' led to *her,* having *her* passport taken away and then returned shortly afterwards with 'On parole' stamped in it, accompanied by a warning,

"We'll let you in this time, but she had better get a Green Card."

She did get one.

I wrote to the then Head of Homeland Security, Michael Chertoff, with a catalogue of complaints from Buffalo to Tijuana with names and events. I didn't get a response. My complaints continue to this day with a recent incumbent Jeh Johnson.

Waste of time of course. What I should recommend is an improvement in diet for CBP officers; low glucose levels and poor nutrition lead to bad behaviour!

Most directors are very protective about their film in the early stages of editing, but Nick was happy for Aniston (with Courtney Cox in tow) to look at some sequences alone in the cutting room.

Their arrival had the cutting room all of a dither. My three laddish assistants, the testosterone-fuelled and highly muscle-toned hulks, Bill Henry and Armando Fente, and the boyishly debonair Adam Geiger, unashamedly laid on the charm for our visitors. I, of course, unlike my fawning staff, was hardly aware of their presence, not in the least being effected by their vibrant energy, youthful glow, natural beauty, easy charm, genuine warmth and playful banter: maintaining a dignified and detached professionalism at all times.

Far more affecting and genuinely leaving me weak at the knees, was a visit from a rather large, threatening no-nonsense Editor's Guild shop steward (straight out of *Waterfront* Hoboken) brandishing non-negotiable application forms. Up to this point, I had got away with not being a Union man in America, but that was about to change. Join or take a swim in the East River. I joined.

The wrap (end of picture shoot) party took place on a night of torrential rain. All the actors came: Aniston with her then boyfriend Tate Donovan, Paul Rudd, Nigel Hawthorne, Alan Alda, Allison Janney and all the crew. All very glamorous, all very chic: plenty of Gucci, Valentino, Versace and Prada on display, but my wife stole the show with Balducci's. Balducci's plastic grocery bags adorned her feet (designed for comfort and rain resistant) and, to complete the ensemble, a trendy, off-white, slightly translucent bin liner as a raincoat, apparently much admired in the ladies' toilet. A woman of some eccentricity!

In time, both Bill and Adam became accomplished editors and Armando, making best use of his film experience, movied into colonic irrigation.

Union official arriving on set

Chapter 15

Another large limo on the 101 also on its way to the multiplex.
Inside sits glamorous 40-year-old Abby Spear. She sits alone in the
back giving her face a final 'touch up'. She simultaneously speaks
on her mobile phone using an earpiece,

> *'There must be a way of putting the skids under this man,*
> *because he's costing us a fortune… It's not the film we*
> *wanted… What options do we have?'*

Abby carries on her conversation on the phone.
We hear Ed's voice:

> 'Spear runs a major studio. Being a corporate person, she
> often likes to address herself as "we". She's a ball breaker.
> The antipope. A female version of Attila the Hun. Nearly at
> the top of the food chain (there's always someone higher
> like Media Mogul Murdoch, there's no one higher than
> him), she has the mother of all offices, windows in Dolby
> surround. Has support team of vice presidents, senior vice
> presidents, executive senior vice presidents, assistants to
> the vice presidents and assistants to the assistants and very
> long legs, all her own. Attractive in an open easy way, on
> the surface at least, but scrape the surface and who knows?
> Responsible to the corporation, she makes weekly sojourns
> to corporate headquarters for meetings to discuss
> productivity. Burnout is high and job security is only as
> good as the grosses on films, for which she is responsible.
> Insecurity runs all the way down from the top.'

She breaks away from her call to ask the driver,
'How far away is Walter? We don't want to arrive before him.'

I returned to cutting on film for the last time on *Alien Love Triangle;* the love triangle being Kenneth Branagh, Courteney Cox and Heather Graham. Director, Danny Boyle had resisted digital editing up to this point but did succumb on his next film, *The Beach.* I was fortunate to get the opportunity, as Danny's regular, talented editor at that time, Masahiro Hirakubo, was otherwise employed. Masahiro, my assistant for a brief period at the BBC, cut much of Boyle's early work: *Mr Wroe's Virgins* (TV), *Shallow Grave, Trainspotting, A Life Less Ordinary* and *The Beach.* Sharing many similarities with me, cynicism for one, Masahiro has had an uneasy relationship with the industry and the people in it. Inscrutable to a fault, an admirable reluctance to fawn (perceived by some as a lack of enthusiasm and disdain) and uncompromising in his integrity. These traits have led to a career since the Boyle collaboration, less celebratory than some of his less gifted contemporaries.

Triangle was supposed to be one of three shorts to be released, alongside *Mimic* and *Imposter* for Miramax (Dimension), but the other two eventually being made into full-length films left *Triangle* on the shelf for many years. In 2008, the film premiered in the smallest cinema in Wales, a converted railway carriage seating just 23. It was a red carpet event with Branagh in attendance. With this sentimental screening, arranged by film critic Mark Kermode, the doors closed on the theatre for the last time and possibly the film too.

Following a similar pattern, director Franco Zeffirelli's usual editor, Dickie Marden, wasn't available for his film *Tea with Mussolini.* As a consequence, one of the many producers, Frederick Muller (he was also a producer on *Fatherland*), put my name forward for consideration, so I went to Florence to interview with the *maestro.* As with *The Madness of King George*, the production had started filming, so Franco, like Nick Hytner, was pressurised into making a quick decision. When I arrived at his hotel, mid-afternoon, he was having a nap. I felt this was odd at the time, but now as I approach his age then, I fully understand. His associate producer and close friend Pippo Pisciotto, apologised for the delay, which, in the end, was about an hour. Franco was polite, offering me drinks, but not overly friendly; I discovered later that his relationship with Frederick Muller was so poor that any suggestions

from Muller had to be bad ones. He also expressed concerns about the new technology, as this would be his first edit not on film.

However, he took me on – probably on the premise that I could be used (by failing) as a tool to put the skids under Muller at a later date – and moved into Cinecittà Studios in Rome. I had a very experienced and mellow English speaking Italian assistant, Liberata Zocchi who was a regular on Franco's films and a mine of information on how best to deal with Franco's temperament and the vagaries of Cinecittà, where there would be frequent power cuts. Her response to these events was a shrug of the shoulders, silent Italian, which said more than a sack of words.

As the weeks progressed and during filming, I was getting little feedback from Franco and when I did, it wasn't good. I was missing so many 'beats', that I felt I had lost my mojo and thinking it pointless to continue, said as much to Muller. My offer of resignation was passed on to Franco, which he wouldn't accept. Supportive to me throughout these difficult times was the redoubtable Angela Allen, script supervisor, as they are now known, but continuity girl at the time of *The Third Man* and *African Queen*; the latter, one of fourteen films she collaborated on with John Huston. As Huston quickly realised, one does as Ange says, a formidable lady to have in one's corner. She had Franco's ear, built upon many years of working together, (and no doubt many squabbles) and as a result, she had become part of Franco's 'family'. She informed Franco that *sh*e had actually been behind my recruitment and not Muller.

From then on his attitude towards me changed, and eventually extended to the point of my being addressed as 'My darling, Tarique'. Later, he fired Muller, along with his very able son, the 1st Assistant Director, Sam Muller. Franco was so unpredictable, he would think nothing of standing up in the middle of a screening to rant and rave in Italian at something or somebody. Giovannella Zannoni, another producer and undeserving of any abuse, seemed to take the brunt of it. It must have happened many times before because she took it all very calmly; she too, was 'family'. These virtuoso performances could go on for several minutes, making it impossible for the audience to concentrate on the film. On the other hand, when one expected a rant, it never came. On returning to the UK, we had a screening in West London, which started while I was still making changes to reels in the cutting room, twenty minutes

away. My UK assistant, Mark Harris ferried reels as I completed them, but I failed to keep up. The screening was stopped towards the end, and the audience waited for me to arrive. When I did, the screening continued and ended. I fully expected a public humiliation but it never happened. He was as sweet as could be and totally understanding.

Power cuts were frustratingly frequent in Cinecittà. They could last for minutes or even hours; I would constantly make back-ups for fear of losing cut sequences during a 'crash'. There was a total lack of urgency regarding fixing faults and no amount of screaming and yelling made any difference. *Che sarà sarà.*

Annoyingly, I had to vacate my desired cutting rooms to make way for the incoming Walter Murch, who was cutting *The Talented Mr Ripley*. My eviction didn't make for a happy introduction to the great editor.

The director's cut was taken at a leisurely pace with Franco coming in around eleven then leaving for a long lunch and returning later in the afternoon, often with the composer Alessio Vlad. Ostensibly, this was to sketch out the music for the film but the keyboard he brought with him, was used more to provide backing for their renditions of many Italian folk songs. I felt enormously privileged and entertained, being their only audience.

With Franco *opera*ting in New York, he was happy to leave ADR sessions to me – not an altogether easy experience with some of the cast – and also happy for me to communicate his responses to Vlad's developing score back in Rome. Franco would phone me and in very colourful language give me his thoughts. I would then translate these thoughts to the composer in a more prosaic way: "Franco feels that the music isn't quite delivering the rhythmic muscular contractions in the pelvic region characterised by sexual pleasure that he requires."

Zeffirelli always sound mixed his films at Twickenham studios and always with Gerry Humphries. Gerry, at the time of *Tea with Mussolini*, had long since retired from sitting behind the mixing desk and had taken an office job running the studios. However, Franco wanted him, and Gerry was of the opinion, not shared by other mixers at the studio, including his son, Dean, that he could still do the job. Dean, of an amusing mordant disposition, normally brought an air of serenity to the quite often stressful process of dubbing (sound mixing), but on this occasion the prospect of his

father being let loose on a console that had changed dramatically since his father's pre-history days, was uncharacteristically freaking him out. A diplomatic solution was found to keep all parties happy by secretly disconnecting the faders and buttons within his reach and installing Dean next to him on the desk to actually mix the sound. The subterfuge worked, confirming Gerry's belief that he still had it in him to mix and Franco's belief that Gerry was a great mixer.

Sound Recordist on set

Chapter 16

Ed is sitting alone at the refreshment counter of the multiplex trying to hide his anxiety behind a vanilla milk shake. Looking around he sees more public arriving and herded in the direction of the test screening, trying to judge if they will be a sympathetic audience or not. The groups that formed the circles are now moving in a Brownian motion of particles, randomly in different directions, back and forth in increasing agitation, as the arrival of their holinesses is imminent. Apprehension and fear is in the air. They continue to have their mobile phones to their ears, more as comforting props, as few are actually using them. Only executives Pierre Alonso and John Mayer's voices can be heard,

> *'Walter, slow in traffic five blocks away.'*
> *'Abby North on Sepulveda.'*
> *'Walter, turning on Morrison.'*

Satyajit joins Ed at the counter, a coffee in his hand.

> *'I feel we should take cover, Satyajit. Incoming missiles.'*

Then to rub it in:

> *'Any last requests?'*

Satyajit, too nervous to speak, doesn't.

> *'Relax, it'll be fine, they just need the audience to tell them what they think.'*

Satyajit isn't convinced:

> *'They might take my film away from me.'*

Satyajit sips on his drink, nervously looking around him. Seeing him in such a state, Ed, on compassionate grounds, keeps his thoughts to himself:

'The worst scenario is they'll threaten, torture and beat you into submission and if the film still bombs, you'll be put in deep freeze for several years. They might defrost you some time in the future, give you a miniscule budget on a script no one else wants to do, and if you make a success of it,

138

they'll allow you to re-join the circus. It's all about credits, you see, Satyajit; you don't have enough with an Oscar for a short, my old chum. On the bright side, with a big hit, like Jaws, you'd be good for a few failures.'

Ed slurps up the last of the shake. The silence and the waiting continues. Satyajit trying for some humour:

'It's very bizarre if you think about it. They choose a simple boy from Bombay to direct very English story, disguised as a Western, to please Middle America. I'm not sure I trust their judgment.'

He laughs nervously. Ed continues with his thoughts:

'If it's trust you want, you're in the wrong business, Satyajit.'

Satyajit embraces Ed then joins a reconnecting circle. Pierre, Tom, Boyd and Kelly have regrouped. Boyd has his string cheese and macchiato. Pierre relays what he's been told by Walter's driver:

'Walter should be pulling up right now.'

Satyajit asks:

'Is he happy?'

Pierre relays this question to the driver:

'What's his mood?' *and then relays the answer:*

'He's eaten well, a good sign.'

John Mayer, the Paramount Executive who's been in contact with Abby's driver informs the group:

'Abby has just left her car.'

I met Sam Mendes when working on *Wings of the Dove*. He was hoping to direct a period film based on the book, *Morality Tale* for Stephen Evans at Renaissance Films. Very sharp, intelligent, articulate, confident, jocular, charming, boyish and persuasive, something about Orson Welles in appearance and manner; we referred to him as Orson Mendes in the *American Beauty* cutting room in the typically childish, irreverent manner cutting rooms do, and I'm sure had he known (perhaps he did?), he would have loved the comparison. More importantly, in terms of editor-director bonding, he was also a lover of cricket. *Morality Tale* never got made, at least not with Sam, but years later, he approached me to cut *American Beauty*, which I couldn't do at the time, being contracted to something else. Months passed, and out of the blue, I got a call

from him saying he was back in London completing the director's cut on the same film and would I be interested in taking over from Chris Greenbury who had committed to another project. It wasn't a film in trouble, as Sam was quick to point out and he was right. The work they had done was so good I wasn't sure if I was able to contribute anything at all. It had also been cut on Avid and to date I had only worked on Lightworks. Greenbury's assistant, Tracey Wadmore-Smith (I had worked with her on *Doomsday* and *Fatherland*) stayed on and PJ Harling was enlisted to help with the beginnings of my painful Avid experience which continues to this day. Notwithstanding all my reservations, we did manage to fill out the coming months with experimentation, particularly with the fantasy sequences, the front and end of the film, transpositions and choice of temp music.

There were still slightly comic remnants of the script, Lester Burnham (Kevin Spacey) in pyjamas and dressing gown flying Mary Poppins like above the street, which hit the proverbial cutting room floor pretty quickly. The Fitts house scene, where the three 'sit like strangers in an airport' watching television was moved back and forth and eventually forth to precede the Realtor Ballroom scene rather than follow it. Similarly, the post-coital motel scene 'I fire a gun' was moved earlier to follow Lester being hired at Mr Smiley's.

A montage sequence of Ricky and Jane (Wes Bentley and Thora Birch) making a video on Malibu Lake was considered redundant and deleted. Harder to compress was the ending. Beautifully shot, but overlong with a series of events (about forty shots), lasting a full ten minutes after the discovery of Lester's body. The released version lasted just over three minutes with only sixteen shots. Lost in this process was Colonel Fitts (Chris Cooper), discovering the tape implicating his son for the murder (Ricky asking Jane, "Want me to kill him for you?") and handing it over to Police Inspector Fleishman, then subsequent images of the trial and both Ricki and Jane's committal to prison. Lost too was Angela's (Mena Suvari) celebrity status as an eager witness to Ricki's obsession with dead things and then a glimpse of her promising career as a TV soap actress and finally Lester soaring into the clouds once more.

In the script, the story actually starts with Ricki in jail followed by numerous other scenes: Angela being questioned at the trial, Colonel Fitts bringing the damming tape to Inspector Fleishman's office, a tabloid news show being watched by Colonel Fitts showing the contents of the tape, and then back to Ricky in jail. These scenes, though shot, had already been deleted before I arrived, apart from a short extract from the tape, Ricky asking Jane, "Do you want me to kill him for you?" This remained in the film. Much of the temp music had been chosen by Sam, using primarily Thomas Newman soundtracks although the opening sequence was accompanied by, and cut to, Carl Orff's Gassenhauer. Many sequences were influenced by Newman's work (he is very much the go-to man for editors seeking temp music) and I think he made a huge impact on the editing and eventual success of the film.

As we approached the end of the director's cut, we upped sticks from London to the Lantana facility in Santa Monica: to carry on the great work, show the film to the DreamWorks hierarchy and to take notes and make changes. In this process, I didn't get to meet Stephen Spielberg, as he preferred to screen alone or with his executives; although some time later, I did pluck up the courage to introduce myself to him at the Oscars when he was in mid-conversation with Walter Parkes (Executive in charge of *American Beauty*), but I think they both thought I was a waiter.

In one visit to the DreamWorks offices, I reacquainted myself with Bob Cooper, the HBO chief who fired me years earlier. He was now working for DreamWorks. The conversation went along the lines, "Remember me? You fired me." It wasn't quite the Lester/Brad moment, 'my job consists of basically masking my contempt for the assholes in charge' but still somehow satisfying. I don't recall his reply but he seemed somewhat diminished in his new role as an employee.

Test screenings went reasonably well but gave little indication that the film would become the success it did. Scores were good but not off the chart. I remember in one screening upsetting the then DreamWorks marketing executive, Terry Press, by having the volume set too high[16]; one of her minions travelling back several rows to tell me I was distressing the poor lady's ears. Well, it was her show and not Sam's. At another screening, someone from the audience told Mendes not to change a frame. I would never hear those words again with a preview audience. Also at the same screening was an uninvited mouse, which seemed to settle at my feet. I lowered the sound just in case it was a Press agent in disguise!

I came to realise that in another incarnation, Sam would have made a very fine editor, that is, if he'd had the patience to sit in

[16] in test screenings a cable is run from the projection box to a volume controller attached to the arm of one of the seats, so that the operator, usually the editor, can control the audio level.

front of a screen all day, which, of course, he hadn't. Fizzing with ideas, he was itching to grab the computer mouse and do things himself but finding the Avid even more alien than I did, he was reluctantly happy to let me get on with it. In any event, he only had one hand free, the other being frequently massaged by a kneeling Tracey. Perhaps he kept his ego in his hand. With regards editing though, he was in his element, or at least in one of his many elements.

He had an office adjoining the cutting room with a connecting door. I'm an early starter but often he would be in before me and with the sound of activity in the cutting room, the door would open and the artful Mendes would bound in ready to bowl a few googlies[17]. Very irritating at times, because an editor needs time to pad up[18]: have a coffee, chew the cud with the assistants, re-view work done the previous day, make a few phone calls, check emails and prepare the mind to enter a state of flow by lighting candles and chanting for enlightenment (for the approaching day) and forgiveness (of ills perpetrated by the director). These rituals are important for the well-being of all editors. Ask yourself, do I feel lucky today?

Eventually, I couldn't resist locking the connecting door (the lock was on my side) just to force him to take the long way round. Water off a duck's back for Sam; once he had entered via the corridor, he would just unlock the connecting door without a word of rebuke and continue to work. Self-possessed, self-absorbed and arrogant at times, he is also very collaborative, imaginative, appreciative, encouraging and generous with a great sense of humour that extends to having the piss taken. So much of the praise for the editing of *American Beauty* that I and Chris Greenbury received, was down to him. I was very fortunate to inherit such a good film.

[17] cricket expression for an unexpected spin of the ball once bowled.
[18] leg protectors in cricket.

Chapter 17

John, Tom, Pierre, Boyd, and Satyajit all stand in line in readiness to be presented. John, still on the phone with Abby's driver,

> *'OK, she'll be coming through the door any moment.'*

Satyajit, unable to control his emotions any longer, glides almost weightless with arms outstretched across the floor towards her, announcing:

> *'I see her, I see her.'*

Pierre and Tom enjoy every second of Satyajit's anxiety.

Pierre: *'Is that what you'd call currying favour?'*

They watch as Satyajit and Abby embrace.

Tom: *'Are they kissing or stabbing each other in the back?'*

Pierre: *'Personally, I find it very moving.'*

As the hugging continues Walter enters but through doors on the other side. The line breaks, Tom and Pierre shooting off to greet Walter and family, leaving a conflicted Boyd not knowing in which direction to go.

Abby breaks free from the desperately clinging man,

> *'How are you, Satyajit?'*

Oil oozes out of every pore forming a slick around him.

> *'I hope you like my little film.'*
>
> *'Oh, we've heard such wonderful things, Satyajit,' she says, quite unconvincingly.*
>
> *'Really, really, what have you heard?'*
>
> *'You know...things...good things...from...people.'*
>
> *'People, really? People? Imagine that!'*

Walter brings his forces to meet with Abby's, collecting Boyd on the way. Boyd having decided his long-term interests lie with Walter. Walter and Abby exchange air kisses then embrace, Abby brushing away squashed particles of food from her clothing.

> *'Abby!'*

'Walter!'

Further greetings are exchanged and the group move towards the theatre.

'Someone get me popcorn, big bucket,' demands Walter.

The lower-ranking Pierre obliges and leaves.

'And I'll need to take a wiz before the show. P, check the bathroom's clear.'

On *Center State*, I was reunited with Nick Hytner again. I suspect he took the film on the rebound after being displaced on *Chicago*. In spite of his many months' work (fifteen I think), developing the project for executive producer Harvey Weinstein, Weinstein decided Rob Marshall was really his man; his philosophy of changing personnel now being applied to a director and without even a frame being shot! That disappointment and possibly a less than satisfying experience with Sony on *Center Stage* made his decision to turn his back on the film industry and run The National an easy one. Rather like John Cleese's, 'don't mention the war' sketch, one doesn't mention *Center Stage* in his company, which of course I do!

Nick (on the left) with Linda Murphy (Boom operator)

Nick (on the right) with Naomi Donne (Makeup Artist)

*Ballet Anwar with Adam Geiger, Saska Simpson and Armando Fente
(pictures courtesy of Sony Entertainment)*

I loved working on the film. The story about a group of young dancers in a New York ballet school was corny and hardly original, but the dance sequences were so beautifully staged, choreographed and shot, that it was a joy to cut. Dance sequences like action sequences always make the editing look good, even bad editing.

Music was one of many issues for Nick; having to appease Sony hierarchy by having to promote Sony Music songs in the film. I suspect *Come Baby Come*, *Cosmic Girl* and *Candy* wouldn't be on Hytner's Desert Island wish list.

Nick, not one to take producers gladly, and given to the occasional theatrical display of temperament, gave one of his best performances in the foyer of a suburban Los Angeles multiplex in a two-hander with producer Larry Mark. Following a test screening, the now nearly empty arena was theirs to appropriate and they used it to great effect. Both very articulate and excitable men of equal height, weight and persuasion, the verbal exchange was blistering in intensity and colour, as was the physical movement across the floor and into the car park, good elevation, a glissade here and there, grand jetés and evasive pirouettes. Mark (later, producer of *As Good As It Gets*) gave as good as he got, but I had to declare Hytner the winner *en pointes*.

Hytner/Mark pas de deux

Chapter 18

Entrance to the men's restroom. 'P', stands outside on sentry duty.

Walter, at the urinal, begins to pee...slowly. From one of the stalls, he hears vomiting. He growls,

"Fuck."

Then with double meaning,

"P!!!"

Paisley hears the distressed call, but its ambiguous nature and the possibility of being exposed to Walter's willy suggests discretion is the better part of valour. She remains on guard.

The vomiting continues, Walter increasingly agitated:

'Ugh, Jesus!'

The slow passing of water continues as it does with men of a certain age and benign prostate enlargement. A spider, dangling from above, catches his eye; it drops down perpendicularly towards his balding pate. He angles his head away, still focused on the intruder above but still managing his aim in the rough direction of the bowl. The spider drops further, almost to eye level. He blows at it, his breath sending it away for a moment before it arcs back on its thread towards him, he ducks, losing control of his pistol, the urine hitting the splash back and rebounding onto him.

"Oh fuck!"

The vomiting ceases. The spider crawls back up, retreating in acknowledgement of too big a prey.

Walter finally expresses the last drop and moving over to the washbasins, continues with his ablutions, giving himself a much-needed makeover: brushing off bits of food, washing his face and making the most of his remaining hair, fluffing it to give greater density. Studying his reflection in the mirror, it appears flushed; an emotional response to his very private moment being gate-crashed by both eight and two-legged creatures, to say nothing of the unwanted spray on his trousers.

Recovering from the ordeal, normal service is resumed; he likes what he sees, grunting in self-appreciation. Then leaves. The exit door bangs shut and we hear Walter lambasting 'P' as they move away down the lobby. When silence returns, Satyajit slowly emerges from the stall, still in some distress from vomiting but recovering. He moves over to the washbasins, rinses his mouth and takes up the same position as Walter staring at his reflection in the mirror. A man going to the gallows stares back at him.

The Oscars, the year *American Beauty* was nominated, were held at The Shrine Auditorium, a step up from The Dolby Theatre now used. I felt it was tacky then but it's even more so now. I felt totally out of place, a reluctant participant in a cheesy game show. If I won, would I break down in tears and thank Allah or El Shaddai, depending on whether I favoured my father's or my mother's religion on the day? Would I offer commiserations to my fellow nominees while actually delighting in their failure? Would I 'God bless England', in the way Americans do their country? (I could just imagine the sardonic reaction in the UK). Finally, should I thank my parents for having me and for my wife for doing the same? Or perhaps, indulging this fantasy a little further, throw in a recently learned time step (my wife used to tap dance), sing a song, or give a fashionably political speech. If I lost, would I go into an interminable sulk while maintaining an outward expression of joy for the winner? I did the latter.

A nomination has more to do with being attached to a successful or well-promoted film rather than any specific accomplishment. In my experience, best editing comes from working with very poor material (in terms of script, performance and shot footage) and making something worthwhile out of it. It isn't from working on great scripts with brilliant directors and with budgets and schedules long enough to give you all the time and angles an editor could wish for. The best work goes unnoticed; once upon a time 'best editing' was considered seamless but not anymore. Who knows what decisions were made in the cutting room and by whom anyway?

How 'hands on' was the director? How influential was the editor? What were the rushes like? None of these questions can be

answered, so the award is pretty meaningless. Admittedly, being nominated and winning is better than not, but shouldn't be treated as being anything other than being lucky. Sadly, subtlety in most categories goes unnoticed. Being 'noisy' in most categories does not.

The reality of the event is being herded like cattle (now like entering airport security), the waiting around, the forced conversations, the fake smiles, the phony interviews, the pretence of nonchalance and the sheer utter boredom of the ceremony itself. Then there is the packed Governors Ball after the event, where the shunned losers sit like wallflowers while watching the excited winners circulate with false modesty, waving their trophies in the air. Oh, the temptation to stick a leg out! Then there is the cold food and eventual escape from the building (rather like entering Oxford Street underground station in rush hour), to be followed by the waiting-in-line for your limo (one amongst hundreds circulating the area like pedalos), 'come in No 154'. In the weeks preceding the event you are feted with flowers, gifts and interviews. The minute after losing, you become an embarrassment.

The vacuousness is understandable, because to participate and survive the ordeal you really do need to enter a different level of consciousness, a trance-like state. The winners getting quick release from reverie on hearing their name and then, while in the process of recovery, delivering varying degrees of cringe-making speeches, dependent on their body metabolism; while the losers remain comatose until the door of their departing limousine slams shut.

However, as we heretics are reminded, the spectacle is good for the industry – attracting audiences and publicity. Promotion on this scale means good business: possibly the difference between profit and loss. One should be grateful and embrace the moment. Anyway, if other crew and cast are to be honoured then certainly editors should be amongst them.

Days after the Oscars, my failure notwithstanding, I was invited by Robert Miller, one of *The Crucible* producers, to meet Neal Slavin and Tom Adelman. It was an interview of sorts (in that the job was mine to lose) but conducted at a coffee shop al fresco, amongst the street entertainers of Third Street Promenade in Santa Monica. *Focus*, Arthur Miller's only novel was about to be made into a film, with Slavin directing, Adelman line producing and Miller Jnr. producing along with Slavin.

For Slavin, a highly respected stills photographer and commercials director, this would not only be his first film but the fulfilment of a lifelong ambition. Having read the book as a second year art student in the early sixties, he determined one day to direct it for the big screen; thirty-five years later, he was in a position to do so.

Slavin also brought the finance through a close friend of his, Michael Bloomberg, the billionaire business magnate, politician, philanthropist and ex-Mayor of New York City.

Bloomberg, with no particular interest in making films, liked the book (about social paranoia and anti-Semitism set in New York in the mid-forties) and felt confident enough in first-time film director Slavin to fund the project; initially with development money and then later by fully financing the whole production. Slavin's lack of filmmaking experience, however, was a cause for concern for Miller Sr, who procrastinated for two years before allowing him to buy the film rights. Neal's jubilation was somewhat tempered though, on hearing that if Miller didn't approve of the script, all would be lost, the film wouldn't get made. The script written by Kendrew Lascelles, was approved and a year or so later went into pre-production. Arthur's son, Robert Miller, having met Neal through a mutual friend was brought on to partner on the production as producer and hence my introduction.

Spooning with the director and producer!
(Picture courtesy of Saska Simpson)

During the shoot in Toronto (known as a body double for New York), I got news that Arthur would be dropping by the cutting room. I had briefly met him on *The Crucible*, but now he was coming to tea. Well, he came to the cutting room and was offered tea by my UK assistant, a star-struck Saska Simpson, but preferred water. Saska, a huge fan and student of his work at university, had spent the morning preparing speeches expressing her admiration and devotion but when the time came could only manage, "Can I get you something to drink, Mr Miller?" and that with some difficulty. However, I did pluck up the courage to ask for an autograph, at least not for me but a friend of my mother's; the first of only two occasions I have asked for an autograph, the second being from Alan Bennett on a future film, *Lady in the Van* (again for someone else). One just doesn't do that kind of thing!

Arthur was accompanied by his wife Inga (like Neal Slavin, an accomplished photographer), and Robert.

"Dad, this is Tariq."

"Dad, this is Saska."

"Dad, what would you like to see?"

Arthur Miller, a colossus in the literary world; Pulitzer prize winner for Drama; reluctant witness before the House Un-American Activities Committee; so much the public figure but here, just 'dad' to Robert.

For Robert, *Focus* was a second opportunity to impress his father and confirm, as with *The Crucible*, that Miller senior's work was indeed safe in Miller junior's hands. Both Inga and Arthur were warm and appreciative of the time given to them and approving of Robert and Neal's work.

With production at an end, we returned to Santa Monica to complete post. Sacrificed in this transfer was my assistant, Saska, who, not surprisingly, was unable to acquire a US work permit, galling in that American technicians are able to work in the UK with greater alacrity. Her replacement, Adam Geiger (*The Object of my Affection, Center Stage*), thankfully stepping across from New York to take over.

The carousel opening of the film, although scripted, hadn't been shot in Toronto, nor had various other elements for visual effects sequences.

With reference to the carousel, Arthur Miller writes: "He was in some sort of amusement park."

"Then before him stood a large carousel, strangely-coloured in green and purple patches."

The 'he' being character Lawrence Newman played by William Macy.

Initially intended as a place-holder, Neal used his own first generation Sony digital tape camera to shoot, hand held, the 1916 Looff carousel housed in the Looff Hippodrome on Santa Monica pier, once run by Henry Gondorf in *The Sting*, co-incidentally played by another Newman, Paul Newman.

Miller continues in his book:

"The brightly coloured carriages, all empty, were going in a circle."

For carriages read horses, shot imaginatively from every conceivable angle by 'cinematographer', Slavin, very much in his element with his eye to the viewfinder.

To represent the underbelly of the carousel, cogs and wheels were created by a prop company and once again lit and shot by Neal. These were intercut with the carousel footage to illustrate,

"Something was being manufactured beneath the carousel, and trying to imagine what it was he grew frightened."

The impressionistic nature of the sequence allowed for liberal use of the Lightworks visual effects tool: defocusing shots, bleaching out colours, zooming in and out and gradually accelerating the rotation of both horses and gears until derailment wakes Newman from his nightmare, a premonition of what was to come – the derailment of his life when he is wrongly taken for being Jewish.

We felt the sequence worked well enough technically, not to need re-shooting. Emboldened by that, Neal went on to use his camera to shoot other inserts, elevated train tracks and the bridge into Manhattan, saving the production a considerable amount of money.

The film wasn't particularly well promoted, but the timing of the release, October 17, 2001, couldn't have been worse. As part of its world premiere, the film was shown at the Toronto Film Festival on the 10th September, receiving enthusiastic applause from the Elgin Theatre audience; but the horrors of the next day, rendered much we consider important as an irrelevance.

With the world in a state of shock over the terrorist attacks, there was going to be a period of healing before an appetite for

moviegoing returned; theatre audiences dipped for several weeks before recovering to give an even higher box office average than the previous year.

Bloomberg's faith in Slavin was rewarded in terms of financing a picture of quality, but as a business enterprise, I suspect it was somewhat of a disappointment.

Reviews were favourable, Slavin's expressionistic style applauded, performances by William Macy, Laura Dern, David Paymer and Meat Loaf found approval and the film-noir camerawork of Juan Ruiz Anchía praised. Add to that Mark Adler's exquisite music, it really deserved bigger audiences.

The freedom given to Neal and then, by association, to me, was the closest I have got in the freelance world of moviemaking, to working at the BBC. The Bloomberg executives showed a paternal interest but were not in the least meddlesome; both 'Bob' Miller and Tom Adelman were a good-humoured encouraging rational presence and there were no audience test screenings. *Focus* has to be one of my most enjoyable experiences and the most disappointing in terms of recognition. Had the film been a box office success, Neal would have directed several other films by now, but as it stands, he is still waiting to make his second.

Not being offered work, he commissioned and developed a project of his own, an intriguing story based on a newspaper article he had read. *I Was a Military Complex* tells the true tale of a group of self-employed friends: an actress, a costume designer, a publisher and a writer, Arthur T Hadley. As a group, they set up a fictitious business, AT Hadley Tank Company in order to establish a line of credit. Their problems begin when the US government is fooled into believing the legitimacy of the company and start ordering tanks.

Being fooled wasn't the preserve of the US government as Neal went into partnership with a 'trusted' friend. A few years later, he no longer had the rights to the project, the 'trusted' friend did.

The experience of another director friend, Marcel Jejune (not his real name) is best told as a fairy tale…

Chapter 19

The audience has settled, the executives are seated. Ed sits on an end seat towards the back with the volume control taped to his left armrest. The volume control has a cable leading out the back, which runs along the floor and up into the projection box through an opening in one of the projection windows. Next to him sit Annie and Michael, both looking around at the audience, in particular, at a large black man who catches their eye or rather their ear, as he is on his mobile in loud conversation with someone.

Michael notices something else,

'Is that a m...m...m...mouse down there?'

Ed and Annie turn to look but don't see anything; Michael's stammering having given the mouse time to disappear.

Annie satisfied he is mistaken continues observing the audience. Ed observes her, thinking,

Annie Palmer, decorative, grounded but conflicted first assistant editor with designs on editing but equal designs on sleeping and shopping. Serially seduced and betrayed by that breed of shit, sorry, short film directors to edit for them with the promise of a 'long' film. But as is commonly known, first-time long film directors have shit short memories.

A few rows back, Abby Spear sits with John Mayer, who has a note pad and penlight at the ready. In the same row, but several empty seats along, Walter sits with his wife and mother-in-law. The seats between are marked 'reserved' but actually could be marked 'no man's land', acting as a buffer zone between these two colossi. Walter is consuming the biggest bucket of popcorn, spitting corn from his mouth like a cannon on a firing range. Immediately behind family Walter, sit Franco, Tom and Pierre.

Barry, an employee of the research department is about to address the audience. An audience occupied with eating and

drinking. Large buckets of popcorn, drinks, hot dogs and sweets are being consumed or dropped to the delight of the hungry unnoticed mouse.

Barry calls for everyone's attention and gives a speech he's made hundreds of times before.

'Good evening ladies and gentleman. My name is Barry and I would just like to say a few words before we start the show. First of all, thank you so much for coming and being part of this process. You are quite privileged, in that you are the first audience of this movie anywhere in the world and the makers of it would love to have your reactions. At the end of the screening, I would like to ask you to remain seated, as questionnaires will be handed out for you to fill in. I shall also be asking about twenty people to stay behind to form a focus group and run through the film with me. I would like to point out that I have no connection with the makers of this film whatsoever, so you can be totally candid with me about your responses. The film is a work in progress, so the sound may not be quite right and the colour may be all wrong, and the music you'll hear isn't going to be the final music, it's just a temporary score, but I assure you all these things will be ironed out when the film is finally released. So enjoy the movie. Oh, and finally, please switch off your pagers and cell phones.'

As the lights dim on the audience, Tom is aware that Satyajit isn't amongst them, whispering to Pierre,

"Where's our visionary?"

They both scan the seats around them. Tom gets up and leaves the theatre as the film is about to start. His feet crunch through the popcorn in the aisle, narrowly missing the fattening mouse, to emerge into the now nearly deserted foyer. He sets his eyes on the men's room. This too, on closer inspection, is empty.

◆

A Fairy Tale

**(Based on a true story of treachery. Names have been changed
to protect the guilty
– and the possibility of litigation)**

Once upon a time in Hollywoodland, there was a writer/director, Marcel Jejune, who set up a company to make films with a colleague, Micky Finn, who was sitting on a pile of money, into which he had fortuitously married.

Finn, who had earlier sponsored Jejune on his first award-winning film, needed a purpose to his life other than alcohol consumption and this new venture seemed just the ticket. Dolores, Finn's wealthy wife was pleased to see her husband happy and creatively involved in something other than alcohol. With a budget of around $4m, their first film under this new company went into pre-production – to be produced, written and directed by Jejune. To assist in managing the production, Jejune requested the help of an old and trusted friend, UK-based Tweedeldee. Tweedeldee, in turn, wanted to bring on his associate from the UK, Tweedeldum. Having a history of filmic naughtiness in the UK, and with a reputation for being bad people, Jejune was strongly advised against hiring these two opportunists but being jejune, he blithely continued on his course of action.

Dum and Dee needed work permits, so Jejune had the production pay for an immigration lawyer to start their Green Card process. Dum and Dee had their own camera equipment and technicians, offering Finn 'a good deal', which, on acceptance, they shipped to the US, in the process, negotiating themselves a very handsome fee. Dum and Dee had post-production facilities back in the UK too, for which they also negotiated a very handsome fee, persuading Finn of the necessity to complete post-production in the UK. Then there was a producing fee for the both of them and that was very handsome too.

Dee was getting on famously with Finn; they shared a drinking habit and liked each other very much. They started filming somewhere north of south, Dolores making the trip from LALA land to monitor the sobriety of her husband and see where her money was going. All seemed tickety-boo but with some casting issues, Jejune was persuaded by Dee to return to LA and do some casting, 'only you can do it'; Dolores also returned home at this time, content her money was being well spent and that all was well and sober in the family. However, Dolores had no sooner gone, than Finn returned to his favourite pastime, wetting his whistle, which had become decidedly dry through recent abstinence; and in Jejune's absence Dee felt emboldened to re-write the script, pointing out, to the now, three-sheets-to-the-wind Micky Finn, the failings of the writer/director, absent in LA, 'when he should be here', north of south.

Jejune returned, objecting to the re-writes but Dee now had Finn bottled up, and, in fact, Dee was now the producer Jejune used to be. Dee's staff, yes, he now had staff, started writing too: the first assistant director started writing; a script doctor was hired to write; even dumb Dum was writing; it had become a festival of human writes, so in the spirit of collaboration, even Jejune was asked to re-write the re-writes of the re-writes. But it was no longer the film Jejune had written, he was very sad but continued to work, because

to walk out would have been financially crippling. There was discontent on the set with the cast confused and unsettled but they, like Jejune, needed to work, so stoically they too continued. Tweedeldee then decided that he didn't like some of the crew, particularly the ones hired by Jejune, and fired them; and wasn't Jejune being paid too much? He asked him to take a pay cut, Jejune refused. Jejune struggled to make sense of his life and the ever-changing script. He tried to make it work, finding ways to incorporate the new script with scenes shot prior to the re-writes. Meanwhile Dum and Dee, in need of rest and recuperation, made 1st class trips back to the UK, returning with family to rented accommodation north of south – all costs on the production. Jejune then started filming script not approved by the Tweedels, Dum and Dee, who were very, very angry, bouncing up and down as Tweedels do; didn't he know this was now their film and Jejune just a hired hand? They warned Jejune to behave or else! Jejune didn't behave and the night before the Thanksgiving break, 'or else' happened. Dee arrived at Jejune's hotel door and fired him. The first assistant director was now the director and writer, although he too was discarded during post in the UK, leaving Tweedeldum and Tweedeldee in full control, because Micky Finn had been away with the fairies for some time. The cost of the completed film rose to $8m. The film didn't get a release! Tweedeldum and Tweedeldee now have Green Cards and still make bad films.

Mickey Finn was last seen alone in a coffee shop in Hollywood, his Bentley parked outside. He is still married to Dolores.

Jejune hasn't directed a film since.

Chapter 20

The screening is in progress. On screen in a Tucson bar, Harry and Jack, two men in uniform are discussing their fear of fighting. Ed has his hand on the volume control, adjusting the sound in both directions with small movements. He observes the frequent comings and goings of the audience, counting them out and in hope, counting them all back in again.

John, sitting next to Abby, is taking notes from her,

> *'Bar sequence too slow, cut out pauses.*
>
> *Too many lingering looks, we feel the anxiety of the audience.*
>
> *Is there any other coverage?*
>
> *More close-ups, no energy!*
>
> *Confusion!*
>
> *Consider cutting scene.*
>
> *Slow! Slow! Slow!'*

Walter, mouth full of popcorn, watches John taking notes. He grunts, displacing popcorn from the vicinity of his mouth onto the floor, to be nibbled gratefully by the mouse. On screen, we now see the interior of an army barracks, Harry sitting alone in contemplation. His movements have been slowed to enhance this moment of reflection. Bizarre Hindi music accompanies this scene, causing Golda, Walter's mother-in-law some discomfort, she whispers to her daughter Annette, who in turn, whispers to Walter.

> "Ma says she hates the music."

Walter acknowledges her comment by spitting out a shower of even more corn. Franco, quick to distance himself from the overheard comment leans forward and whispers into Walter's ear,

> "This isn't my music."

Walter ignores him but Annette turns and smiles. Franco takes the opportunity to introduce himself,

> "Oscar-winning composer, Franco Totti."

She acknowledges the introduction with a pained smile.
Tom and Pierre spellbound by the snow machine in front of them confide with each other,
 "What do you think?"
 "I think he likes the popcorn."

Fired again! With hindsight, accepting *Four Feathers* was a really bad decision. A year's work erased, along with my credit (the latter my decision). I had an opportunity to bail out before the start of production because Sam Mendes had asked me to cut *Road to Perdition,* but having already agreed to *Four Feathers,* I couldn't jump ship. Later, director Shekhar Kapur informed me that an editor swap had been under consideration; Jill Bilcock, who had worked with Kapur on *Elizabeth,* being transfer listed along with me. More irksome was the fact that I loved *Perdition,* whereas *Four Feathers* was poor, both in my cut and after a further year with my replacement, equally as poor. I liked Shekhar a lot initially, and his wife cooked great curries which, in post-production, he brought to the cutting room for everyone's pleasure. His film *Bandit Queen* was impressive and he appeared to have a vision for *Four Feathers* which he articulated with enthusiasm and authority, having done a great deal of research, almost a thesis on the subject, confirmed by a massive file he showed me. The film was completely storyboarded[19] by him and seemingly under control, so I felt in safe, strong and confident hands. Two studios were involved: Miramax (Harvey Weinstein once again) and Paramount (Sherry Lansing and Stanley Jaffe). Jaffe was at my initial meeting/interview but then strangely disappeared off the scene. Off the scene too, was the friendly face of David Parfitt. Originally, one of the producers of *Four Feathers*, he was given an audience in Rome with the other pope, Harvey, and informed that he was now to be deployed on Harvey's other project, *Gangs of New York;* Scorsese's epic being in dire need of an enforcer, the film running way over-schedule and budget.

During the assembly and throughout most of the director's cut, the producers kept their distance. The shoot was pretty uneventful

[19] Artist's sketches of all the shots planned; camera movement being indicated with arrows. Sometimes these sketches include lines of dialogue.

apart from one or two incidences of unscripted hostile fire between me and the DOP, Robert Richardson. Richardson was given to varying the camera speed at will, without giving any written indication of doing so, making life very difficult for my assistants in the syncing process. We appealed to the camera assistant but she informed us apologetically that Bob had no inclination to be cooperative: in fact, was deliberately being obstructive. However, he was a giver in another sense, in that he was given to giving me editing notes (this is not usual practice), which I occasionally read along with the slate number on the clapperboard.

Hiding my true anger, I sent him an email threatening to fly out to Morocco to put his creative lights out, unless he changed his ways. I copied my agent in LA in case Bob didn't receive my email (at that time we had the same agent), and somehow it was read by Richardson's wife, who naturally concerned, wanted to know what was going on? For Richardson, admittedly a fine photographer, a multi-award winner and very much the Chosen One in many people's eyes, and possibly his own, an irate fellow technician giving him grief for something he had done, was not only an irrelevance but a way of life.

I did make it to a desert location eventually and the bad Bob had now become the good Bob, not through my presence, but the absence of his; when there was fleeting contact, no reference was made to the email.

I arrived the evening before a two-day shooting break, so there was much letting down of hair in the hotel, which the unit occupied almost exclusively. Bob had retreated to his room to recharge his mischief-making or more kindly just to recharge, but Shekhar, relieving some of the pressure he was under with this army of people under his command, stayed to entertain the troops with a good impersonation of dancing, both on the floor and tables accompanied by vocals I wouldn't care to repeat. Trying so hard to be one of the gang, it was hard not to be endeared by him. To relax and 'to think', Shekhar would ride into the desert, sometimes alone, sometimes returning to invite Richardson. On one such occasion someone on the crew was heard to say, 'Oh look, the director has forgotten his brain'.

On location, I was disappointed not to re-unite with script supervisor Angela Allen (*Tea with Mussolini*). Angela had departed the production, being fired a few weeks into filming; the first and

only time in a career spanning over sixty years that had happened. Prior to the unit move into the desert, Angela answered a knock on her hotel door, to be told by the production manager, "Don't bother packing, you're not coming with us."

It wouldn't have been for incompetence; perhaps her frankness was too much for Shekhar to take. In any event, she wasn't given a reason for her dismissal, or informed who was behind it, as I discovered when meeting her later in London. In producers and director, *Feathers* had an Agatha Christie of characters who could have initiated her departure.

Making fleeting visits to set, it's easy to make poorly informed judgments but I did wonder whether this juggernaut of an enterprise would have just kept on rolling with or without a director.

My visit was timed for non-work days so that I could have Shekhar's undivided attention; non-work days meaning the unit can get away to catch up on sleep or recreation, or just to get away from each other.

My pilgrimage into the desert (two flights including a stop over and a three hour car drive into the desert) to touch base with my Muhammad, was ostensibly work essential but as it turned out, just a jolly. I had brought the latest assembly on DVD, to discuss any concerns that I had, and to take notes. My biggest concern centred around Wes Bentley's stilted English accent. I felt he was concentrating so hard on getting it right that his performance was suffering; too stiff in the upper lip!

I showed Shekhar the cut footage and he agreed it was worth addressing the issue with a quiet word to the actor, but he felt that it might be better coming from me as I sort of knew Wes from *American Beauty* days. In the end I didn't, Shekhar realising that Bentley wouldn't take kindly to taking direction from me, and that his own authority might well be undermined by my doing so. I didn't spend further time with him as he was exhausted and had homework to do for the coming week of battles with studio, story, craft and crew. Who'd be a director? I, on the other hand, rode into the desert on a camel, without my brain.

The start of post-production back in London was enjoyable. Shekhar was more relaxed and engaged, engaged in the work and engaging socially. A gently spoken, warm, prepossessing and philosophical man, I thought more suited to a life in Academia, teaching and writing than directing. We shared a similar sense of

humour, a similar sense of the film – agreeing on most editorial
decisions – and to cap it all, we even shared a country and year of
birth. He was also related to the famous Anand family: Uncle
Chetan Anand having directed my father in *Neecha Nagar*, winner
of the Palme D'or at the first Cannes Film Festival in 1946. A
marriage made in Dean Street. We tried this and that, moved scenes
around, deleted others, tried alternative takes, toyed with music, all
the things editors do; and enjoyed the curries. The editing team of
myself and assistants Saska Simpson and Lisa Clifford-Owen had
now expanded to include sound editor, Tim Hands and assistant
Jack Whittaker, who were starting to do preparation work for the
sound mix further down the line. One big happy family, which even
included Harvey's boys in London, the always entertaining caustic
duo of Paul Feldsher and Allon Reich.

The director's cut, as it now was, was available to be unveiled
to the big boys. A period of time then passed with viewings, notes,
more viewings, more notes until it was deemed the film was ready
for test screenings. My eventual undoing was an audience screening
at Paramount Studios, the home of Sherry Lansing. It didn't go
particularly well, the scores were low. The questionnaires revealed a
lot of creative writing, mostly negative. Not particularly original
was a response to 'what did you like most about the film?', which
was 'the fucking end!' Another response, 'a pity it wasn't called

Two Feathers, because it would have been half as long'. The plot wasn't liked, the characters not liked, the music not liked, the pacing not liked, nothing liked apart from, of course, photography!

On return to the UK, days passed in silence while the gods deliberated the best way forward. Before I knew it, the furniture truck had arrived and the best way forward was naturally without me; I was to follow Ange out of the door. The marriage made in Dean Street was now becoming a divorce and most annoyingly without a settlement! When Kapur came to offer his condolences, it was a familiar speech and one I was to hear yet again ten years later, "I am so sorry, there was nothing I could do. Your work has been fantastic, you're a great editor, and I hope we can work together again." The kind of platitudes familiar to all replaced editors delivered by producers and directors, not totally disingenuous but more in hope of alleviating some of their own guilt. I was miffed and perhaps with too much vitriol, expressed my miffedness to his face. He retreated from the spat much the injured party; the guilt had become mine.

I tried to find some solace in a note from Harvey, although his deep sorrow at my departure was delivered in the form of a fax, which had been plonked, unceremoniously on my desk after being spat out of the fax machine. Call me precious but I didn't think a fax was quite befitting my grief. The original wasn't even hand-written! Nor was it accompanied with a bouquet of flowers, a packet of M&Ms, nor even a Tribeca Zucker's bagel (considered to be one of the best in New York).

Sherry Lansing at least phoned my home, using her very own voice, and left a message; I wasn't there to take the call. It expressed the same sentiments of deep sorrow but adding, if I wanted to talk about it I should call her back. I didn't call her back not knowing what to say, but I can't deny being moved by her offer.

Shekhar blamed the studios and they blamed Shekhar and the truth was probably somewhere in-between. I was replaced and my replacement flown in from LA along with his assistant. They were given the full flower treatment, financial and otherwise and the immeasurable Harvey love I so longed for. The new broom swept Shekhar from the cutting room, hopefully missing out on the delicious curry lunches and more than doubled the size of his empire but in the process banished Saska, my first assistant to a newly scheduled night shift. With further humiliations from the

editor and his assistant, 'Are you still here?', Saska left. His patron, Harvey, would have been so proud.

The rest of my assembled team, heads down, wisely stayed in place, because many, many, months of paid work lay ahead.

After another year of day and presumably night shifts, the new remodelled film was released to the world... and bombed. Schadenfreude! Said to have cost $80m, it grossed $18m worldwide. Somebody lost a lot of money.

Many years later, when Harvey invited me to breakfast (he did love me after all) the subject turned to *Four Feathers*, and I expressed the sacrilegious view that his re-cut was a wrecking ball. For a man known not to shy away from confrontation this challenge could have been met with a grenade of expletives, or at the very least, the presentation of the breakfast bill: but he did neither, defending the re-cut and his wunderkind 'fresh eye' with the controlled passion of a father defending his son. His argument being that my cut, as it had become, would have bombed even more than his. In military speak, I was just collateral damage in the process of damage limitation.

Second Assistant Director on set

Chapter 21

Inside the projection booth, Marlene and Howey, satisfied that all is going well, are relaxing by having their customary food break. They sit at a small table in the corner of the room, with Marlene pouring herself a coffee from a flask and Howey, opening a huge pizza box, his eyes on a small TV on the wall showing a basketball match. The sound feed from the theatre is turned low, so as not to disturb the basketball commentary. The picture unwinds from the platter, makes its long precarious snaking journey over the pulleys and is then swallowed briefly by the projector only to then re-emerge, returning to the platter once again. The sound reel following a similar path on its own projector.

Outside the multiplex, close to the entrance, sits Satyajit cross-legged on a bench, deep in meditation.

In the theatre, the scene seen back in Soho of the couple making love is now on screen. Off screen, a phone rings. The rings can be traced to the big black man, who takes the call,

> *'Yeah. Yeah. I got that.*
> *What? I can't hear ya!*
> *What?*
> *Um, yeah, yeah.*
> *No, I tell ya what to do.*
> *Tell him no sale, got that?*
> *No sale.*
> *Yeah. Yeah.*
> *Bye.'*

There is commotion around the black man but there's no one with the courage to take him on.

Shekhar returning to the theatre almost collides with another man on his way out. He stops and watches as a female researcher armed with clipboard, asks the 'walk out' his reasons for leaving? He responds briefly, 'Cos it's shit man!'

Overhearing this, the crest-fallen director stands rooted to the spot, uncertain in which direction to move, in or out?

◆

The highlight of *Sylvia* was being on location in New Zealand. My first visit to the lower hemisphere and an opportunity for the missus to catch up with rellies and friends in New Zealand and Australia. It was the year of the 2003 America's Cup in Auckland and our tenth-floor rented flat gave us a grandstand view of the marina and boathouses for the various teams. Our stay coincided with the latter stages of the event, and in spite of the Kiwis losing, it was great to be part of the party atmosphere.

No party atmosphere working on the film though, being a largely depressing story of the breakdown in the relationship between poets Sylvia Plath (Gwyneth Paltrow) and Ted Hughes (Daniel Craig), which eventually leads to her suicide.

Fortunately, there were no suicides in the making of the film but my relationship with director Christine Jeffs, if not quite mirroring that of Plath and Hughes, was an uneasy one. Christine was hired by producer Alison Owen on the strength of her first feature length film, *Rain*; a film I subsequently watched and thought quite poor.

Apart from questioning Christine's credentials, I was also concerned that Christine, on happily informing me that she had been an editor, would just want someone to push buttons for her, but that fear was allayed by some research, which didn't throw up any significant editing credits.

I was wrong to question her directing abilities though, as the rushes were very good, indicating that she knew what she was doing with this tragic story.

During the shoot, the cutting room was set up in a facility house in Auckland, a hotbed of gossip with Tom Cruise also filming *The Last Samurai* in New Zealand. One of the many stories filtering through the building, centred on his crew being given colour-coded shirts and only those of a certain colour being allowed to address or make eye-contact with the Hollywood A-lister; I'm sure no more than malicious gossip about an Operating Thetan.

On wrapping, we moved into a vacant room above an estate agent's office in the small town of Warkworth, about an hour's drive north of Auckland. This, because we (my assistant Saska and

I) would be closer to Christine's home, just a fifteen minute drive away. We set up the two sets of equipment (the assistant's and mine) at each end of a longish room. We then had a delivery of an enormous armchair from Christine's home, which being too big for the room we put in the hall. The next day, our first day of working together, started badly. Jeffs arrived, looked at the arrangement of the room and declared, "This isn't going to work!" The assistant's station and assistant were moved out into the hall and the armchair brought in and placed centre-stage like a throne, about 12 feet back from the screen and me; a chariot configuration, with the horse being me. I looked for the whip.

I found editing with Christine difficult. I was being asked to make bizarre edits and became petulant, "Well, if that's what you really want, I'll do it, but I'm taking my name off the film," to which she responded, "Don't be so old school," (red flag to an old bull). New school being deliberately cutting scenes out of sync or playing a whole scene visually on Ted and Sylvia just staring at each other while hearing the audio of their dialogue running over their faces. Christine might well have been ahead of her time, a super impressionistic approach.

She brought a selection of music with her to audition for use with the edit, which I didn't like, but neither did she like my choices. With very bad grace and on a regular basis, I made further protests in the style of John McEnroe, "You really can't be serious?" which were met with remarkable equilibrium on her part; a steely silence when a code violation or spanking would have been much more appropriate and perhaps more interesting. Saska would discretely disappear for lengthy periods, ostensibly to get coffee but in reality to get away from bickering children.

The atmosphere was toxic on a daily basis, so much so that Christine took Saska aside, to ask if I always behaved this badly. We were two like-poles repelling each other. I couldn't have complained if I had been fired but as far as I know Christine never held up the red card. Quite how we managed to complete the film together is beyond me, perhaps a tribute to both Allison and co-producer Neris Thomas' delicate handling of the situation.

The beauty of the freelance world is that however much of an ordeal a production is, you know it won't last forever. With the start of something new, the previous negativity is replaced with optimism, enthusiasm and excitement, and in my case, that came in the shape of a director I had always admired while at the BBC, Richard Eyre; now Sir Richard Eyre after his ten year stint at the National Theatre. Nick Hytner was to follow Richard into the National and I imagine Sam Mendes in time will do the same. I doubt if Sam's competitive drive would allow his two friends to have something over on him, a Knighthood, which seems a given with the job. All three high achievers: in education (all three at Cambridge), theatre, musicals and film, and for Richard and Nick, opera. In Richard's case, add TV and author of books and screenplays. Nick has also recently authored a book. With that kind of CV, one would imagine Richard to have the strut of a peacock and to be quite intimidating to work with, but on the contrary: his own self-doubt, 'the grit in the oyster' as he puts it, allows for an openness and willingness to consider other people's ideas and points of view. Self-doubt is with us all in varying degrees but of the three (Sam, Nick and Richard) most apparent in Richard and least in Sam. If he has doubt in himself, he shows every confidence in those around him, and he did so with me on both his films, *Stage Beauty* and *The Other Man*. *Stage Beauty*, a romantic drama set in the 17th century about dresser Maria's (Claire Danes) aspirations to act female parts (forbidden by law), hitherto the domain of leading actor, Kynaston (Billy Crudup). King Charles II (Rupert Everett) is persuaded by his mistress Nell (Zoe Tapper) to lift the ban thereby giving Maria her opportunity and the inevitable conflict with Kynaston.

As with *Madness*, I was let loose to direct 2nd unit and as with *Madness* it was no more than horse and carriage up and past. Of course, I tried to build my part but Richard, like Nick, was very delicate in requesting I cut down my over-indulged sequences to

half their length. Much of the temp music came from an Afro Celt album, which surprisingly worked with this period film. It was an unusual choice, but Richard responded to it emotionally setting aside an intellectual argument for dismissing it.

Significantly for me, this temp music was instrumental in my being asked to cut Robert De Niro's, *The Good Shepherd*. On finishing the director's cut in London, we took the film to New York for a screening at TriBeCa Films for De Niro and his company partner, Jane Rosenthal; TriBeCa being one of the co-producers. Richard, having to take a later flight, wasn't able to make the screening, so I had what can only be described as the thrill of showing the film to this great actor and Jane Rosenthal myself. I had transported myself through the projection spyglass window at Shepperton forty years earlier into the same space as Gregory Peck. It had taken forty years but I had been forced to overcome my shyness.

I sat at the back of the near-empty theatre behind the console, with De Niro next to me and Jane to his left. They were both warm and welcoming. I recall being mesmerised as De Niro produced three cell phones and arranged them methodically (like Nadal and his bottles of water) on the desk in front of him.

At the conclusion of the film, there was the usual awkward silence but quickly followed by words of praise from Jane. She then asked Bob for his thoughts, and after a moment's deliberation, he said, moving his arms for emphasis:

"Yeah, yeah it's great, it's great, great. You have a bit of this, and you have a bit of that, and then there's this King guy thrown in and then you have more of this and that. Yeah it's a great movie."

Like me, a man of few words; I loved him. They disappeared to their offices a few floors above the theatre and I waited for Richard's arrival in the street. Taking the lift down, I reflected on my last visit here to show the Weinsteins, *Wings of The Dove*; Miramax was housed in the same building. Should the doors open on the Weinsteins facing me, how could I avoid making eye contact with Bob Weinstein? Softley's warning had had a profound effect on me. I exited, head down like a fugitive, into the not so fresh Tribeca air.

When Richard did arrive he asked what De Niro thought of the film, and in reply, I said, without elaborating that he thought it was 'great'. Richard, always expecting the worst but now with spirits lifted, left me to hear what he hoped would be a eulogy on his work. On returning from Bob's office, I asked him what he said. Richard replied,

> *"He said it was great, great, great. You have a bit of this, and you have a bit of that, and then there's this King guy thrown in and then you have more of this and that. Yeah it's a great film."*

We were both euphoric.

Sometime later, when De Niro approached me to cut *Good Shepherd*, we arranged to meet at the Bel Air Hotel in LA. I hadn't seen him since that first screening of *Stage Beauty,* so I didn't know what to expect.

The normal routine for these things is to go well prepared (having read and re-read the script, so that likes and dislikes can be discussed), make suggestions, fool yourself or rather be fooled into believing you've got the job, exchange platitudes, then leave. Being fooled is part of the ritual, with directors hinting at a marriage to each person they interview. A recording of some of these interviews could land directors with a breach of promise.

If the job is yours, you know pretty quickly, if not, you're left in ignorance. I'm still waiting to hear on films I interviewed for several years ago. It's probably better to err on the discrete side by saying what the directors like to hear, but a colleague of mine, when asked what he considered the role of the editor to be, replied with admirable honesty, "I see myself as a redirector."

Not quite relating to interview etiquette, but relating to editors saying it like it is, Lou Lombardi, when asked to comment on two distinguished directors (admittedly a long time after working with them) said, "Peckinpah is a prick, Altman is a cunt."

My 'redirecting' colleague didn't get the film, but with interviews, I think one can tell pretty quickly whether there is genuine interest in being hired or just being part of the process: similar to getting quotes for fixing a boiler. I imagine my colleague felt it was a lost cause and spoke his mind as I did when interviewed for Thomas Vinterberg's *Far From the Madding Crowd.* I had done my homework, even re-watched the Schlesinger version and tried to summon up some enthusiasm when meeting Vinterberg and

producer Andrew MacDonald. I loved the old version when first released but now it seemed decidedly clunky; perhaps a reason for remaking it.

I failed to disguise my negativity, further killing any hope of getting the film when mentioning that one particular scene (wealthy farmer Boldwood arrives at a festive dinner being given by Bathsheba and joins in a sing-song,) reminded me of a similar scene in *Airplane,* where air stewardess Randy borrows a Nun's guitar to cheer-up sick girl Lisa as the plane is about to crash. Danish Vinterberg, unlike English producer Andrew MacDonald, didn't find this observation at least funny or helpful, informing me that my comments had depressed him to the point of not wanting to make the film anymore. Thankfully, he recovered his equilibrium to make a successful film.

But De Niro wasn't interviewing me for the job, he had already told me he wanted me partly because he was impressed with the temp music in *Stage Beauty*. In fact, I don't even recall talking about the script or him even asking me what I thought of it. Being of similar introvert personalities, we were both equally awkward, but, fortunately, there was a 'third person' in the room in the shape of a TV, showing a basketball match and eating up the silences.

The anticipated start of *Good Shepherd* was delayed by several months enabling me to work on HBO's *Mrs Harris.*

Caterer on set

Chapter 22

Howey has finished his pizza, washing down the last remnants with root beer. He tries to interest Marlene in the basketball match with loud shouts of approval or dismay, depending on the performance of his team, but she is engrossed in the Enquirer magazine with the news that Prince Charles is a transvestite. Unnoticed by them, Satyajit enters the booth and walks down towards them looking through the various spyglasses at the films below until finding his own. He sees Howey and Marlene,

 'How's it going, boys?'

Marlene casually looks up at this intruder.

 'You're not allowed in here. Can we help you?'

 'I'm the director.'

 'Yeah? Well I'm the charm department, honey.'

Marlene returns to Prince Charles, not in the least impressed but Howey perks up,

 'No kidding. Which film?'

Satyajit points in the direction of the projector closest to them, Howey acknowledges,

 'No kidding, we don't get you guys coming back here as a rule. You look like a director.'

 'Oh, thank you.'

 'You got a great movie.'

A huge smile beams across Satyajit's face.

 'Really? It's my first western movie.'

 'No kidding. Marlene, it's his first western movie.'

Marlene continues reading, but without looking up attempts interest,

 'Is that right? What d'you know?'

But Howey is genuinely impressed,

 'That's it. You'd never know. I got to hand it to you. You'd never know.'

Satyajit feels the need to clarify,

> *'Not just "Western bang, bang, stick up your hands", but Hollywood…'*

> *'Yeah, yeah, I understand. Here, let me give you some cards, you know, if ever you need my help back in your country. I hear you people make more films than we do?'*

Howey reaches into his pocket and gives Satyajit some cards.

> *'Oh, thank you. God bless you. So you like my little movie?'*

> *'Fantastic. Blown away. You'd never know, you know what I mean?'*

Satyajit, not knowing what he means but translates it as a compliment,

> *'You never know.'*

Satyajit moves away to the spyglass to be 'blown away'. Muttering to himself,

> *'Real people. Real people like my film.'*

As he passes the platter and approaches the projector, his arm slightly displaces the film on the rollers which begin to rock dangerously. No one notices.

◆

My contribution to *Mrs Harris*, an HBO film based on the brutal murder of Cardiologist Herman Tarnower, proved to be short lived, no more than an uncredited 'walk-on' part. Written and directed by UK-based writer, Phyllis Nagy, the film was being shot in LA with the intention of completing in London. But within a few weeks of starting, I was shown the exit. This was now for the third time, these misfortunes now bordering on the careless. For my UK assistant, Saska, it was an even shorter appearance. On the day of my dismissal, she arrived in LA all bright-eyed and bushy-tailed, ready to do the hand over from my US assistant, only to be told to get the flight back.

I was hired belatedly and met the first-time director for a chat and cup of tea at her rented accommodation in LA, just days before shooting. She seemed pleasant enough, although a little fey and otherworldly.

I followed her around the garden, attentive to her every word, the sun's rays playing on her gossamer wings as she floated inches

above the ground. It was an ethereal moment; I felt an inner peace as I swallowed her oxidised Oolong tea.

The script was interesting with Annette Bening and Ben Kingsley in the leading roles and HBO Films was now being run by someone I knew, Colin Callender, the executive in charge on *The Doomsday Gun*. Having had a successful career running HBO Showcase in New York, he was appointed as Bob Cooper's successor in LA, President of HBO Original Movies no less.

At the start of production, like all the Heads of Department, I received my goody bag from HBO, including a beautiful white dressing gown – so the comfort level was high (apart from being told, in a memo to all cast and crew, that Ben Kingsley was to be addressed as 'Sir Ben Kingsley'). Oh dear, those rumours were true!

The material came in, I assembled, making occasional visits to the set to give positive feedback to the director and crew, presenting a smiley face in public, as one has to, while saving expressions of concerns for more private moments with the director. The problems started with the first of these private moments. As we approached a non-filming weekend, I suggested to Phyllis that she should come to the cutting room to watch the assembly with me as I had some reservations I wanted to share with her. I had made two versions of the cut so far, one faithful to the script, the other with a degree of re-ordering and unscripted intercutting. She came in and at the end of the viewing of the scripted version voiced her thrill and excitement at the assembly. I possibly should have left it there, with the contented director skipping off happily into the sunset, but being hostage to fortune, I then showed her the second version, after explaining why I didn't feel the scripted version worked. The end of this second viewing was met with total silence, the air was charged, the static electricity bristling the hair on my arms and curiously raising the short hairs on her head to the vertical. The effect of my cut on her was so traumatic that she was in some sort of paralysis of mind and mouth; possibly an episode of situation anxiety. But before I could call for medical attention, she upped and left, leaving the room several degrees colder than when she entered. She obviously hated my alternative cut, along with the thought processes behind it, but instead of a mature discussion, retreated into a juvenile sulk.

Later that day, I received a call from Liz Karlsen requesting I meet her and another producer, the highly acclaimed New York

based Christine Vachon, first thing Monday morning at their office. Vachon, part of the New Queer Cinema of cutting-edge gay films is a daunting lady; a pocket battleship. Her short and chubby stature, close-cropped spikey dark hair and no-nonsense facial expression, presented an intimidating figure. Her known passionate and unconditional support of her directors had only one consequence for me: I was back at school being told to go the Head's office to receive punishment for some sort of misdemeanour. A slap on the wrist, detention, suspension or more probably expulsion?

Drawing by Katrina Annan

The meeting was beautifully orchestrated. I was kept waiting in the outer office until granted permission to enter. The room appeared dark. They sat, backs to a window, with Venetian blinds half drawn, the sunlight playing on me through the slats giving the impression of a marked man. They appeared to be in a raised position, like Louis B. Mayer's desk at MGM but this, and the fact they were both in black, might be a false memory or a consequence

of the low lighting; or a nod to melodrama. I also had the illusion of them both knitting. I was Sydney Carlton facing Madame Defarge in *A Tale of Two Cities*, watching my name being stitched onto a garment with cold-blooded dispassion; Vachon's producing company was named Killer Films after all! Vachon took the floor but remarkably remained seated in doing so. Karlsen sat alongside Vachon trying hard to show a united front (although, I suspect, sharing my discomfort) and Phyllis, albeit absent in body very much present in fairy spirit.

I had sinned against their precious charge Nagy	'T'
Their flower had needed cherishing	'A'
And cultivating	'R'
With love, care and tenderness	'I'
And not uprooted by some ignorant oaf	'Q'

It was a similar rebuke my wife gave me when I tore up the Californian Poppies in the garden thinking they were weeds. My UK agent, Mamy, later confirmed that I had been a failure in the nurturing stakes. So, with much regret, I was 'going to be let go', a familiar phrase suggesting a degree of pain for the executioners. I didn't speak to Phyllis again, or sadly but typically, hear a word of commiseration from any of the floor crew I had befriended; such is human nature.

Following my departure, several editors (all male) came and went, presumably also failing to provide the necessary mothering for this very needy director. Thankfully, my feelings of failure and despondency were lifted by a very humorous exchange of emails with SIR Richard Eyre, whose observations on my experience were very insightful, witty, supportive and unprintable.

The three ladies re-united many years later (Nagy as writer only), alongside the Weinsteins to make *Carol.*

Chapter 23

On screen, the picture seems to slip and then, thankfully, regain its composure. Ed and Annie look at each other, hearts beginning to pound, this isn't good. The scene we are watching is high on melodrama.

We are on the lake with Charlotte being rowed by James. Hindi music accompanies the scene.

Charlotte: *'RUB MY NOSE WITH YOURS? YOU KNOW YOU DO IT WITH SUCH FREQUENCY THAT I'M WONDERING IF IT'S SOME SORT OF FETISH, AND PERHAPS YOU HAVE OTHERS I SHOULD KNOW ABOUT?'*

He stops rowing to rub noses with her. Then continues to row.

'EVERYTHING WAS ALMOST PERFECT, WASN'T IT JAMES?'

James: *'YES, IT WAS CHARLOTTE.'*

Charlotte: *'I THINK EVEN THE HINDU GODS ARE JEALOUS OF US. WORSE THAN THE GODS WERE MY FRIENDS.'*

James: *'DON'T PUNISH YOURSELF CHARLOTTE, IT HAD TO END THIS WAY. THINK OF IT AS RELIEF. THINK: I NOW HAVE MY LIFE BACK.'*

James smiles.

Charlotte: *'THAT'S WHAT I TELL MYSELF.'*
(Pause)
'JAMES, I BOUGHT A FARM AS FAR AWAY FROM KANSAS AS POSSIBLE.'

James: *'A FARM?'*

Charlotte: *'A FAR FARM WITH CAMELS.'*

John's pad is full of notes as he continues to take down Abby's critique,

'Camels? What is this drivel! Was this in the script? Hindu gods? Camels?

Lake scene possible re-shoot.

Why does she smile?

Doesn't work.

Too much melodrama.

No tension.

Change the music.'

Golda leans over again to Annette and whispers. Annette leans over to Walter,

'Ma says she really hates the music.'

Walter grunts without a discharge of popcorn; he's eaten it all. Franco leans forward with another disclaimer,

'It's not my music.'

Satyajit, who has now returned, sits cross-legged in the aisle next to Ed's seat.

He whispers to Ed and gestures lifting the sound. As Ed is too slow to respond, he attempts to take control of the volume knob himself. After a short struggle in which the sound is abruptly raised and lowered, Ed gives him the control. It's a point in the film where the music is being used to support an emotional moment. Satyajit increases the volume way beyond the comfort level, causing consternation to the audience and Walter,

'What the fuck!'

Satyajit looks up at Ed and smiles in a disarmingly innocent way and gives him back the control unit. Ed turns the volume down. The same mobile phone that rang earlier, rings again. There are moans from the audience as the big man takes the call,

'Yello… Yeah… Tell him I'll call him back… No, he knows the asking price.

Yeah, yeah.'

A small white man seated in front of the big black man turns to him,

'We're trying to watch a movie here, would you mind…?'

But the big black man cuts him off,

'Yeah, well I'm trying to run a business here, so turn around and watch the fucking movie.'

He returns to the phone

'Yello… No offer him less… Offer him less!'

The small man is undaunted,

'Are you going to stop or do I have to call someone?'

The big man getting angrier,

> *'Hang on a second…call who the fuck you want asshole…what's the problem anyway? There's more action on my phone than on the fucking screen. Just shut the fuck up and watch the goddam movie.'*

The small man stands, as does the big man, they face each other, well, not quite. The audience has lost interest in the film, preferring to watch the real drama in front of them. It comes to an end with the small man's female companion pulling him down to his seat,

> *'Leave it alone honey, just sit down.'*

The black man finishes his call. He is aware of being looked at by the people around him and, in particular, Satyajit,

> *'What the fuck you looking at?'*

◆

'You looking at me?'

I'm in Brooklyn, sitting in a location trailer fitted out as a cutting room with this apparition next to me that could conceivably be Robert De Niro. As cockney Lorraine Chase said in her 1970s commercial for Campari, "Am I in paradise or Luton Airport?"

Every film with a new director brings concerns about compatibility and trust, but somehow with this icon and director of one of my favourite films, *A Bronx Tale*, I was naturally more apprehensive than usual. With heavy hitters like Universal and Morgan Creek behind the scenes, how long would I last? Which of the many faces of De Niro would I have to confront? Would a difficulty in verbal communication, a largely withdrawn personality with lashings of inhibitions and shyness be a hindrance to this relationship? And that was just me. I wouldn't say I have particular insecurities about my work but without the occasional slap on the back, they are never far away, even with directors I have worked with several times before.

If De Niro had an ego, and it's hard to believe you can receive all that acclaim and not have a pretty big one, I was never aware of it: genuinely modest about his achievements, unassuming, generous in his appreciation of work and generous financially, with gifts and

picking up the tab at restaurants and, noticeably, even-handed in his dealings with monarchs and serfs alike.

It is very unusual to have a cutting room on set the whole time, but De Niro felt more secure having me within reach. Wherever the unit went, my trailer would go. The rushes would be fed to me daily by one of my two assistants, Adam Geiger or Carlos Rodriguez, who both remained in the primary rooms in Soho, Manhattan. An extension of the editing family was in the shape of the wry Ryan Macormick, De Niro's assistant; the bookish Jason Sosnoff, production researcher; and the fetching, super-efficient Jennifer Lane, post-production supervisor.

An early test came for me when editing a scene between General Bill Sullivan (De Niro) and Ed Wilson (Matt Damon). In the scene, Sullivan is trying to recruit Wilson into the CIA. In all the closer footage of Sullivan making his pitch, his eyes tended to wander off to the side rather than being fixed on Wilson. A small thing, but I felt this weakened Sullivan's authority. When Bob came in to review the scene with me, I was in a dilemma whether to say anything or not. After all, I had had previous here; memories of old and recent bad experiences flooded back. These were early days, I didn't know him well enough, perhaps I should keep my council until I knew him better. But to De Niro's credit, he registered very quickly that I was less than effusive about the scene and encouraged me to speak my mind, "If you don't like something, say so." I tentatively drew his attention to his 'eye acting'. Well, it's one thing saying speak your mind but another really meaning it. He really meant it. There were no hysterics, no damaged ego, just a considered response, "Yes, you're right, I'll reshoot it." He had recognised the intention behind my comment. He did reshoot it, and in all honesty, it wasn't that different, but that brief exchange laid the foundations for a very open and secure 'speak your mind' collaboration.

He was open in other ways too. Most directors are extremely protective, even paranoid, about the "cut", not allowing anyone to see it until they have had their input. De Niro was quite different. Having my trailer on location, I would regularly have actors and crew come in to look at scenes I had assembled or was assembling. There was a genuine interest in the editing process that he encouraged. He was interested in any thoughts, positive or negative,

as a consequence of these visits and didn't show any signs of insecurity when they were negative.

He was meticulous about performance, often going for numerous takes and often without re-slating, that is marking a new shot with a different take number; so, take one might actually have several takes within it. To facilitate comparison, Adam would isolate line readings from say twenty different performances, and 'stack' them, one after the other. We would run them for Bob, narrowing down the twenty to say a selected ten, then five, then two, then one; only then to compare one to take five, and then perhaps go back to take fifteen, and so on. It was an arduous and frustrating process but at least one in which De Niro could see the humour.

The hours were long, seven-day weeks not unusual, and it almost drove Adam back home to Minnesota and a much saner existence helping his brother in his hardware store. As Adam said:

"Bob poked his head into my room after working a long Saturday and said, 'See you tomorrow at 7.' I just thought – 7 am on a Sunday – wow, I gotta get out of this line of work!"

During post-production, we set up at Pinewood studios in the UK, as De Niro was shooting *Stardust*. He would pop in straight from the set still in costume, and sit with me while we worked. Very surreal!

De Niro, as he appeared in the cutting room, ready for work!
(Courtesy of costume designer, Sammy Sheldon)

The two studios financing the film previewed to a mediocre response. Of course, my position was in jeopardy once again, with Chinese whispers originating in the Morgan Creek camp, "I just think you should know, they're looking for somebody else." To appease this movement to good shepherd me out of the picture, De Niro asked if I would be prepared to take notes from editors Tim Squyres (in person) and Pietro Scalia (on the phone) and also director Steven Soderbergh (on paper). He made it quite clear that it was my call (regarding the first two) and if I didn't agree it wouldn't happen, nor would he allow Morgan Creek to fire me. With that kind of support, it would have been churlish to say no. In the event, I had trouble deciphering Soderbergh's notes and the other contributions, although I'm sure well intentioned, were not particularly welcome, nor helpful.

Bob, having disengaged from this process of 'helpful' thoughts, was quite happy to play the studio game with no intention of doing anything other than what he wanted. He asked if there was anything worth considering in the three S's suggested remedies and took my generally negative response as his. This 'them' and 'us' mentality resurfaced later, on the only occasion we locked horns. It followed a viewing at the TriBeCa theatre several months into post-production. It was a theatre full of celebrities, Tim Robbins, Joe Pesci, Whoopi Goldberg, John Turturro, Chazz Palminteri to name but a few. Prior to the screening, I had foolishly changed a piece of music towards the end of the film. When it came up, he leaned over to me in the theatre and whispered, "Don't ever put in a piece of music without checking with me first." Now, I am really not one for confrontation, particularly not with a potential raging bull but for some reason I got up with the film now approaching its conclusion, and flounced out. On seeing me exit, Bob got up and pursued me. My assistant Adam, who had remained in the theatre, told me later that the audience, having become aware of the live show about to unfold were itching for the film to end in order to pursue the action outside.

Out in the foyer, Bob and I stood toe to toe, exchanging something other than pleasantries, with left-right verbal jabs and below the belt accusations of me being a prima donna from Bob, and counter punches from me claiming anything that came into my unzipped mind, from foul play to paranormal activity. As the audience emerged and took their ringside seats, we were in full flow. Bob became aware of the attention and guided me into the

stairwell exit where we continued our verbal fisticuffs. Adam, once again delighted in telling me that the audience remained to listen in on events, now audible, being in the stairwell, with full Dolby surround.

By this point, I must have been totally out of my head because it was no longer De Niro I was facing but Jake LaMotta, Travis Bickle and James Conway. I threatened to leave, but Bob refused to let me go, telling me that we had to fight the evil empire together, "Them against us." My response was sadly ungracious, short of creativity and childish, "Well, I don't want to." He then produced an uppercut with "you're a fucking great editor, I won't let you leave", which nearly knocked the wind out of me, but I parried instinctively with a punch well below the belt, "Well. I'm a fucking better editor than you're a director." Whoops!

Now if ever I deserved a knockout blow, it was right there and then. I braced myself for a crushing left hook sending me down several flights of stone stairs.

Instead, Bob beamed back at me, a huge smile across his face, followed by a bear hug, saying, "Let's go and have a coffee."

Another screening was arranged at the TriBeCa theatre for super director and De Niro's friend Martin Scorsese, but like Spielberg on *American Beauty*, the screening was to be a private affair. Having checked the theatre for sound and picture quality, I exited into the foyer to discover the great director eating alone in the

corner with his back to any prying eyes. With his reputation for being edgy and irritable, I was reluctant to make my presence known; I was mindful of ex-Paramount boss Barry Diller who, on being introduced to people he didn't want to meet, harangued a minion with, "Never introduce me to someone I don't know!" Rumour has it that when Marty and Thelma are closeted in the cutting room, entry is made through a buzzer system; one buzz for the first assistant and two for the second assistant. With that degree of paranoia, my unannounced and unrequested presence could be inviting displeasure.

I looked around to make sure my probable humiliation would not be witnessed and stepped forward, "Hello, Mr Scorsese, my name's Tariq Anwar. I'm the editor of Bob's film." He looked up at me slightly shocked, slightly threatened, slightly violated but managed to control his anxieties long enough to give an acknowledgement of sorts, "Huh." He then returned to his dining.

I really think I made a lasting impression.

Deeper into post and with further concerns about the cut, James G Robinson, CEO and Chairman at Morgan Creek (a used car salesman in his previous life) had Andy Fraser, one of his executives, fly to New York to return with a copy of all the media[20] from the cutting room; the intention being to have one of their editors in LA re-cut the film. The order to hand over the drives was given directly to Adam without consultation with anyone else. On Adam informing me and me informing De Niro, a decision was taken to withhold the media from Morgan Creek. Adam relayed this message only for Robinson to threaten him with dismissal. The media wasn't released and Adam wasn't fired. In all this, there was no direct contact from Morgan Creek, neither with me, nor, to my knowledge, with De Niro.

The first assembly ran a healthy five hours plus. For many weeks, it remained close to that length, making the weekly screenings quite painful. Gradually, it was whittled down: four hours, three and a half, three but still not down enough for me (90 mins is my attention span). I suggested a cut of about two hours and Bob indulged me giving me time to play. He respectfully watched my efforts, was very gracious in his comments but still preferred the longer version. It was released at around two hours fifty minutes.

[20] rushes/daily footage prior to being edited.

Chapter 24

Marlene and Howey are both pre-occupied as the film begins to lift off some of the pulleys and fall to the floor, picking up dirt in the process. The film continues to run through the gate but gradually the variable tension, pulling and loosening, causes a grating noise which alerts Marlene to the approaching catastrophe,

'HOWEY!'

They both rush towards the projector, trying to lift the unravelling film back onto the pulleys. It's a losing battle.

Inside the auditorium, the audience watch, with a mixture of shock and amusement, as the film starts to slip, sliding away, losing sync in the process. Ed, in panic, gets up and leaves, followed by Annie, followed by Tom and Pierre and Michael. Satyajit stares at the screen entranced, as the images merge into one. Walter feeds himself imaginary popcorn eyes glued to the screen; Abby continues to give notes off the blurring images,

'Altogether too arty!'

The mouse meanwhile has found its way to the feet of the big black man and starts to nibble at his shoes. He becomes aware of something and looks down,

'Oh fuck! A rat!'

This causes a hysterical reaction amongst the female audience who start to scream. Everyone is now getting up, some onto their seats, including and especially the black man. Walter continues to eat air, and Abby continues to give notes,

'I sense we're losing the audience.'

Back in the projection room, Howey and Marlene appear to have things under control, but a piece of paper, collected up by the moving film, makes its way up to the projector unnoticed by them. Ed, Annie, Tom and Pierre burst into the box just as the paper gets stuck in the gate causing the film to seize up and crumple in on itself. The heat from the projector light burns onto the trapped film,

continuing the kaleidoscopic effect on screen. Everyone stares in amazement, helpless. Ed closes his eyes, hoping by doing so, to erase what just happened.

After many years, I was reunited with Sam Mendes in American suburbia with *Revolutionary Road*. As Sam put it, with typical humour, "Maybe you've forgotten all the horrors of our previous experience and are ready for a new one!" Time had diluted any 'horrors' as time tends to do, but by comparison with some experiences since, there was nothing horrible to remember; I can't imagine why I said with reference to working with him, "Once was enough!"

I was also re-united with executive producer David Thompson, now Head of BBC Films. I had approached Thompson in another lifetime, when still at the BBC, about the possibility of directing a script I had written; sadly, neither the script nor I impressed him. I was also fortunate to have both Jennifer Lane and Adam Geiger working with me again; Adam, resisting the pull of the hardware store in Minnesota, deciding to give the industry just one more shot.

The BBC had secured the film rights and through Thompson, enlisted producer John Hart and then screenwriter Justin Haythe. The very necessary big name Kate Winslet became attached and then later, an even bigger name, her *Titanic* love interest and 'best friend', Leonardo DiCaprio. Sam was approached to direct,

although Joe Wright (in Thompson's scurrilous view, "a younger, more attractive, Sam") briefly entered the frame and then, thankfully, from my selfish point of view, exited. Other producers were Bobby Cohen and Scott Rudin. Rudin, fondly known as the 'Bully of Broadway' and 'the biggest a-hole in Hollywood' is also an EGOT (not as disparaging as it sounds), having won an Emmy, Grammy, Oscar and Tony. Almost cast out of the same mould as Harvey Weinstein, there are obvious similarities: love of film and power, body size, hair loss, appetite, ambition, temperament, reputation and objects of fun. But grudgingly, there is something to be admired in both. Being good at your job, if not excusing bad behaviour goes a long way to mitigate against it. Not surprisingly, there is a considerable amount of noise level surrounding these two bruisers.

Cain and Abel of Tinseltown

However, if my relationship with Sam was generally not adversarial there were clearly divisions elsewhere on the film, with Hart in one corner and Mendes/Rudin in the other. Hart, a sociable and erudite man was like Thompson in producing style, entering the ring of conflict with the velvet hands of gentle but effective persuasion. Contrast that with Rudin, charging out of the opposing corner wielding a sledgehammer. I cannot personally vouch for any bad practice regarding Rudin on *Revolutionary Road*, but then, I put that down to working *with* him (purely as an extension of Sam, and

189

somewhat shielded by him) as opposed to working for him (by far the lesser of two evils). Our paths have rarely crossed: prior to *Revolutionary Road,* only once at a chummy cutting room viewing of *American Beauty.*

I had little direct contact with him on the current film, either in the cutting room, where he rarely appeared, or at official screenings, his notes at these events being relayed via the director. He did, however, organise his own screenings, unbeknownst to Lane and pretty much everyone else. There was a Rudin screening in White Plains, NY, which only came to light when one of his then assistants, was asked by Lane about Scott's availability on a Wednesday night for something or other. He responded with:

"Well, no, Scott can't do it on Wednesday night, he's got the Rev. Road screening."

"What Rev. Rd screening?"

"Oh, wait, you don't know?"

Jennifer Lane didn't know, Bobby Cohen didn't know, John Hart didn't know, I didn't know, because by then I had left to work on another film. Sam knew but didn't attend. By all accounts, the preview was well received, as Adam put it, "A movie about how miserable life is in the NYC suburbs played well in the NYC suburbs."

The story about the unravelling of Frank and April's marriage was put more dismissively by my wife, who when discussing her negativity about the story with John Hart, said bluntly, "It's just about a woman in a bad marriage who kills herself." Maybe a tad simplistic as an observation and whether April intentionally killed herself or not is open to discussion, although I think April's phone call for help suggests not.

The film was far from miserable to work on though, on account of having a very open, honest and creative relationship with Sam (where praise and criticism could be fearlessly exchanged in equal measure) and with the novelty of the changing environment, the nomadic cutting room continuously on the move: two facility houses in Manhattan's Soho, Sam's UK country house in the Cotswolds, returning to Sam's office in the Meatpacking District in New York and then later Los Angeles for music recording and finally Midtown New York for the sound mix.

At its fullest length, the film ran about 150 mins. Over the many months that followed, that was reduced to a final running time of 114 mins.

Most significantly, the many flashbacks of April and Frank as children and then later, their first meeting and early romance leading to their first viewing of the Revolutionary Road house were deleted. Initially, much time was spent on their placement within the story; sometimes a flashback was best triggered by scene A but then, found to work better after scene F, but then again, there was some argument for putting it before scene H and so on. The flashback scenes remained in one position or another for many months, until Sam unceremoniously cut them out altogether. Niggling away in Sam's mind was the belief that something wasn't quite right with the film and that the thrust of April and Frank's worsening relationship was being impeded rather than being propelled by the flashbacks; for example, getting to April's suggestion of going to Paris (a significant story moment) was taking far too long. Sadly, other good scenes were dismissed along the way, particularly one of my favourites, Frank recounting a story of an earlier birthday to neighbours Shep and Milly; a story, April makes bitingly clear, he had told last year. Fortunately, these scenes still have life on the DVD deletions for the film. Gradually, some of the flashbacks were re-introduced.

The opening (faithful to the script) started with the play and Frank's journey from the car park to the hall, to watch April perform. This sequence stayed for some time but Sam, feeling the ensuing row by the side of the road lacked context (the disappointment of failing to live up to earlier expectations), wanted a different approach. We re-instated the flashback of the young couple meeting at a party in Manhattan, preceded by an exterior establisher of the party apartment building. As this establisher hadn't been shot, suitable stock (library) material was found and manipulated with visual effects to match the incoming scene in terms of period and action. For Hart, this was 'too much like the start of *Capote*' and less elegant than the original scripted opening; Haythe's initial reaction was negative too. My concerns were that neither April nor Frank looked physically much younger in the flashback and that April, in particular, appeared too mature, an issue wherever the flashback was placed, but to me, placing it at the head of the film exposed its deficiencies more.

The new opening prevailed. Other flashbacks returned, the last being realtor Mrs Givings, showing the young couple what would become their new home, which was re-instated shortly before picture lock; Sam having last-minute anxieties about its omission.

Another problem area, certainly from Hart's point of view, was the scene towards the end of the film, with April, Frank, Millie and Shep at Vito's restaurant, partly on account of a re-writing of the scene, of which Hart was unaware, and partly on account of performance. In heated debate with Rudin, Hart expressed the view that the scene made April totally unsympathetic to which Rudin replied eloquently, 'she's about to fuck her neighbour in the car for fuck's sake. How sympathetic do you want her to be?' The scene was re-shot with new dialogue, as was the scene of April's suggested relocation to Paris. The latter because of poor staging, lighting and for being over-written. In both instances, Sam having the courage to admit that he might have got it wrong.

How to end the film was another issue, with Hart putting forward a strong argument for keeping an emotional scene of Frank reading a note from April following the news of her death. As Hart put it, 'the catharsis of him, curled up in a chair weeping is what the movie desperately needs'. For Sam though, the scene verged on melodrama and overstepped the degree 'to which to plunge the tragedy'.

The post-production was protracted. With the picture close to lock and with Sam's blessing, I left early January 2008 to start *The Other Man*.

I left believing there were just a few minor changes to be made, but over the coming months, and in my absence, the number of changes grew; Adam minding my back throughout, apart from short periods when he too had prior commitments and had to leave the film. Rudin continued to exert influence over the cut with Hart, often out of the loop, being reduced to requesting to see changes he had heard about through the grape vine.

The changes continued into the Summer with both Sam and Adam doing everything they could to keep me involved: Adam by sending me QuickTimes of every alteration for approval or disapproval, Sam by having the production fly me back and forth several times from London to New York and LA, just to keep me part of the process of re-cutting, music recording and sound mixing.

This latest movie-making experience had Adam back in his brother's hardware store in Minnesota but later, he returned to the industry.

Production Manager on set

Chapter 25

The test screening is over. As the audience leave, they hand over their questionnaire sheets to several research employees standing by the door. Other research workers sit at a trestle table set up by the exit door, to collate and scan through the papers to get an initial and general response to the film: good, bad or indifferent, without going into too much detail. There is tension in the air, not only for the filmmakers but also for the research company to provide the 'exit poll' by the end of the focus group.

In the auditorium, twenty or so of the audience are seated at the front, with Barry, the moderator standing in front of them. The filmmakers shuffle forward nervously towards the front looking for an appropriate place to sit; not too close to make the focus group aware of their presence and not too far back that they can't hear what's being said. They sit in their tribal groups: Walter's clan, Abby's clan and then Satyajit's team. Satyajit with Ed and Annie sitting closest to the action, and a few rows further back are the producers and studio brass.

Barry: *'Thank you all for staying behind and helping the producers in making this a better film. Apologies for the break in the screening, these things can happen but I hope it didn't spoil your enjoyment of the film. As I said before, I am not part of the production team, so you can be as honest as you like and you won't hurt my feelings. My name is Barry and I would love to know your names.'*

He places a recording device on the floor.

 This is just a recorder to aid my failing memory, so if you could just speak loud and clear... Let's start with you, the lady at the back...'

The focus group call out their names,

 'Patti...Oscar...Scott...Lizzy...Brian...Bradley... Shauna...Hubert...'

Annie nudges Ed in the arm, attracting his attention to the returning mouse, chewing up a questionnaire.

Barry: *'OK, that's great! So that's twenty of you. Let's start with a show of hands.*

How many of you thought the film was excellent?

No show of hands. Satyajit slumps lower in his seat.

OK, that's no one. How about very good?

One hand goes up.

One, great...that's Brian, right?

Brian nods

Moving on to good, how many thought the film was good?

Three hands go up. Satyajit slumps even lower.

That's three... Shauna, Grady and Tom. Fair, how many thought the film fair?

Five hands go up

Five... How many hands for poor?

Eleven hands go up

OK, well, that's eleven on poor.'

Satyajit has almost slid under the chair in front to join the surprised mouse.

The Other Man, a film adapted by director Richard Eyre and Charles Wood from the short story by Bernhard Schlink, took me back briefly to Ealing Studios. Still in a renovation process, this site, neglected for years after the departure of the BBC, still looked a mess.

The canteen and camera crew car park had given way to a swish glass fronted office block; home to a film school, gaming and graphics companies, artist agency and production offices. The stages and cutting room blocks remained, although with paint peeling off the discoloured walls it was a

sad sight. 'S' block cutting rooms, including my old one, had been doubled in size by knocking down connecting walls but now they served as office space. A handful of makeup and wardrobe rooms had been converted to cutting rooms on the third floor of North block but access to the once elitist 'T' block rooms was appropriately denied by locked doors. Administration buildings housing offices, 'dispatch' and 'post' had been demolished to make way for temporary pot-holed parking. It was difficult not to succumb to nostalgia, but as Proust said, "Remembrance of things past is not necessarily the remembrance of things as they were."

Thankfully, the two rooms assigned to me, once offices, were in a part of the Gate House not yet abused by remodelling and, being able to park in the in-out driveway by the Gate House, I was able to pretend nothing had changed by not venturing further into the studio.

The Other Man was essentially a love triangle, exploring Liam Neeson's jealousy at discovering his wife's (Laura Linney) adultery and subsequent obsession to find her and her lover (Antonio Banderas) to seek both understanding and revenge, only to find his understanding leads to forgiveness.

Unfortunately, the critics were pretty unanimous in failing to find either understanding or forgiveness: "ponderous", "mediocre", "silly", "dreary", "suffers from terrible editing", "muddled little dud", "sexual temperature nap inducing", "obvious and poorly prepared twist" (the wife is dead, not missing), but, of course, "handsomely shot"! As for Richard (a director of "unshowy authority" and "fearless observer of nastiness and kink" – press comments based on his superb *Notes on a Scandal*), he "executed with so little passion that the film might as well as be about car upholstery". From the sublime to the ridiculous! Well, a reviewer who can't get excited about car upholstery is in need of a leathering, preferably administered by the 'fearless observer of nastiness and kink'! But all in all, it was a thumbs down.

The music score for the film was eventually written by Stephen Warbeck, although we flirted with Philip Glass for a long time; both composers having worked with Richard before. My first impression of Glass, was of meeting one of the most significant composers of the 20th Century, that is how he is regarded by many, and that's how he came across to me; a man of serious intellect, music and otherwise. Having written operas, musical theatre works, ten

symphonies, eleven concertos, solo works, chamber music and numerous acclaimed film scores, on shaking hands I felt, as with Harvey Weinstein, I should have bent my knee. Sadly, I am more in awe of his reputation than of his film repertoire.

Editors plunder music from anywhere to use as temp but I have had difficulty using Glass film scores for anything I have worked on, the one exception being *The Good Shepherd*, where tracks from *The Fog of War* were used. His 'repetitive structures' are mesmerising and desolate, inducing an altered trance-like state waiting for some sort of relief of a melody or musical development. It can be a long wait.

The Other Man was largely temped with the scores from *Rendition* (Paul Hepker / Mark Kilian), *Narc* and *Solaris* (Cliff Martinez).

We ran the film for Glass in New York with Richard giving Philip his overview and then his thoughts and ideas on how specific cues might work but typically inviting discussion and collaboration from Glass. Glass spoke eloquently and with a great deal of insight (as all composers do), dismissing some of the temp music as 'not working' but also generously acknowledging when it did work. Some cues he felt unnecessary but equally there were moments not currently spotted for music, that he felt could be helped with score; the kind of response one gets on most films.

We returned to London, Richard more optimistic than I, eagerly anticipating Glass' submissions. Over the coming weeks, we received themes and musical sketches, which we tried against picture. Some worked, most didn't. With time pressing, and with the need for face-to-face contact, Philip sent Nico Muhly (his assistant and possibly the person doing most of the work) to London to sit with us and address our concerns; but the problem was always going to be their resistance in producing a score that more closely resembled, and improved on, the temp (for me) and had some resonance for Richard. It was a frustrating time for everyone including Nico, who said "well if all you want is sustained chords you could get anyone off the street to do that" and "if I had been asked to score this film, I would have refused because the temp is the kind of music I hate". At least the disconnect was out in the open.

The post-production schedule was extended to accommodate the new composer Stephen Warbeck, who astonishingly produced a sound track to our liking within a matter of weeks.

With the hiatus, I was able to do the commute to NY and LA to finish *Revolutionary Road* and start work in London, on *Fry in America,* a BBC documentary series of six sixty-minute episodes, following British treasure Stephen Fry's journey through fifty US States in a London black cab. I shared the series with editors Frank Burgess and Saska Simpson. Keeping us all on the straight and narrow were directors JP Davidson (also series producer) and Michael Waldman. My two episodes were with JP, as always a laid-back, engaging and guiding presence.

Being essentially a road trip from A to B, the structure was pretty much set for all episodes; the only challenge being to cut down the many interviews and experiences on route, squeezing them all into the sixty-minute slot. With the first of my two episodes, Fry meets fishermen in Maine, Presidential hopefuls in New Hampshire, Salem witches, deer hunters, New York mobsters, ice cream blenders and explores a nuclear submarine. There were around thirty hours of material to sift through.

With documentary interviews, it's as well to build the shape around what's being said, focusing purely on the audio, deleting and re-ordering text as necessary, initially ignoring the visual bumps that appear on screen; these can be ironed out later with inserts, shots of the interviewer or illustrative material. As with drama, scene transitions are important, with audio as significant as picture, using sound effects, overlapping and pre-lapping dialogue, music, commentary or voice-over narration.

Some twenty years earlier, when working on JP's, *Kingdom of the Thunder Dragon,* his brilliant film about Bhutan, we tried to break away from the convention of having commentary, feeling that the documentary worked with just images and subtitled interviews carrying the story; adding a narration, to our minds would be too damaging to the impressionistic nature of the film. But Andrew Neal, the Series Editor of *Under the Sun*, the banner under which *Thunder Dragon* was being made, felt otherwise. His refusal led to an appeal to higher authority, no less than Alan Yentob, then Head of Music and Arts, but it failed to produce the desired result. It was transmitted with the briefest of voice-over. Composer Steve Marshall, then with the BBC Radiophonic Workshop, provided an

inspired sound track that was hugely influential on the editing, as were the images of photographers Richard Ganniclifft and Martyn Colbeck.

Fry was refreshingly free of strife! Only Fry and JP to please with courtesy viewings for executives Richard Klein (BBC) and Andre Singer (Production Company Executive).

Working on documentaries with JP is like going on retreat from the movie world, a process of healing and rejuvenation.

Writer on set

Chapter 26

Seated around a large table in a conference room somewhere in Los Angeles, are a very forlorn group. The Santa Ana winds are blowing in from the desert and according to popular legend make people crazy and homicidal in the process. At each end of the table are the monarchs, Walter and Abby. At their sides, sit their support team of cheerleaders, Pierre, Tom, Boyd, and John. They have been here some time, the table being littered with the remnants of sandwiches, pastries and drinks on a paper cloth of questionnaires and audience research statistics. Boyd is the only one with movement, texting with one hand and eating with the other. Abby's ambitious secretary sits in the corner away from the table taking notes, only at this moment there are no notes to take.

Ed isn't present but his voice is,

'The post mortem; a diagnostic to discover the nature and causes of audience dissatisfaction and to offer remedial solutions. Armed with volumes of statistics from the test screening, the creatives stir from an apparent vegetative state to brainstorm and find a cure. It is in this rarefied atmosphere that we experience the non-duality of higher consciousness and witness true genius at work.'

Walter speaks,

'We have a problem.'

Then burps in a low register as if to give weight to his pronouncement; an exclamation mark.

Boyd: *'Yeah, tested 40-50%, the audience didn't like the characters, scenes, pace...'*

Tom: *'We know, Boyd, thank you.'*

Abby speaks,

'Maybe it'll do well internationally...in India, for instance. That's a billion there.'

Nods head in agreement but nothing is said.

(Pause).

 'We didn't like her smile.'

The group look at her.

 'The smile in the boat, totally unmotivated, totally ruined the film for us.'

John: *'I agree, totally inappropriate. A major problem.'*
 (Pause)

Abby: *'There are too many pauses.'*

Followed by a further long pause, after which, she expands,

 'Normal people don't speak with pauses.'

A respectful silence follows to confirm these are not normal people.

John, Abby's lieutenant feeling it appropriate to end the silence shows his colours,

 'Abby's right. The film has to move. We need a pace friendly, commercial cut. I personally have been drawn to, like two cuts a second, average. What was this...one cut every four seconds?'

'One every 7.35 seconds,' says Boyd, taking exactly 7.35 seconds to deliver the words between mouthfuls of string cheese.

 'I think there is a strong correlation between cuts per second and dollars through the till. There's an equation for it. N equals X squared something to the power of something else.'

The magnitude of this revelation alarms John,

 'Jesus, this is worse than I thought. One cut every 7.35 seconds? I mean, that's European Art House for fuck's sake.'

Boyd: *'At most, we'll take $50 per screening.'*

Boyd continues,

 'We need to grease up the works, throw a few explosives.'

Pierre: *'How about a camel chase?'*

There's not much enthusiasm for this but the idea of greasing up the works has great appeal to Walter, who in a previous life sold second-hand cars,

 'Lubrication! Now you're talking my language: oil, timing, wheel alignment, misfiring. It's not running on all cylinders.'

Further burps follow illustrating a misfiring engine.

 'Needs buttering up.'

Abby interrupts,

>*'We forget, is this really the film we commissioned?'*

Coming off the bemused expressions, John volunteers,

>*'Hell, we didn't read the script. Did anyone read the script? We mean like all the way through…anyone?'*

No response.

>*'We've caught a cold on this one.'*

Abby perplexed,

>*'We thought we were making a musical Walter? Didn't you say it was a musical?'*

Walter alarmed at the mention of music,

>*'That's another thing, I hate the music.'*

Tom nodding in agreement,

>*'Walter's right, it lends an unwanted melodramatic flare to what an audience expects.'*

Walter continues,

>*'What the fuck was it?'*

>*'Hindi pop,' Pierre informs him, stirring the pot,*

>*'Turn of the century Hindi pop.'*

>*'I like a tune I can hum. With lots of white notes.'*

Tom continues,

>*'Less may equal more profound emotion.'*

Walter continues wistfully,

>*'I really like the white notes.'*

Suddenly, from nowhere,

>*'The music really is overwrought. Treads on, rather than accompanies the powerful story. We need to apply a more restrained score which allows the poignant performances of our characters to emerge. Subtly complementing rather than overly indicating the emotional response from our audience.'*

The whole table turns to the speaker sitting in the corner, the Ambitious Secretary.

We hear Ed's voice,

>'In her third year of the studio executive training programme, a product of the non-sexual propagation of genetic material within the family and consequently prone to gibberish. Actually related to the almighty, Abby's mogul boss.'

The table turns back. Abby continues,

'And the slow motion.'

John, head not quite balanced nods alarmingly like a dog on the rear shelf of a car.

'Oh my God! Oh...my...God! Undermines the swelling energy.'

This is all too esoteric for Walter,

'I didn't see tits. Didn't we shoot tits? I didn't see tits. What the fuck happened?'

'I saw a flash of tit, perhaps half a second,' says Tom.

'Fuck, I missed it. Why the fuck didn't he give me 7.5 secs of that?'

Boyd, having now consumed everything on the table, and observing the frenzied feeding on the carcass of this film,

'I didn't get it. It didn't speak to me on any level. I didn't feel fucking engaged.'

Walter turning red with excitement,

'Exactly! And if you're going to have dialogue, then make it conversational, right? Like, not "Rub my nose with yours" but rub my fucking nose with yours.

You do it with such fucking frequency that I'm beginning to wonder if it's some sort of fucking fetish. And maybe you have others I should fucking know about?' Now that's conversational.'

Tom ever supporting,

'You have a point, Walter.'

Pierre equally so,

'A fucking good point.'

They continue the banter,

'It could be edgier.'

'More life to it.'

'Less linear.'

'Slow.'

'Old.'

Abby now tiring of all this intellectual talk looks at her watch,

'What time is it?'

Tom, not quite understanding her question,

'Way too long, whatever it is.'

'Five hours thirteen minutes, without credits,' replies Pierre.

Abby on her original train of thought,

203

'We have to pick up the children.'

Boyd, not listening but remembering his solution to all problems,

'I really think we should fire somebody.'

Tom joins in the conversation with him,

'Anyone in mind?'

As does Pierre,

'The composer?'

'He hasn't started yet,' Tom acquainting everyone with the post-production process.

Boyd still determined to fire someone,

'Let's fire the post-production supervisor. Just as a token.'

Walter joins in,

'We should fire the writer for getting us into this mess'.

Everybody,

'We already did.'

Tom: 'The director?'

Another pause while the group consider.

Abby: 'He'll call a press conference to denounce us. Where is our visionary? 'Why isn't he here?'

John: 'We didn't invite him.'

Abby: 'Remind me why we hired him?'

John: 'He won an Oscar.'

Tom: 'For a short'

Pierre: 'He was cheap.'

Abby: 'Cheap? Ah, what are we into now?'

Boyd: '$55 million, give or take'

Abby: 'And with marketing?'

Boyd: 'Another $20-$30 million.'

Abby: 'We've got to get that back.'

Tom: 'Not with this cut.'

John: 'Definitely not with this cut, too much acting.'

Abby: 'Too arch. Too art house.'

John: 'Interstitial.'

Walter: 'Fuck yes. Interstitial.' Then whispers to Pierre, 'What the fuck is interstitial?'

Abby: 'Too long. And that smile, took us out of the movie.'

John: 'Too many pauses.'

Boyd: 'Pauses equals art house.'

Abby: 'Equals empty seats and corporate firing squad.' (Exasperated) Oh for God's sake! We are too young to be sacrificed at the altar of this Hindi esoteric and his illusory metaphors and Tiki Tiki Ta music.'

Tom: 'And far too much melodrama!'

Walter reaches forward and cracks open a can of diet coke. He drinks straight from the can and then puts it down.

Walter: 'We might be overreacting.'

Boyd, quick to show support of this turnaround.

Boyd: 'Well we know it has potential, the material is there.'

Walter: 'It could be a great film. We just need to go another step. It appeals on a...'

Pierre: 'Visceral?'

Walter: 'Yeah, I like that, a visceral level. A visceral interstitial level.'

Abby: 'What do you suggest, Walter?'

Walter: 'A new approach.'

Abby: 'Do you have someone in mind?'

Walter: 'One of my boys from the shop, Xavier Schwartz. Tom?'

Tom reaches for the VHS/TV remote and presses **play**. On screen appears a commercial with a starburst opening to reveal Xavier Schwartz on a stylized cutting room set. With him on set is Barbie his assistant. Schwartz is emaciated and weaselly, Barbie is short and fat. The commercial is choppy and untidy with jump cuts, double action, stretched and distorted images etc., to illustrate the message. Music accompanies the scene.

Xavier: 'My name is Xavier Schwartz.'

Barbie: 'Cut.'

Xavier: 'Called Doctor in the game.'

Barbie: 'Cut.'

Xavier: 'I breathe life, love and imagination, into films that need rejuvenation. And all I require in return, a small measure of consideration.'

Barbie: 'A small measure of consideration... He cuts action, he cuts drama. He cuts comedy, 'n' corners too. His films are sometimes black and white. And sometimes even blue! Oo.'

Xavier:	'So if your film's in trouble. Try me out and don't delay. Just remember to call my number. And Xavier will save the day.'
Barbie:	'Xavier will save the day.'
Xavier:	'My name is Xavier Schwartz.'
Barbie:	'Snip, snip, snip.'
Xavier:	'Motivation isn't greed.'
Barbie:	'Heavens no!'
Xavier:	'I'll glue and paste, with timely haste. Satisfaction guaranteed.'
Barbie:	'Satisfaction guaranteed. He cuts by feel and not by numbers. Intuition, not by the book. Give him the chance to fix your film, 'n it'll have a different look.'
Xavier:	'So if your film's in trouble. Try me out and don't delay. Just remember, call my number. And Xavier will save the day.'
Together:	'Xavier will save the day.'

My LA agent rang to say there had been an enquiry about my availability for a revenge film called *Law Abiding Citizen*. Once again I must have been a second, third or fourth choice because filming was about to start. I was in London and, shortly after reading the script, took a call from one of the producers, Lucas Foster. It didn't seem like a testing interview type of call, although I got the impression, later to be confirmed, that Lucas was very much a 'hard ass'; a term he uses about himself although admittedly in reference to his toughness with scripts. Had Lucas been in the army, he would have been in Special Forces. When we finished the call, I had apparently got the job. The filming was entirely in Philadelphia and with the cutting room in LA, I didn't get to meet the director F. Gary Gray until the end of shooting, although we did meet and greet on the phone shortly after my arrival. Gray, a skilled director, particularly of this genre of film with *The Negotiator* and the remake of *The Italian Job* to his name, provided material that he knew would work, so my task was both enjoyable and not particularly challenging. Performances from Jamie Fox and Gerard Butler were good as were all the secondary roles. My assistant

206

Kenny Marsten, would upload cut sequences for Gray (with temp music and sound effects laid in) on a regular basis, and I would get largely positive feedback from him on location.

On returning to LA after filming, Gary came to the cutting room with his personal assistant, also a Kenny, laden like a mule with bags containing paperwork, laptops and food. Breakfast would be prepared, laptops switched on, script and notes set out on the table in front of the patiently waiting director. I never heard Gray's Kenny Yates say 'massa', but he might as well have done. Some weeks later, Gray, I believe, fired him.

Gary and I greeted each other amicably and then got down to some rules of engagement for the next ten[21] weeks of the director's cut. He informed me how he liked to work. A bit late in the day to discuss these things; issues like this usually surface at the interview stage but as there was no interview with him before production this was all going to be news to me. He liked to start late and work late and would like me to do the same. Not good for me, as I like an alpine start and to leave early (although it rarely is early). He expressed the belief in a democratic cutting room. Fascinating thought, although, with the implications of drawing up a Cutting Room Constitution or Bill of Rights, it did occur to me that the director's cut might be a life sentence; had he run the film set the same way, they'd still be shooting now and of course, as we all know, the movie industry is as much of a democracy as North Korea!

What it meant in practice was Gary liked to have a mini-focus group on every sequence or perhaps a run of several sequences I had put together; the focus group being made up of anyone who was around at the time, which largely meant my assistants and his and any passing trade with an opinion.

The idea of taking notes from gathered assistants didn't fill me with too much rapture but then, one takes notes from producers and focus groups, so why not assistants? Am I really so insecure about my work that I can't take editing notes from someone on work experience? The answer, unfortunately, is yes. I couldn't hide my unease, but Gray insisted, and so with the assistants slightly bemused, particularly mine, we went through this ritual for a short

[21] Directors are usually given ten weeks after filming (or after seeing the editors complete assembly) to deliver their cut to the producers.

time. The boys would come in with their note pads and make notes as I played a sequence I had been working on. At the end of each viewing, we would, as a group, discuss how to improve my edit.

If Gary thought there was something worth pursuing out of these discussions, even though I might have shown some opposition, he would recommend I spend time pursuing them. Interestingly, I don't recall Gary exposing himself to the possibility of having his ideas rejected in this democratic process, so in practice, it was an autocratic democracy.

As the days progressed, I couldn't hide my hostility and with increasing levels of anxiety, the tension in the cutting room became unbearable. The post-producer, Dave Gare, took my calls of distress and my frequent requests to follow Kenny Yates into the blue yonder, with assurances that the agony would end at the end of the ten weeks, when the producers would take over. I am sure the very savvy and resilient Gray, a true professional and along with Foster, hardened in warfare on the playing fields of paint ball, knew the lay of the land and the 'time out' that awaited him. He took everything in his stride, displaying a thick skin and a surprising sense of film history by having his hair cut professionally in the cutting room. I took this to be his homage to Robert Altman and his Lion's Gate offices, in which would be a barber's chair, pool table and pinball machine. It would only be a question of time before the latter two appeared.

Democracy at work in the cutting room

The weeks passed with occasional 'how's it going?' calls from the producers, including Gerard Butler and his manager Alan Siegel, who were in varying degrees, sympathetic, encouraging and mischievously amused by my suffering.

At the end of the director's cut, we had a screening for a select audience after which I was told to attend a meeting to take notes. Gray was not invited to the meeting. His paint ball leave had suddenly started. Astonishing as this was to me, Gary appeared totally unfazed.

But my suffering was not over, instead of one Gary, I now had three: Lucas Foster, Mark Gill and Robert Katz, each with their own laptops, food requirements, mobile phones and strong opinions; opinions delivered at a pace that would satisfy the most critical of test audiences. Gill, an alumni of the Weinstein Miramax, adopted a speed I would classify in editing terms as a dramatic rate, Katz, a comedy rate and Foster very much in the action category. Excitable conflict was the order of the day between the three of them with frequent interruptions for drawing breath, telephone calls and new age nourishment.

Several weeks into their edit I discovered another editor, the highly respected Michael Tronick installed a few doors down, working on a film sounding very similar to mine; in fact is *was* mine. Mischief was clearly afoot.

Unbeknownst to me, the producing triumvirate felt the need for a different set of clippers on the last reel. My complaints were met with, 'oh, it's only the last reel' as if that vindicated their actions; the last reel being only 14.28% of the whole film. It then became, or so it seemed to me, a competition as to who could cut the shortest last reel. If his was 15 mins 10 secs, I would present one at 15 mins 8 secs. A Tronick 15 mins 5 secs would be met with a 14 mins 59 secs and so on. Neither of us got it down to below 1 min, which may have pleased them most but if memory serves me right, I think I got the gold star, although some of Tronick's work remained. He departed, as did later a stream of music editors, being chewed up and spat out on a weekly basis. Much of the temp music had been laid by me but several sections didn't work for the producers or Gray, who had now returned (Gary had been invited back to approve and finesse the work of Cerberus). Because of an approaching preview, music editor after music editor came in and auditioned their work to the judging panel: Gray, Katz, Foster and

Gill. It was America's Got Talent for music editors. Some were given a second chance, most, dismissed. The distinguished and highly experienced Bill Bernstein, music editor extraordinaire, was one of the survivors, claiming the experience to have been one of his worst. It was fraught but we made the preview sound mix deadline.

The test screenings went surprisingly well, as did the film on release.

With an interview with Tom Hooper for *The King's Speech* looming, I was keen for any information on the director that might help me improve my interview strike rate. *Law Abiding* mixer Marc Fishman, who had also worked on Hooper's enormously successful *John Adams* obliged me, but only with a knowing smile.

Production Secretary on set

Chapter 27

*An office in Walter Weisman's private jet. It is carpeted in grey,
with a red runway type rug leading from the entry door to his desk,
so that every time he enters, he gets the red carpet treatment. We
are taxi-ing to take off on a flight from Los Angeles to New York.
Satyajit sits at Walter's expansive desk, his eyes taking in the many
framed photographs of Walter's large family and Walter himself
with various celebrities, the scripts, the half-empty family-size
popcorn bucket and then a football size balloon of the world.
Satyajit looks around at the walls of the plane, which are adorned
with numerous awards and film posters, most notably the* Great
Dictator, *Charlie Chaplin's satire about Hitler. The poster depicts
Chaplin as Hitler, reclining on a table with the globe in his hand.
Also on display are various works of erotic art. Satyajit is about to
dip into the papal popcorn bucket when the door to the private
quarters opens and his holiness Walter, breezes in with Tom and
Pierre in tow. Satyajit rises with a hint of a deferential bow, about
to greet Walter with a handshake but instead receives a bear power
hug making his speech difficult.*

Walter:	'This is such a great movie, you know what I mean, a fucking great movie.'
Satyajit:	'Thank you, Walter, that means a lot to me.'
Walter:	'You've made me very proud.'
Tom:	'Hey, Sadge!'
Satyajit:	'Tom.'
Pierre:	'Glad you could make the trip with us.'
Satyajit:	'Of course, thank you.'

*Walter releases Satyajit from his embrace and sits, taking the
balloon off the desk and holding it symbolically in the palm of his
hand. Tom and Pierre take seats either side of Satyajit boxing him
in.*

Walter:	'$5000 per hour.'

Satyajit appears puzzled.

> '*This little baby, if you wanted to hire it.*'
> *(Referring to the plane.)*

Satyajit: '*Oh!*'

Walter: '*I don't want to fuck with you, Sachit, I respect you too much. You are a great filmmaker. I work with a lot of directors but with very few filmmakers, know what I mean? You are a great filmmaker, a man of vision,*' Satyajit feigns modesty.

> '*Oh, I am just a storyteller, a simple storyteller.*'

He smiles to Walter in front of him and left and right to Tom and Pierre. They smile back in a patronising kind of way.

Walter: '*Just a storyteller? Don't bullshit me. You are a fucking great simple storyteller, Sashit. The best. I consider you to be one of the top ten, fuck no, top five great simple story tellers in the world.*'

With that, he releases the balloon into the air, allowing it to rise and drift back down onto his palm. The three watch, entranced.

Walter: '*I like you, Sash.*'

Satyajit: '*Thank you.*'

Walter: '*No, I mean it, I like you.*'

Satyajit: '*I like you, too.*'

Walter: '*Hear that, he likes me.*'

Tom: '*Who wouldn't, Walter?*'

Walter: '*Here, try this.*'

He hands his balloon to Satyajit who holds it by the knot.

Walter: '*No, no, in your palm.*'

Satyajit does as he's told and palms the globe.

Walter: '*How's that feel?*'

Satyajit: '*Feels good.*'

Walter: '*I can work with you.*'

Satyajit: '*You can.*'

Walter: '*In the future, I mean.*'

Walter lays his hands on the pile of scripts in front of him.

Walter: '*Now you have to do something for me.*'

Satyajit: '*Oh anything, Walter, anything.*'

Walter: '*Who are your loyalties with, Sashity?*'

Satyajit: '*Oh, with you and Abby, of course, absolutely.*'

Walter: 'That doesn't quite do it for me, Sashy, I'm not feeling it.'

Satyajit: 'With the film?'

Walter: 'You're really hurting me, Sashy.'

Satyajit: 'With you, Walter, with you.'

Walter: 'If you mean that, Sash, I am deeply moved.'

Tom: 'I think he means it, Walter.'

Pierre: 'I'm sure he means it.'

Satyajit: 'I mean it.'

Walter: 'Do you know what the problem with this film is, Ajit?'

Satyajit: 'Is there a problem?'

Pierre: 'A fifty percent problem.'

Walter takes a pin from his desk and pricks the balloon still in Satyajit's hand. BANG!

Walter: 'Obesity.'

Walter pulls open his drawer and pulls out a bag of balloons all the same as the one he burst. He throws several in Satyajit's direction:

Walter: 'Here.'

Then starts to blow one up whilst talking.

Walter: 'It's morbidly obese (blow). That's a metaphor (blow). I like metaphors just like I like the white notes...

Satyajit perplexed again,

On the piano. Know what I'm saying?' *(Continues to blow.)*

Satyajit: 'Morbidly obese, you mean like a tummy tuck here and there?'

Walter: 'Fuck no. Surgery, Sashit. Fucking radical surgery. You got to cut out the fat, and you got to kill that Tiki Tiki Ta music. What the fuck was it?

Satyajit: 'Oh, you mean Dha Tita Taka Dhin Dhin ?

Walter is non the wiser.

Satyajit: Just something Ed and I...'

Walter: 'Who the fuck's Ed?'

Satyajit: 'The editor, he's good, very good. We work well together.'

Walter ties a knot in the balloon and rests it on the desk.

Walter: 'I admire your loyalty, Sajity. God I admire your loyalty.'

He picks up one of the framed photographs,

'Family and friends, that's what it's all about. Family and friends, right?'

Satyajit: 'Yes, family and friends.'

Walter: 'You're not Jewish, are you, Sijit?'

Satyajit: 'No, but I'd like to be someday.'

Walter: 'I just have this empathy with you... It's eh...'

Tom and Pierre together,

'Visceral.'

Walter: 'Yeah visceral and interstitial and kind of difficult to articulate, but I want you to know I don't get it very often but a fucking great visceral interstitial empathy...'

Walter rises and walks around the back of Satyajit putting his hands on Satyajit's shoulders massaging them with increasing strength.

'But I gotta tell you, I'm dying here, Sashit. As God is my witness, I am dying...Tom?'

Tom and Pierre together,

'He's dying.'

Walter: 'I'm dying, Tom's dying, Pierre's dying, the film's dying, we're all dying. Someone's to blame for all this dying. Someone has to be responsible. Any idea who that might be, Sishit?'

Walter's hands knead deep into Satyajit's shoulders.

Satyajit: 'You know this isn't my cut, don't you? This is the editor's cut.'

Walter: 'It hurts me to hear you say that. It must hurt you to say it. I can't bear all this hurt and dying. Believe me this is really stressful...'

Walter reaches in his pocket for some pills while Pierre fills a glass with water and hands it to him. Walter swallows the pills.

'I don't hear you breathing, Sashity, are you with us? Speak to me, relieve this stress, I need to hear your voice.'

Satyajit: 'I have given him a canvas and all the colours he could wish for but he hasn't painted the picture you want.'

214

Walter: 'We want, Sashit, we want!'

Walter resumes his seat.

Walter: 'Fuck, you have such a way with words and you know what? You're standing too close to the canvas, Sash. Metaphorically speaking. You're seeing the detail but not the whole. How can you see the picture when you stand so close to the canvas? You need to move away and look at it with...what...what are the words I'm looking for, Shitty?'

Satyajit: 'Looking for?'

Walter: 'Yes, what are the words I'm looking for?

Satyajit is struggling for an answer

Let me give you a clue, to give a new perspective on something? Two words, the second word rhymes with thighs.'

Walter looks at Tom and Pierre as a child would,

'I like word games.'

Satyajit: 'Ties? Lies? Eyes...? Eyes?'

Walter: 'The second with flesh.'

Satyajit: 'Flesh...'

Walter: 'Flesh, yeah. Flesh and thighs. If I came onto you, and that would never happen, I'd be...'

Satyajit: 'Fresh...eyes.'

Walter looks in shocked amazement,

Walter: 'Did you hear that, boys? He's saying fresh eyes. You're a fucking brain surgeon, Sashy. Why couldn't I think of that? A way with words. You got great talk. I like a car with great torque...'

Walter laughs at his own joke; Pierre and Tom join him.

'You know what I did before movies?'

Satyajit: 'No, Walter, what did you do before movies?

Walter: 'Sell cars.'

Satyajit: 'Sell cars, I didn't know that.'

Walter: 'Well, now you do.'

Walter reaches for a cigar, putting it to his mouth waiting for it to be lit. Tom and Pierre start searching for a lighter or matches.

'There's no difference, selling cars or fucking movies. I've got this fucking expensive car sitting in my dealership costing me money every day it sits here. By the time you

finished dicking with this film, there'll be no customers for the fucking thing. And one thing about selling is you have to know and control your customer, timing. It's all about timing. The cars gotta leave the fucking showroom. I gotta think about how much to spend on publicity and I wanna spend big, because you've made a fucking great movie, but I have to feel the investment is worth it. I don't want to stick this film on the fucking shelf but I may have to do that if I can't see it working, do you get my drift? I will stick this film on the fucking shelf and I don't give a shit what anyone says. Achha?'

Satyajit: *'Achha.'*

Walter: *'Didn't think I could speak Indian did you Sash? I'm an educated man. Are you going to work with me on this?'*

Satyajit: *'Yes of course, Walter'*

Walter: *'I didn't hear you, what did you say.'*

Satyajit: *'Yes, Walter, yes.'*

Walter: *'God, I love you, a fucking genius. Who'd a thought…fresh eyes.'*

Walter pops a cigar in his mouth,

'Where's the fucking lighter?'

Tom and Pierre search the near vicinity,

Walter: *Where's the fucking lighter?*

Tom: *'There isn't one, Walter.'*

Walter: *'Then land the fucking plane, and get me one.'*

The producers of *King's Speech* were pleading poverty when it came to doing my deal, which was the same for all the Heads of Department and possibly the actors too; a 'we're all in this together' argument for accepting a cut in salary frequently put forward on low-budget films. What is never taken into account is the fact that editors normally have a far longer commitment to a film than the other HODs. So for a designer, or DOP, it's a low rate for possibly three months, whereas an editor could be on a film from six to nine months on a low-budget film. If a film is hugely successful, as *King's Speech* was, who benefits financially within the higher echelons of production is clouded in mystery, but it isn't the crew.

Agent Mamy was able to put forward a convincing argument and extract a bit more, but what seemed like a good gesture by the producers at the time was brought into question some months later. As we approached 'picture lock', I was surprisingly told by producer Iain Canning, that they couldn't afford to keep me on, and that the whole of the finishing sound and picture process would happen in my absence, unless of course I was prepared to do it for free. However, he went on to say, if the Weinstein Company (the financiers along with Momentum and the UK Film Council) were unhappy with the edit and were prepared to pay for an extension, then of course I could see the film through to the mix. So, it appeared my only salvation would be an unhappy Harvey. It was a no-win situation because an unhappy Harvey would find another editor anyway. Canning claimed that I shouldn't have been surprised at being 'let go', as this had always been the arrangement. News to me and agent Mamy. I suspect the canny Canning had sweetened my original deal with my own money. It was a similar story for my assistant, Tony Tromp. They could only pay him for a further ten days after my departure but expected him to spread those ten days over five weeks, so that he would be available for any technical problems that might arise. He refused, upsetting the post-production supervisor along the way but reached some compromise so that the film could be finished. Similarly, three days was all that was allocated for the DOP to colour grade the picture, a process that could take up to two weeks, and once again it was hoped the DOP would throw in some free time. Tom Hooper, the director, even offered to pay me out of his own pocket to be at the final mix for a few days but with relationships so soured, I declined.

That apart, working on the film, on the whole, was enjoyable. I hadn't worked with Tom Hooper before but had loved his *The Damned United*, a film about football manager Brian Clough. For someone who has no liking for soccer or sport in general, Hooper was a strange choice for the film but in spite of that, I thought it was really well made.

The shooting ratio for *Kings Speech* (amount of film shot to amount of film appearing in the final cut) was extremely high for a drama. Tony calculated it at seventy-to-one. Scenes were shot multi-camera with not only the conventional wide, medium and close angles but also some shots with somewhat eccentric framing; subjects either occupying a relatively small area of frame, with acres

of empty space around them, 'negative' spaces as Tom would call them or looking out to the short side of frame, away from centre, once again leaving a lot of 'negative' space. The Queen's first meeting with Logue, and Logue's first scene alone with the King are examples. I found these shots jarring initially, but with repeated viewing got used to them. Tom explained he was looking for "a visual analogue to stammering". He used a similar technique on *Damned United* and then the HBO series, *John Adams*.

As with other films, I laid in a temp score during the assembly process. I had difficulty finding anything that would work for George V1's wartime speech and purely by chance came across Beethoven's 7th Symphony when sifting through various film sound tracks at home. Beethoven's 7th popped up on the CD of composer Simon Boswell's *Photographing Fairies*. Although I had a rough, music-less assembly of the sequence, the Beethoven once laid against picture, informed the editing thereafter. Tom responded very positively when shown the assembly, as did *King's Speech* composer Alexandre Desplat; the music remained tied to the sequence to the end. I experimented with other Beethoven tracks for the next music section, post-speech, settling on Piano Concerto No 5, which once again I auditioned to an approving Hooper. Mozart's Concerto for Clarinet guided me through the montage of Lionel's therapy session with George and Elizabeth. This montage broadened story wise, to include the factory visit, which was originally scripted as a separate scene. Finding matching visual moments between the factory and therapy session, swaying feet, stammering voice, etc., gave the sequence a cohesive and as-intended feel.

The volume of material led to many permutations of scenes. Over the ten-week period of the director's cut, scenes came and went and came again, sometimes in the same form, sometimes not. Opinions were canvassed and ideas investigated; Tom's approach to editing is forensic. It's much the same on all films but on some, the introspection is greater than others.

The director's cut was shown to the many producers, most importantly Ian Canning, Emile Sherman and Gareth Unwin, who all gave notes. We addressed them and then screened for Harvey Weinstein on one of his visits to London.

I hadn't seen Harvey for a while and perhaps because of that or because many introductions are made at screenings and I might have misheard, he called me by another name, Xavier!

Subsequent to the screening, we received his thoughts. His notes are of interest because a year or two later, when on another State visit, he invited me to breakfast, ostensibly as a 'thank you' for the editorial advice I had given on *A Week With Marilyn* (most of which was ignored) and a 'thank you' for the work on *King's Speech* (which he had apparently saved by re-editing). I don't think Harvey does tea with labourers, skilled or otherwise, so I was expecting a trap, a rabbit hole to tumble into. I thought I was being 'played', but as I had nothing to offer, I couldn't think why.

Anyway, the good-humoured breakfast was an opportunity to voice old grievances (*Four Feathers*) and to point out that in fact he hadn't saved *King's Speech* after all. He claimed that he had, and that the success of the film was largely down to his notes, most of which, according to him, we had taken on board. I said that we had rejected most of his notes but he was adamant we hadn't, and so it went, yes you did, no we didn't, yes you did. I was back in nursery. I suggested that on returning to New York, he might like to retrieve his notes and then we could go through them together. That didn't happen.

The Notes:

The Weinstein notes started with the statement that the "movie was way too long at 2 hrs" and that "significant trims could be made in the opening and set up". They felt the microphone shots were too protracted along with Bertie's "agonisingly long bout of stammering", but on the other hand, they wanted more crowd shots. Furthermore, the opening temp music was too ominous and there was a lack of context for the film.

The film was released at 1 hr 59 mins. We didn't change the temp for screenings nor substantially the shots in the opening. A caption card was added and additional lines written for the radio announcer to give context.

Further into the film they suggested cutting the marble scene and making trims to Logue's audition piece on account of his Australian accent being too weak to betray his background to the director. They also felt the 'cultural snobbery' exhibited in the scene was distracting. Cutting the scene altogether was also a suggestion.

The marble scene remained as did the audition piece with minor trims.

They felt David took too long returning to the royal dinner table (*no change here*). They questioned the King's euthanasia scene (*eventually cut*) and felt the lead up to the coronation too long (*no change*). Bertie and Elizabeth's visit to the Logue house, 'an empty subplot,' was suggested as a deletion (*it remained*). They considered the moment after the King's big speech anti-climactic and should be tightened (*it was left as is*).

On an emotional level, they wanted more 'tenderness' between Bertie and Logue (*there wasn't any more*) and more warmth from Bertie during the opening Wembley speech (*there wasn't more*). Could Logue's confessional speech at the Abbey be 'amped up'? (*it couldn't*). David's breakdown at his father's bedside played 'too phony' (*we didn't change this substantially*). They also had difficulty with tracking David's state of mind regarding becoming King, 'David is all over the map and we can't get a handle on what's going on'. They wanted to 'streamline his character in order to mitigate the number of contradictory clues to David's sketchy makeup' (*very little change was made in this area*). Could we 'tone down' Timothy Spall's (Churchill) performance? (*we didn't to any great degree*)

On a clarity level, they didn't understand why Baldwin was so disapproving of David's upcoming marriage, particularly as there is mention of the Colonies not caring one way or the other (*we dropped the Colonies reference but as Baldwin clearly states with reference to Wallis Simpson, 'a twice divorced American' not given to giving David exclusive sexual rights, sharing favours with 'a used car salesman', we thought this pretty clear*). Finally, they felt we could do more with Bertie's final speech, "Make it resonate so that it's much more obvious that it united the nation and girded the country for war" (*there were no changes here*).

Fortunately, the film tested with over a 90% approval rating.

During the breakfast brunch, Harvey informed me that at a meeting of King's Speech producers in New York, it was decided to give me (and perhaps others?), £30,000 as a 'thank you' for my part in the success of the film. Iain Canning, apparently agreeing to undertake this amazing act of generosity on returning to London.

Harvey asked if I had received this money and on replying negatively, he assured me he would look into it, which indeed he did. On making further enquiries, Lucas Webb at the Weinstein office, reported back that Iain Canning in response had 'some definitive views on the subject'. That's producer speak for, "A nod's as good as a wink to a blind bat."

I am still waiting.

Editor on set

Chapter 28

*The Intrepid Fox, Soho, midmorning. Ed sits alone drowning his
sorrows. Sad music plays on the jukebox. He looks up to look at his
own reflection in the wall mirror of the bar, slightly distorted by the
warped-by-age glass.*

'Ed Symonds, disfigured, disillusioned, sardonic and ever
so sad. Many years past his prime. Sucked dry by directors
in a career spanning all too many years. Burnt brightly, but
briefly, in an industry at the mercy of fashion but now past
his sell by date; increasingly disenchanted, solitary and
disconnected from reality. Desperately seeking comfort
and soon to be seeking employment as a milkman. '

Annie enters and approaches his table.

Annie: *'There you are, a little early to be drinking?'*

Ed: *'I've been fired.'*

Annie: *'What?'*

Ed: *'Dismissed, discharged, sacked, canned, let go. I
found this typed note in my room this morning;
not even hand written. '*

Ed shows the note to Annie, who reads,

*'Dear Ed, I'm afraid we shall have to let you go. It was the
studio.*

*Thank you for all your wonderful work, your friend
Satyajit Krish. '*

Annie: *'Oh, Ed, I'm so sorry.'*

Ed: *'I also got faxes, one from Weisman and one from
Spear, similar sentiments,*

*...Dear Ed, sorry to let you go, it was the director, thank
you for your wonderful work, don't take it personally, your
friends Walter and Abby. '*

Annie: *'What shits!'*

| Ed: | 'Well, I can't say it wasn't expected; the scores were low, the film does drag, it's all my fault.' |

Jim enters the pub, carrying a gift-wrapped present. He is followed by Nigel and Michael.

Jim:	'OK boss?'
Annie:	'Ed's been fired.'
Jim:	'Yeah, I heard. A Bummer'.
Annie:	'You knew?'
Jim:	'Nige saw the faxes.'
Nigel:	'Yeah, well, no, the receptionist told me.'
Ed:	'The receptionist? How did she know?'
Nigel:	'Security.'

They look at Nige quizzically,

Annie:	'Who told security?'
Nigel:	'The cleaner told security... Rebecca told the cleaner.'
Ed:	'Oh great!'
Jim:	'Here, I brought you something.'

Jim hands Ed the present. He opens it. The cover still has a Book Bargain label on it, showing a price reduced from £12.50 to £5.

| Ed: | '500 essential gardening plants. Thanks Jim, just what I wanted.' |
| Jim: | 'I thought it was something you could take up. I wrote something inside.' |

Ed finds the inscription,

| Ed: | 'It's been epic working with you, good luck in your retirement. Retirement?' |
| Jim: | 'Well, you know, in a manner of speaking. We all signed it, look.' |

As Ed finds the page with signatures, lots of them, Ray walks in,

Ray:	'Got the red card then, eh?'
Annie:	'You knew too?'
Ray:	'It's all over Soho.'
Annie:	'Jesus!'
Michael:	'It's a p...p...p...pisser.'

Ed reading the sentiments on the page:

| Ed: | 'Awesomely sad... Rebecca,' |
| | 'The trouble with referees is that they know the rules but not the game...' |

	'Very philosophical, Ray.'
Ray:	*'The Shanks, my hero.'*
Ed:	*'Yeah.'*

Then reading on,

	'Have a good one, Nigel.'
Annie:	*'A good one?'*
Nigel:	*'A good retirement.'*
Ed:	*'I'm not retiring.'*
Nigel:	*'Bastards.'*
Jim:	*'Christian Bale was fired in favour of DiCaprio but then rehired.'*

And off their puzzled looks:

Jim:	*'On American Psycho.'*
Ray:	*'Yeah, I read that somewhere too.'*
Jim:	*'So there is hope.'*

Mick the bartender approaches,

Mick:	*'What will it be, fellas?'*
Jim:	*'Whose lob?'*
Ed:	*'Mine, I guess.'*
Jim:	*'Pint please, Mick.'*
Nigel:	*'Me too, Mick.'*
Michael:	*'Same for me.'*
Annie:	*'White wine and soda.'*
Mick:	*'Ed, another? On the house.'*
Ed:	*'Same again, thanks Mick.'*
Jim:	*'Say the word boss, just say the word. Solidarity, right, lads?'*

Silence.

| **Jim:** | *'Anyone know who the new boy is?* |

With the trials and tribulations of *Law Abiding* and *Kings Speech* behind me it was time for a re-alignment of my chakras at the JP Davidson editors retreat; this came in the shape of documentary, *Down by the River*; Hugh Laurie's homage to many of his Blues heroes. For Laurie, too, it was an escape of a kind, from the confines of the studio and the long running series *House*, to the freedom of the roads leading to New Orleans. As Laurie says in the film when referring to Professor Longhair's wonderful 'Tipitina',

"The clouds parted and the sunshine fell upon my childish face." Being such a huge fan of jazz, blues and gospel, Laurie's journey, both emotional and on the road, was a joy to work on. Directed once again by JP Davidson and shot by long-time friend Andrew Dunn (*The Monocled Mutineer, Madness of King George, The Crucible* and *The Lady in the Van*), I would happily have left the many hours of material uncut: Laurie in recording studios, driving from Texas to New Orleans, jamming and hamming it up on route, interviews with him and co-contributors, performing in New Orleans. Those were the elements making up the documentary to be linked, once cut, by an informal Laurie voice over. In terms of structure, the film would start in Texas and finish in New Orleans and necessarily, scenes shot on route would have to follow in geographical order, other than that, there was complete freedom. Such freedom leads to over indulgence and a role reversal, with the JP encouraging me to cut when my inclination was not to. One viewing for the executives and another for Hugh Laurie, minor changes and it was out the door. Bliss!

Flying in the Emirates first class suite to Dubai was a treat unlikely to be repeated again. It was all thanks to visual effects supervisor Simon Frame, who had recommended me to producer Behrooz Paknahad. I was on my way to meet Iranian director Ahmad Reza Darvish and the other producers of the film *Doomsday*, later to be retitled, *Rooze Rastakhiz*. The script, translated into English from Farsi, for my benefit and Simon's, was about the fissure between the Shias and Sunnis, set in biblical times. It was independently financed by Middle East financiers, although, when in its infancy, the Iranian government had some financial involvement. The government withdrew this finance following a Darvish directed commercial on behalf of the more liberal and enlightened opposition party during an election some years earlier. Both Reza and Behrooz had fallen fowl of the Iranian authorities over the years, but Reza's status within the country had given him some degree of protection, less so for Behrooz whose contribution to anti-government newspaper articles landed him in detention. The script had to have government approval and during the filming, government officials were sometimes present to make sure that the director didn't stray from the approved path.

Between playing with all the toys in the first class suite, I re-read the script and once again looked at the DVD of selected

material I had been sent, back in England. It was all very impressive: the scale, staging, performances, locations and shot compositions.

Dubai had been chosen because I was unable to get a visa for Iran in time. I was met by Behrooz at the airport and driven straight to the hotel, some distance from the centre. Although desperate to see the sights, the view from a car window was as close as I was going to get during this two-day stay. At the hotel waiting for me were: Reza, executive producer Taghi Aligholizadeh, post-supervisor Kamran Saharkhiz and Moj Oskouei, a writer and filmmaker and the only lady amongst us. Moj would come to interpret when Reza and I worked together in London. All apart from the director spoke English. The welcome was extremely warm, respectful and friendly. This was probably my first experience of an auteur director (most deserving of the overused 'film by' credit), but there was nothing in his demeanour that suggested I would have a subservient role. The epic film, a labour of love and very personal to him, had already been shot (off and on over nine months) in Iran and Kuwait (a second choice, as plans to shoot in Syria had to be abandoned). Most of the many extras were Iranian soldiers.

We discussed schedules and working practices but in all of this, they were very happy to accommodate my preferences. Reza, although I'm sure used to being in the cutting room from day one, agreed to let me have three weeks on my own in London making the first assembly. There was talk of working in Tehran after that, but we suspected the issue of visas would become an insurmountable problem.

An Indian passport would have eased my entry, but that possibility was later denied when the Indian High Commission in London ignored my application, in spite of being born in New Delhi.

Over the next two days in Dubai, we drove back and forth to a local facility house; the impressive Burj Khalifa, Burj Al Arab and Palm Islands tantalisingly close but out of reach, only being seen through the window of a hired mini-bus. My sightseeing was limited to a nondescript office building on a small trading estate in a suburb of Dubai bordering on the desert. I could have been in Betjeman's Slough or on an industrial Los Angeles wasteland.

I watched as much of the 70 hours of rushes they had brought with them as I could. I watched the screen while being aware that

Reza, Behrooz, Kamran and Moj were watching me for reactions, or chatted in Farsi. With the translated script and shooting notes in front of me, I was able to follow much of what was being said and get a good feel for the material, stopping occasionally for question and answer. Once again, I was very impressed but was slightly concerned that much of the editing had been done in the camera. Reza had imagined the edit of a scene in his head and shot accordingly. When on single shots, he wouldn't always cover the whole scene but would cut the camera after a line or two, then start a new shot for further lines and so on. Consequently, reaction shots to what was being said by other characters were not in much evidence. Neither was there an abundance of overlapping action, making edits from one shot to another difficult.

This lack of coverage did slightly compromise the editing but on the other hand, with fewer options it did facilitate a quicker assembly.

Back in the UK, I set up shop with a Lightworks and thankfully found an assistant, Lucy Donaldson, who was prepared to take on this, to her, alien machine. Technically, there were further problems, as the original material had been prepared for editing software, Final Cut Pro, but between them, Lucy and Kamran were able to iron out those problems.

Surprisingly, the foreign language didn't present too much of an obstacle; the pauses in sentences and inflections in speech helped to make sense of what was being said. Choosing takes (there weren't that many), was also less difficult than one would have imagined. Fluency and hesitations are noticeable in any language and the conviction behind delivered lines on different takes relatively easy to distinguish. The biggest problems arose when the actors improvised, had minor fluffs or spoke words not in the script. As expected, dialogue scenes fell into place quite quickly and there was so much coverage of the action sequences that once again they didn't present too many problems, although time would show that in spite of helpful artist sketches to guide me, my interpretation of historical battles was sometimes a reinvention of the truth.

When Reza and Moj arrived after three weeks, I had a rather long three-hour assembly to show them. Considering the film's importance to Reza, I was nervous of any adverse reaction but fortunately during the screening, I picked up on a heartening vibe with warm squeezes on my shoulder and the occasional, 'good,

good'. In spite of language errors in the edit and incorrect telling of some of the battle scenes and some questioning of the temp music, he was very generous in his response.

We then worked on the film in more detail, changing takes for performance and discussing as best we could in the circumstances, why I had cut scenes the way I had or why other scenes had been transposed or deleted. The deeper we got into the edit the more Reza would have me 'stop', 'go back', 'go forward', 'stop', 'go back'. It was very frustrating at times for all of us but Reza remained good-natured throughout. I was mindful of the producer's wish to have a tight domestic cut and an even tighter international one but Reza was reluctant to lose much initially. He treated the material, particularly anything regarding Hussein with such reverence that it was difficult to cut anything out, "History is history, we cannot change it." But his mind wasn't entirely closed and he indulged me with alternative shorter assemblies which he quickly dispatched to 'international'; 'international' being of much less interest to him. In all this he was insistent on having lunch breaks (paid for by the production), and not working beyond 6 pm. Amusingly, there would also be frequent smoking breaks during the day.

By this point, my assistant Lucy, had painstakingly subtitled the whole film, making further editing much easier.

Behrooz joined us for a few weeks and then later the executives came: just to enjoy hanging around in the cutting room, giving minor thoughts, taking us all to lunch and leaving. Their attendance was very much a courtesy as this was clearly Reza's film, their main concern being a shortened international version that might get distribution in the west.

I sent a subtitled copy of the shorter version to Negeen Yazdi (also Iranian), then Executive Vice President Acquisitions and Co-Productions, The Weinstein Company, in the hope of arousing interest, but failed to do so.

In 2014, the domestic version premiered at the 32nd Fajr International Film Festival in Tehran but was shown only once before sparking protests for showing the face of the prophet and his household. The government stopped release of the film until further changes were made to the film by Darvish, such as blanking out the faces of the Holinesses. Sadly, the movie's fate hangs in the balance

Chapter 29

Cutting room. A grey day; the day of departure. Ed is collecting personal items and placing them in a box. There are no sounds of film activity, as there is no one around to make them. As he packs, we hear in voice over,

Jim: 'We all know how difficult this must be for you, Satyajit.'

Satyajit: 'Oh yes, I have been under a lot of pressure.'

Jim: 'We'll do what it takes to re-boot the system, right, lads?'

Satyajit: 'Yes, I would like that.'

Nigel: 'We're right behind you, Satyajit.'

Interior coffee shop, Soho. The conversation continues. The group, Satyajit, Jim, Nigel, Ray, Michael and Annie, sit at a round table having coffee and croissants.

Michael: 'I guess this will mean another test screening...more...f...f...f...f.'

Annie: 'Fucking air miles?'

Michael: 'Focus groups.'

Satyajit: 'We have reached a cross road and are experiencing a moment of crisis. This crisis is inevitably accompanied with some sort of pain. A pain so severe that we wonder if we can survive it. But it is a shared emotion. Possibly, a life altering emotion. The question we each have to face is, what do we want to do with that and in my case, and I hope you all want to join me in this, in my case, I want to elevate this moment into something beautiful.'

Satyajit holds out his hands, which are grasped by Jim on one side and Michael on the other. They in turn hold out their hands, Jim to Nigel and Michael to Ray.

Satyajit:	'A ring of love.'

They close their eyes. Annie, between Nigel and Ray, doesn't participate, forcing Ray and Nigel to connect behind her.

They sit in silence.

Satyajit:	'We worship The Three-eyed One.'
Annie:	'Would that be Weisman?'
Satyajit:	'Who is fragrant and Who nourishes well all beings; may He liberate us from false paths for the sake of immortality even as the cucumber is severed from its bondage. (Pause)
Jim:	'I'm beginning to feel it, Satyajit.'
Nigel:	'Me too.'
Annie:	'What exactly are you beginning to feel, Nige? The cucumber?'
Nigel:	'It.'
Annie:	'It?'
Ray:	'I would just like to say, just for the record...

All eyes open and turn to Ray in expectation of dissent, but

 ...I am here for the film.'

All (except Annie):	'Hear, hear!'
Annie:	'I think I should leave...'
Michael:	'N...n...no! Annie, you can't, your first loyalty is to the f...f...f.'
Annie:	'Fucking film?'
Michael:	'Film.'
Satyajit:	'Exactly, your loyalties shouldn't be with me, nor Ed, just the film.'
Annie:	'Don't you see they've fired Ed? Perhaps they'll fire all of us?'
Satyajit:	'Oh no, I wouldn't let that happen.'

There is something of the mercenary in taking the editing chair from someone else and particularly when the chair is still warm. It's usually short term and well paid ('fresh' eyes being paid substantially more than perceived 'rotting' ones), it's better than unemployment, there's less of an emotional attachment to the project and then there's the carrot of a joint credit in return for doing

relatively little; plus it's great to have one's ego stroked by being asked. The downside is, it just feels a little grubby.

Agreeing to do recuts is something I do now with trepidation, particularly after being at the receiving end a few too many times and particularly if the request is being forced on the director. To have someone new come in and essentially remodel a film that has been lovingly worked on for months and months is inviting trouble. I worked for a few weeks on *Birth* at the behest of one of the studio executives, Ileen Maisel, that film now being in the hands of the assistant editor Claus Wehlisch, the editor, Sam Sneade having left for another project. Given a week on my own, I then presented my effort to director Jonathan Glazer, whose response, 'What have you done to my film? You've made it too genre too mainstream?' was so deflating and undermining that the only consolation I could find was in a recently heard thought that alienation is good for one's art. However, after that initial reaction, Jonathan did reconsider some of the changes, accepting a few and altering others to suit his fancy.

The process of selecting a 'fresh eye' has changed over the years. In the past, the studios or producers have someone in mind to bring in and 'doctor' a problem film. Today, the 'problem' is put out to tender; the film posted on a secure website for two or three editors to view and come up with their 'fixes', either in terms of written notes or in the form of a conference call viva, "so we are really interested in your thoughts about the film?" It's an exam that requires hours of study and preparation, both in terms of watching the film several times and on reading the script. These calls can be excruciating: drowning in silence with non-responsive executive listeners. The kiss of death, when terminating the call, is on hearing, "we are such great admirers of your work." It's an illusion of respect because the likelihood of getting a courtesy call back, or email, thanking you for your troubles (unpaid of course) along with a polite rejection are remote, more often, you don't hear anything at all. Or, on making enquiries yourself, you simply get an annoyingly palliative message from your agent several days later, "Oh yes, they decided to go another way." The editor with the best submission gets the job, the others are right clicked and deleted; out of sight and obviously out of mind.

In any event, the producers have your notes!

I was approached by StudioCanal to look at *Bel Ami* and then slightly later, a French film, *L'Écume de jours* (English title, *Mood*

Indigo). I think *Bel Ami* had had a tortured history, initially been cut by Masahiro Hirakubo for directors, Declan Donnellan and Nick Ormerod and later, after Masahiro and the directors had left, by Gavin Buckley, supervised by producer Uberto Pasolini. When I started, the film was in limbo.

There were three versions of the film to look at: the initial long assembly, the director's cut and the producer's cut. As on previous occasions, I emailed my notes on *Bel Ami* to StudioCanal first, to see if they thought my ideas worth pursuing:

Setting the film in the context of France's political and economic aspirations is difficult but perhaps best addressed with a card up front.

Opening/Restaurant – *the Director's cut is better here although I feel even more could be made of the opening scene. Wider shots, coins and anything else like CU's of George.*

I think intercutting the lodgings and restaurant is better than treating the scenes separately but the execution in Uberto's cut isn't quite right. A possible experiment would be to put the restaurant in George's thoughts, and removing the thoughts when washing his face. Then going straight to La Gavotte. In any event the cockroach should go back in and the voice-over removed throughout.

La Gavotte – *Uberto's cut is better, but I am inclined to put the sex back in. Interestingly, George doing the prostitutes hair, post sex (long assembly) shows a tender side to him not witnessed anywhere else. Although, admittedly, his expression while doing it looks like he's about to bite her neck!*

Dinner – *It isn't absolutely clear to me why the butler is so disdainful of George. I guess it's the shoes, perhaps if there is a closer shot?*

I felt the meeting with Madeleine a little odd. Where are the other guests? This scene only makes sense to me if the rest of the scene as scripted – the arrival of the beauties and then their men – has been shot. The scripted scene reads really well, I hope it's there. The Uberto version of the dinner itself is inelegantly cut. It does feel chopped about and the eye line's quite a mess. (I think there are moments throughout out the film, which I would cut differently in terms of internal dialogue cutting. I appreciate this is a matter of taste and this cut has passed through a few hands, so I don't know to what extent I would get into this!)

Madeleine helps George – *I like this scene a lot. Again, there is some interesting material not in Uberto's cut. There are some BCU's of Madeleine as there were of Clotilde (the Director's Cut and Long Assembly) in the dinner, which may have a place, going into George's head, etc. In any event, Madeleine's declaration not to get involved with him I think should be tried again. It makes sense of 'go and see Clotilde' if she articulates what is obviously on his mind and also puts down a delicious challenge, 'you'll never have me as a mistress' to George.*

Vaudrec will always be an enigma I guess. Pity.

Newspaper Office – *Possibly, better shots of exteriors in long assembly. Interior cutting is too snatched but a bigger problem for me is in understanding why Forestier has suddenly turned against him. Was it never his intention to help him that much? Not sure if there's a solution.*

George's Lodgings – *I love the immediacy of cutting straight to them on the bed (Director's cut) but equally, George preparing for her visit has some charm and we do get a good look at his place in daylight. Having said that it does look like a set.*

Montage sex/dancing – *Works really well.*

La Gavotte – *I wonder having George being more intimate (doing hair) with the prostitute earlier would explain her exposing him to Clotilde? And so on…*

Based on these notes, a cutting room was opened, and with assistant Tony Tromp, I started work.

Having now made a fourth version, this was shown first to Jenny Borgars and her assistant Leslie Stewart in the cutting room and then later by DVD to Uberto. I think it's fair to say that his response was less enthusiastic than theirs. There was then a degree of to-ing and fro-ing between Jenny and Uberto by phone and email while I escaped the country for a week. On returning, I sat with both of them in the cutting room to watch the film and discuss. Jenny having been diplomatic and supportive of my version, then made her escape to her office, leaving Uberto and me to thrash it out.

We worked together on a fifth cut over several days but as likeable as Uberto is, in a stubborn, pig headed kind of way, I found it frustrating, venting my frustrations to both Jenny and Leslie:

I think the opening is particularly bad, the omission of moments inside George's head also a mistake.

The dinner scene and letter writing are poor although I have tried to finesse his cut.

The second Gavotte sequence is also not good.

Reels 5 and 6 I have left but they contain a lot of bad editing, which as Uberto probably rightly claims, no one will notice.

I also differ with Uberto's music choices in some areas.

Sadly, I agree with Uberto's observation that bad editing will not be noticed.

I don't watch films with a critical eye, unless something that is snatched, mistimed, over-cut or particularly slow draws my attention to it, and then I start to fixate on the editing. Unfortunately, emotional responses to what is being watched can be achieved by both good and bad presentation, and if the desired response is there, who cares if it's achieved by the latter?

I left the film with Uberto having taken it as far as I could. Gavin was re-employed to make further changes with Masahiro being invited back to give his blessing to the final cut.

While working on Bel Ami I received an email from Sam Mendes and one from David Parfitt.

Agent on set (for lunch)

234

Chapter 30

A sunny day in Soho. An Interflora van pulls away from the cutting room facility and joins the traffic. Pierre exits from the building as a black stretched limousine arrives and parks in the space vacated by the van. Pierre rushes to open the car door.

Pierre: *'Welcome, welcome. Pierre Alonso. I'm so excited at the prospect of working with you.'*

Upstairs in the building Ed's cutting room is full of flowers. We feature a note attached to one bouquet, it reads, 'Welcome to the production-from the director and producers of Courage.*' Satyajit, Tom, Annie, Michael, Jim and Nigel are seated or standing in the room. So silent, one could hear a pin drop.*

There's a ping from the lift generating a collective shock and then a buzz of excitement.

Pierre exits the lift, and followed by Xavier and Barbie, enters the room; Xavier dressed in camouflage suit, more suited to the jungle, and Barbie having the appearance of an overweight Barbie doll. They pause momentarily at the door. Tom gets up to welcome them, the others following suit, standing in a line of tribute, diminishing in importance, front to back; Satyajit to the fore, Nigel to the rear. Pierre makes introductions,

Pierre: *'This is Satyajit Krish, the director.'*

Satyajit extends his hand.

Xavier: *'What a shit hole, Barbie take a note:*
 I want the walls painted, chairs replaced, new curtains, carpet and a fresh bowl of fruit every day. Make sure those unhygienic mugs are thrown out and replaced with plastic disposable ones...and who is responsible for our accommodation?'

From down the line Michael pipes up,

Michael: *'I'm Michael, the p...p...p...'*

Xavier:	'Xavier Schwarz, re-director by appointment. Barbara Doll, assistant re-director. We want to move out of our hotel. We need an apartment…each…somewhere in Mayfair. Six month let maybe twelve depending upon circumstances, and we need a cash float something to the tune of say $500 a day and a car available to us, avec chauffeur, at weekends. My door will be kept closed and no one, no one will be allowed in until I say so, is that clear?'

Xavier faces Satyajit,

'Now, who are you?

Satyajit: 'Satyajit Krish, humble director. I have longed for this moment of artistic co-operation. I have much admired your work…'

Xavier: 'Tom, good to see you.'

Xavier has already moved on,

Tom: 'Welcome, Xavier.'

Xavier: 'And you?'

Jim: 'Jim, sound designer…'

Annie: 'Annie Willow, first assistant editor.'

Xavier: 'I have a first assistant, d'you know what that makes you?'

Barbie, operatically singing,

'Redundant.'

Xavier: 'Or if you must stay on, you could be assistant to my assistant's assistant?'

Michael: 'We don't have the budget…'

Barbie: 'I can't work with just one assistant, I shall need three.'

Xavier: 'D'you hear that, M…M…Michael?'

Annie: 'I shall have to leave then.'

Xavier: 'Oh do stay until the end of the week at least, then I can persecute the hell out of you.
Let's cut to the chase. Get the show on the road. Start the ball rolling. Begin the beguine. Kick ass and flip the script.
Your film is in trouble and I will fix it.'

MUSIC INTRO TO RAP SONG

Xavier: *I'M A SWINGER, HUMDINGER*
A FILMIC GUNSLINGER,
I'M THE BOAST,
THE TOAST
AN ETHEREAL HOST
OF A GIFT SO SUBLIME THE
ARCHITECT OF TIME
I AM THE MODERN CREATOR
A STORY ANIMATOR,
AN EDIT AGITATOR.
SO SHOW ME A SCENE
PUT IT UP ON THE SCREEN AND I'LL
SHOW YOU WHERE YOU'VE BEEN,
GOING WRONG, DING-DONG.
SO...
TAKE A FRAME FROM OVER HERE
PULL A FRAME FROM OVER THERE
GIVE A LITTLE HEAD THAT
MEANS GIVING IT SOME AIR
OH MAN THIS HAS NO SWING,
NO RESONATING RING
NO DING-A-LING-A-LING,
GOTTA MAKE THE SUCKER SING

BARBIE/TOM/PIERRE XAVIER

GO XAVIER GO *THIS BABY'S OUT OF TUNE*
YOU GOTTA LOSE THAT SWOON
I AIN'T GOING TO LET IT BE
UNTIL IT MOVES LIKE MTV

ANNIE

THIS IS NOT THE WAY IT SHOULD *BARBIE, CUT ME FIVE (hand*
BE *on hand)*
IS THERE NO ONE HERE WHO CAN *LET'S GIVE IT SOME MORE*
SEE? *JIVE*
THE FILM IS DEBASED *THE SKILL IS KNOWING*
ED'S WORK ERASED *WHEN TO LEAVE (pointedly at*
WHAT HAPPENED TO *Annie)*
SOLIDARITY? *AND WHEN TO ARRIVE*

JIM/NIGEL **XAVIER**

I THINK I SPEAK FOR ALL US *MY CUTS ARE REALLY*
HURTIN'

HERE

IN SAYING THAT OUR ALLEGIENCE

IS CLEAR
THANK ED FOR THE GIG
BUT WE DON'T GIVE A FIG
OUR PRIDE, IS IN A PINT OF BEER

MY BEAT FOR SURE IS WORKIN'
IT'S QUITE INTOXICATIN'

LIKE HALLUCINATIN'
I'M FEELING HIGH,
ABOUT TO FLY
I DON'T NEED WINGS TO TOUCH
THE SKY

Montage

We watch as the slowly paced lake scene is being transformed into something more 'hip'. Arbitrary whip pans, flash cuts, a hip-hop kind of editing. Schwartz works maniacally moving to the music. Barbie assists by feeding him fruit and posing. Annie starts to pack her things and leaves. Michael, Jim and Nigel fix a red and green light outside Ed's door.

BARBIE/TOM/PIERRE

GO XAVIER GO

XAVIER

GIVE ME TIME AND THIS BABY'S
MINE
THIS KIND OF THEFT
JUST AIN'T NO
CRIME

SATYAJIT
HE'S LIKE A
FARMER IN THE
FIELD
SEPARATING
WHEAT FROM THE
CHAFF

XAVIER
LET THE SLIDE AND
PIZZICATO
PLAY
I'M GOING TO RING THE
CHANGES

AND CHASE THE OILY
SHAKE AWAY

Satyajit is eased out the door by Tom and Pierre.

BARBIE/TOM/PIERRE/NIGEL/JIM/ MICHAEL
YOUR WHEAT IS INDIGESTIBLE
THE AUDIENCE NEEDS ARE…
NAFF NAFF NAFF NAFF
NAFF NAFF NAFF NAFF
GO XAVIER GO XAVIER.
YOU'RE IN THE KNOW XAVIER.
FLOW XAVIER, SHOW XAVIER
THE WAY TO GO XAVIER
GO XAVIER GO XAVIER GO XAVIER GO

End montage

The Bond picture, *Skyfall*, was a long shot. Both Sam and I knew that when he asked if I would be interested in cutting the film. Very much the domain of the action editor, my CV would almost certainly rule me out. But in spite of that, he thought I should meet Barbara Broccoli just for the hell of it. So for the hell of it, I turned up at the Eon palatial Piccadilly offices and met both Broccoli and Michael Wilson and was taken to lunch. It was an awkward situation, particularly for them. I don't think they had any intention of hiring me but felt obliged to go through the motions for Sam's sake. With so many of the Mendes regular (non-action movie) crew having to be absorbed into the *Bond* way of doing things, a line had to be drawn somewhere in terms of risk assessment and I was to be that line. We talked of courses and horses for courses and my response to the first action-packed ten minutes of *Quantum of Solace,* which exposed my unsuitability for *Bond* because those ten minutes not only lacked comprehension but induced a loss of sensation. Broccoli made a good fist of appearing interested in me but Wilson was difficult to read; rather like George Smiley, John Le Carré's creation – the antithesis of Bond. I was being judged by a practitioner of silent, disciplined, intelligence work and I sensed I was failing.

Lunch ended with a bracing stroll back to Eon offices in the February sun and a polite parting with no acceptance or rejection; that came in a call a day or two later, in which an apologetic

Barbara gave me the thumbs down with a consoling 'perhaps there is something else we can do together'. Sam emailed his disappointment with a similar sentiment.

"So what makes you think you can cut an action movie?"

David's email was in relation to *A Week with Marilyn*, which he was producing for director Simon Curtis. Both were happy with the film and happy with the work of their editor, Adam Recht, but Harvey Weinstein wasn't.

For good and bad, The Weinstein Company were behind the film and having viewed the director's cut, felt, typically, that 'it needed work'. David hoped that my involvement might prevent or at least delay the inevitable 'amphibious landing' on Recht's head. Harvey had problems but hadn't specified what they were apart from:

"An important note from the beginning, can we look at more wide shots please? There is too much close up work and we don't want this to feel like television."

With Recht's approval, my involvement was one drawn out over several weeks, a few hours here and there and with Adam at the controls. I really couldn't see much wrong with the film but made some suggestions in the hope that they would soothe the fevered Harvey brow. It worked for a while, but inevitably, the film was taken away and re-cut by Harvey's flavour-of-the-month editor in New York; Curtis and Parfitt schlepping across to approve the changes. There were changes and exchanges, one notably between

Harvey and David, full of expletives and physical threats. Not hard to guess who was on the receiving end but someone's career was going to be terminated.

Having collaborated with Weinstein on many films, this latest humiliation was the final straw for Parfitt, determining never to work with the man again; on his Weinstein scales, abuse had dropped below benefits. I don't doubt that Harvey is aware that for most in the industry, the scales hold in his favour.

On the whole I think the film survived the Weinstein treatment, which included the participation of yet another Weinstein editor but the first thirty minutes was notable for its Saint Vitus Dance editing style of relentless cutting (very fashionable these days); cruelly and falsely attributed to Adam Recht in a review by Box Office:

"Indifferently shot, My Week with Marilyn is manically cut by Editor Adam Recht: in the first 30 minutes, there's a new shot nearly every three seconds, as if to convey energy through sheer image changing. The effect is annoying and sometimes incoherent; during a simple 30-sec speech by Branagh, Curtis and Recht cut between no less than four different shots of his face, all of them randomly timed and from equally arbitrary angles."

Keeping his credit on the film was imperative for Adam, not only to acknowledge his contribution to its success, but also to give him film 'cred' and the hope of more movie offers. The compromise though, is having to accept other people's work as yours.

Unfortunately, in ignorance of how films are made, critics often misdirect criticism and for that matter praise.

Adam returned to work in television.

Writer/Director Yaron Zilberman sent me the script of *A Late Quartet* a year or so earlier, which I loved but couldn't work on, owing to other commitments. We had a brief telephone conversation, I expressed my regrets, wished him good luck and I thought that was the end of it. The appealing story follows the intricacies and passionate relationships between the members of a world-renowned string quartet, who struggle to stay together on the eve of their 25th anniversary season in the face of death, competing egos and insuppressible lust. With such a good script and cast (Philip Seymour Hoffman, Christopher Walken, Catherine Keener, Mark Ivanir and Imogen Poots) I was surprised and flattered to have him approach me again to have a final pass on the cut. I suspect that Yaron was very hands on during his edit (it transpired he could work the Avid) and the version he was sending me was very much what he wanted released, but I also suspect there were others, perhaps the producers and actors, who had some reservations. Yuval Shar, the editor, had already returned home to Israel and according to Yaron, was happy about my participation.

Initially, I was sent a DVD from New York (and later a drive with the rushes), to see if I had any thoughts and whether those thoughts, from his point of view, were worth investigating. I made a number of suggestions by email, to which he later responded with a phone call. We discussed my notes and agreed to my trying to implement these notes over a four-week period in New York.

Like Jonathan Glazer (*Birth*), Yaron left me alone for the first week, staying away from the cutting room with the occasional 'how's it going?' call. There was no trace of anxiety in his voice, rather, enthusiasm. Considering how much he'd personally been involved with the edit and with his investment in the film emotionally, financially and in terms of time, it couldn't have been an easy week.

Central to the film is Beethoven's Op 131, String Quartet No 14, a quartet of seven movements instead of the more conventional four. We see the group rehearsing it several times and then eventually playing it in concert. In Yaron's cut, much of the Opus was used as temp score as well but I felt by using it so much, it

diminished the rehearsal sequences and final performance; it's presence as score intruded on scenes too much rather than just playing a supporting role. I replaced much of his temp with more contemporary music (from composers Thomas Newman and Mark Adler amongst others), trying to introduce a contrasting texture with energy and sometimes humour, which seemed to be musically lacking in the film. In terms of shots, I felt there was a lack of coverage (that is not enough variety of shot to cover a scene). The exception being the concert performance, which was lavishly covered with several cameras.

Some scenes needed trimming front and end, others deleting or repositioning. The internal cutting of scenes, such as Robert with Gabriella in the park; Alexandra moving in; the Flamenco montage; Juliette finding Robert with Alexandra; Daniel with Robert in the hotel room; Robert and Juliette arguing outside the auction house all needed reworking. I thought the group rehearsing and performing were beautifully edited and I would have left them alone, but Yaron, very savvy in matters of Beethoven, wanted to finesse them to the frame.

On viewing my cut, Yaron, not necessarily liking my temp music choices at least understood their objective and replaced some of them with classical pieces of a similar tone. At least it provided a good guide for the eventual composer, Angelo Badalamenti. We had separate viewings in the cutting room with Seymour Hoffman, Keener and Ivanir all voicing their approval and later with a larger audience in a theatre, with a similar result. I left the film happy, but knowing Yaron would continue to fiddle and make changes in my absence, and he did.

As I approached the end of my re-edit on *Late Quartet*, I received a call from producer Liz Karlsen, about *Great Expectations*. Director Mike Newell's editor, Jon Gregory, was unable to start the project, so would I be interested? Some alarm bells rang, as Karlsen had been part of the double act that fired me from *Mrs Harris*, a fact I was delighted to bring up in conversation with her. She responded to teasing with good grace, agreeing with me that Mike Newell would probably not need nurturing, so at least from that point of view I was secure.

Working on a remake, particularly the umpteenth for the big screen, one is on a hiding to nothing, particularly when the 1946 David Lean version is considered a masterpiece. As with the earlier

Far from the Madding Crowd, time has not served those classics well in terms of performance and technique. But saying that is of course, blasphemous. The new version was already in production, and as I still had a week or so on *Quartet*, rushes were posted on a secure website for me to watch and comment on in emails to Newell. On returning to London, we met properly at his house and over a glass or two of wine, bonded. All the gossip on him being a total delight, socially and professionally are well founded.

The reviews were mixed but not, once again, without humour:

"So it takes a special type of talent to turn it into a film quite this flat."

—Catherine Shoard, film reviewer, Guardian News & Media

"But the crime of this Great Expectations is that it has no expectations of itself, or us. It's less an adaptation than a recapitulation."

—Robbie Collin, Telegraph

"Great Expectations runs about 400-600 pages, depending on the edition, this film's running time is 128 minutes, which means, applying the screenplay formula of one page per minute, that screenwriter David Nicholls checked into a nervous hospital after adapting this thing. Maybe Editor Tariq Anwar joined him. Scenes cruise by at an even clip, like someone rushing to work, almost late but not wanting to break an embarrassing sweat."

—RogerEbert.com

Reviewers are skilled comedic wordsmiths; they like to deal in hyperbole. They pride themselves on honest opinion but invariably put their prejudices in print. They are self-regarding, sadistic and sycophantic in equal measure, faceless in a non-literal sense and self-appointed kingmakers and assassins. They fire their poisoned arrows from the safety of their office keypads to land on unsuspecting filmmakers on turning a page of a newspaper or internet site. There is no redress for the victim, redress being time consuming, a waste of time and taken as sour grapes. They write as much to impress themselves and

each other, and to influence opinion and box office. Their voices are one of presumed expertise, a dissertation of doctoral proportions, but in reality, they are largely ignorant of the film making process.

Studio Executive arriving on set

Chapter 31

"It took an act of courage to make a film as bad as this."

Small towers of filled questionnaires, focus group comments and Research Group statistics from the test screening, litter Satyajit's office. The olive, nut and seed bowls are empty. The bowl-filler Rebecca, along with Annie, has long since departed, being found surplus to requirements under the new regime. A video recording of Satyajit's Late Show interview is playing on the television. Krish watches from an armchair, sub-consciously pulling on the neck of a rubber balloon in his hands. The videotape is not giving him the succour he was hoping for, in fact, witnessing the demolition of Thamesmead Sharon's artwork, the irony of his present situation is not lost on him. He is a lonely, distressed and dispossessed director.

The TV sound is barely audible in Satyajit's head, similarly the street traffic in spite of the sash window being open. Satyajit's ears are tuned into the unfamiliar noises passing through the wall of the adjoining cutting room: electronic whooshes and bangs, hip-hop music, fragmented bits of dialogue and cutting room laughter. Scenes so carefully constructed now being cruelly tortured with insensitivity and apparent hilarity; at least, those were the thoughts he was allowing to run riot in his head.

He looks at the deflated balloon, one given to him by Walter, and feels an immediate affinity. In an attempt to puff up the balloon and his ego, he stretches its neck once more, then blows into the opening until it takes the shape of the Walter's world. He pats it up into the air, allowing it to fall back to his palm, then smacks it back up again towards the ceiling. This time the balloon, on descending, is carried away from him by a light breeze from the window; it drifts out of the open door into the corridor beyond. Satyajit rises and follows the balloon, which leads him to Xavier's door. Above the door, two light bulbs, red and green, that we saw being fixed

earlier. The red light is lit. He tries to open the door but it is locked. The door handle noise is heard from within, the sounds inside abruptly stopping. Satyajit freezes, not wishing to be discovered. He looks around at the other cutting rooms, doors once open to invite entry, now all forbiddingly closed. The hip-hop starts again. He returns to his office, closing the door; the closing door's draft, sending the balloon upwards once more.

Montage

Close shot of a world balloon drifting down. It lands on a foot and is kicked back up.

We pull wide to reveal Walter, alone in his office, playing, not

with himself but by himself. The balloon is kicked from one foot to another, then from hand to hand, then from hand to head, then, with more practiced trickery a reverse kick with the heel, all guided by the pictures on the wall.

He is trying to time his movements to Tchaikovsky's Dance of the Sugar Plum Fairy, playing on his office boom box. His movements are surprisingly graceful for a large, uncoordinated, rhythmically challenged person.

Los Angeles. Abby Spear's office. A gun is pulled from a desk drawer, revealing Spears holding it. She is SAD: stressed, anxious and depressed. She toys with it in her hand, contemplating whether to use it or not. She brings it up to eyelevel, turning the barrel to point towards her open mouth. Then, suddenly, she points it away from her and shoots towards the wall. A dart hits its target pinned to a pin board; a publicity picture of Walter and Satyajit, arms on each other's shoulders, all smiles. The dart has landed square on Walter's forehead. Moments later, a second dart lands on Satyajit's nose.

Ed's sitting room. He is dozing in front of the television, slouched in an armchair with a beer in one hand a TV remote in the other. His feet are on a small table next to the gardening book and a dead Bonsai tree. He stirs on hearing his phone ring. It's his agent, ringing to 'touch base'.

Ed: 'Hello?'

Agent: 'Hiiii…'

An extended weary salutation, almost evacuating the air in her lungs.

'just returning your call.'

Ed: 'Oh, the one I made last week you mean?'

Agent: 'So sorry darling, I've been in Cannes. God I hate these festivals. How are you?'

Ed: 'Still unemployed.'

Agent: 'Darling, it's very quiet out there right now, just don't know what's going on? We're trying so hard. Brian hasn't had a sniff for months, but David, you know, another of our editors who won a BAFTA last year, and the European Film Award and Editors Guild Award the year before that and what was the other one?'

Ed: 'The Nobel Peace prize?'

Agent: 'Well he's had such a wretched time on his film…'

Ed smiles to himself, best bit of news in weeks.

Ed: 'So sorry to hear that.'

Agent: 'Can you believe his director, the one you worked with two years ago. Well he brought in another editor, not one of ours of course, and can you believe, he brought in an editor and put her in an adjoining room and then he, the director, wouldn't speak to David at all. I mean not at all! And she didn't speak to him either, the other editor, I mean, frozen out. The poor love. I told him to leave because I'd put him up for something else.'

Ed: 'You did?'

Agent: 'And Michael, Michael, listen to this, Michael our top Oscar winning editor was offered a film up north somewhere, Leeds or somewhere, for peanuts would you believe? Of course he turned it down.'

Ed: 'I'll take it.'

Long pause.

Agent: 'Oh darling, I never thought of you. It's probably gone now. Shame. Anyway, must fly, I'm having lunch with Marcia, you're ex-assistant, she's doing incredibly well, you should be very proud. Must do lunch. I'll touch base later. Bye.'

Night in Dean St Soho. Xavier and Barbie exit the facility house to an awaiting limo; it drives off. A discrete moment later, the sound boys emerge less animated than usual, they easily succumb to some strange magnetic force pulling them in the direction of The Intrepid Fox to imbibe the golden nectar.

Inside the building, one of the security staff, making his rounds on the fifth floor, is drawn to a green light over a cutting room door. He opens the door, revealing Satyajit sitting alone, almost in darkness, eyes fixed on a monitor showing his film. The guard respectfully retreats, closing the door quietly. The flickering images from the screen ghoulishly reflect on Satyajit's face, his expression, like that of Thamesmead Sharon, is stony.

End montage.

Day. Soho. Ed sits in a booth of the near empty coffee shop of an earlier scene, along with Annie. She is surrounded by full shopping bags from Next, Top Shop, Debenhams and House of

Fraser. They are waiting for someone. Satyajit, with Rebecca in tow, enters and sits with them.

Having somehow dealt with a film in Farsi, the prospect of one in Spanish, French and English seemed less of a concern. Considering there were several 'action' sequences in the film, the producers and director might well have excluded me from consideration but thankfully, they didn't subscribe to Eon philosophy. The film, *Libertador* about Simón Bolívar's (Edgar Ramirez) fight against the Spanish, also starring Erich Wildpret, Danny Huston and María Valverde was directed by Venezuelan director, Alberto Arvelo, and shot in his home country and Spain. Once again, I joined the film late, but after a brief call with Alberto, I was accepted unseen, and made the trip down to Southern Spain to meet him and two of the producers, José Luiz Escolar and Winfried Hammacher. Over that weekend, we chatted and dined. The group were surprisingly relaxed considering the scale of the production and the usual edginess that accompanies filming. I largely attribute that to Alberto and José, both at ease in their respective crafts and both extremely likeable and popular with cast and crew. I felt an immediate rapport with both of them, Alberto ticking all the boxes on an editor's wish list.

As I was still completing *Great Expectations*, I started the edit in London, with the rushes being organised by Spanish assistants Joxerra Zabaleta and Teresa Nuño de la Rosa in Madrid. In London, I was helped again by Lucy Donaldson (fast becoming an expert in foreign language films) and decided to remain with Avid software, as finding a Lightworks in LA was impossible (LA would be our final port of call although three enjoyable weeks were spent in the Madrid cutting room to complete the assembly). Lucy's petition to continue working on the production in America was accepted and later proved to be the start of a new life and career in the States, following in the steps of my ex-assistant, Tracey Wadmore-Smith (*Fatherland, American Beauty*) many years earlier.

José rented a house high up on West Granito Drive, at the North end of Fairfax. This housed the production office, makeshift viewing room and cutting rooms for myself and Lucy, and then

later, the supervising sound editor, Jay Nierenberg and dialogue editor, Andrés Velásquez.

As a parting gift for the remaining crew at the end of production, Jay wrote an ironic letter inspired by one written by Bolivar in Jamaica; Bolivar's letter written to Torkington (Danny Huston) reflects on his struggles, and appeals for European assistance and collaboration in his fight against the Spanish. The Sound Department letter reflects on their struggles in post-production.

"Despite many picture changes, our journey continues…perhaps with even greater resolve. We have failed. Our dream of a great final mix relied too much on divine magic, and not enough on strategic and well-planned actions. We will continue the fight to create a great sound mix devoid of bad ADR, cheesy sound effects and sappy music… with levels safeguarding the hearing of all individuals in the room. We must not only appeal to

the various factions, but also to lovers of film and music across the world. Hollywood will benefit when South Americans can make movies that inspire to entertain whilst still making sense. Movies like this one. Except, maybe shorter…and with less…Spanish. And shall Hollywood, the civilised, the merchant, the lover of blockbusters, allow this epic film to open wide across this great nation?

We hope so.

Libertador Sound Crew."

If the 'locked' film felt a little too long for the sound crew, then it's just as well we didn't present them with an earlier cut as the first assembly was 3 hrs 30 mins; lengthy and in dire need of liposuction.

The Cartagena speech for example, which was scripted to stand alone and then be followed by a series of scenes illustrating the uprising, was improved by intercutting the speech with ensuing events. A track from *The Last of the Mohicans* was used to drive and unify the sequence.

The battle of Boyacá (which in early assemblies lasted a lengthy 12 mins), needed to be close to the climax of the film, but in the assembly there was still 40 mins of political drama left to unfold. Collapsing these scenes as much as possible and still retaining important information was once again facilitated by intercutting and, as before, temporary music (from composer Mark Adler) used to pull together the new assembly. Clarity of narrative was addressed at this time, with a number of additional lines added off-screen.

In Bolivar's last scene with a dying Maria Theresa, we added lines from him to support the thought that his fight against the Spanish oppressors was partly motivated by her; that is, in his new line, 'a lot of people to help', he acknowledges her concern for the slave in an earlier whipping scene.

Torkington, with new lines in the beach lunch with Bolivar, helps us understand why Bolivar fails in his first attempt at revolution, that is, in being underfunded.

In the camp scene before crossing the Andes, a reference to meeting Santander on the other side was needed, to explain his sudden appearance.

The Jamaica letter was scripted as a letter of intent, but by changing the text we were able to make it more of an appeal to

252

Torkington for financial aid, rather than yet another voicing of Bolivar's cause; in addition, it darkened Torkington's character.

Moments which didn't exist were also created, such as Bolivar sitting in the carriage in Paris, deliberating on whether to join the fight or not. The shot of him was taken from a much later scene when he returns to his home and sits by the bed. Creating the right costume and backgrounds to make this moment believable is a tribute to the visual effects department. For audience clarity, the idea of having maps was suggested, the Jamaica letter sequence being the best place to insert them without it feeling an afterthought. The additional material was shot in post-production.

The slightly awkward transition from Bolivar riding in the forest following Sucre's death to the meeting with O'Leary was eased by using helicopter shots of the forest (reversed to give a sense of moving away from his grief) along with a shot of a more composed Bolivar – which was not used as intended after Maria's death. It was purely fortuitous that the shot of him in the field ended on his sword, which then cut to the sword on the table in the camp scene with Fernando.

Regrettably during this process, scenes and characters become either redundant or drastically reduced in screen time. A wonderful scene between London (a character no longer in the film) and Bolivar, which followed Bolivar's exile to the jungle, hit the proverbial floor because it was confusing to the story. A sequence to persuade Paes and his men to join the fight by showing Bolivar's courage (swimming across a river full of piranhas with his hands tied) was deleted; deemed unnecessary to the story, as Paes doesn't join them in the Andes anyway.

The battle for Valencia (the 1st battle) was beautifully orchestrated as one shot but lasted too long (4 mins) and had to be treated in a briefer more impressionistic way with imaginative use of sound.

A celebratory party before the Andes crossing also disappeared, along with the director's only part in the film, that of a musician, this was his decision, not mine!

As the film became more refined, the three acts became more evident: Bolivar's early life leading to Maria's death, his fight against the Spanish, the politics following his victory. Comments following various screenings indicated that the third part was fine but that the first two needed attention in terms of pace. Once again,

the device of intercutting was used to compress sequences: Miranda with Bolivar at headquarters following their victory at Valencia; Bolivar at the fort with Vinoni; the carriage ride with Torkington. The Miranda HQ scenes were shot as two scenes but used as three, the last being graded for night, not only to give it a separate identity but also to work better with Bolivar (sitting in the dark), reflecting on Miranda's words.

Over a period of several months, we arrived at a running time of 2 hrs 7 mins. However, this was considered less than ideal for general distribution (a reminder that we are first and foremost working in a business environment), so a further round of cuts, mostly directed at the first third of the film were implemented. Once again, there were painful decisions to make, with arguments for keeping/shortening scenes against arguments for not. Bolivar being thrown out by Prince Fernando, subsequent to being hit in the eye, was deleted, along with a second confrontation between the two shortly afterwards. An off screen line from the Prince showing his contempt for 'colonials' was added to give a sense of Bolivar's humiliation that was largely lost in making the cuts.

With these changes, scenes which played really well in a longer cut seemed to drag in the new shorter version. The dinner scene when Monteverde arrives unexpectedly was shortened losing a delicious confrontation between Maria and Monteverde; Rodriguez in Paris was trimmed down; and a scene in which Hippolyta consoles Bolivar after Maria's death was deleted.

These changes continued well into the sound mix, bringing it down to an audience friendly 1 hr 52 mins.

For a film of this epic quality, there was always the danger of cutting too much, thereby doing a disservice to the history of Bolivar and in the eyes of some reviewers, we did.

Chapter 32

Soho screening room. The latest cut of Courage *has just finished and the house lights come up to reveal a familiar set of faces: Manu, Wasim, Dev and Iqbal sit together and behind them, Satyajit, Rebecca, Annie and Ed, further back are Ray, Michael, Nigel and Jim. They sit in stunned silence. To break the mood, Ed volunteers a comment:*

Ed: *'It's a bit "Sha-na-Boom Boom Yeah".'*

Jim: *'That's from the Staple Singers' hit of 1970, Heavy Makes you Happy. Made twenty seventh in the US charts and...'*

Jim would continue but stops when everyone turns around to stare at him. Satyajit gets up, steps to the front and faces the group.

He pauses at a loss to say anything, then:

 'I am going to be the moderator.'

Then forgets his next lines.

Ed: *(whispering)* *'Thank you all for coming...'*

Satyajit: *'Yes, thank you all for coming...yes...thank you all for giving up your Saturday afternoon. My name is Satyajit and I have had no hand in the making of this film.'*

Ed: *'Hear, hear!'*

There is a trickle of laughter.

Satyajit: *'I mean this version of the film. So you can be totally honest in your comments, I won't be offended, OK?'*

There is a murmur of approval.

 'What I need to know is how you feel?'

Ed: *'I feel anger.'*

Annie: *'I feel disappointment.'*

Jim: *'I feel like a beer.'*

Wasim: *'I feel like a curry.'*

Much agreement on 'curry.'

Music Intro to Sha-Na-Boom Boom Yeah

Satyajit: 'Yes, yes, I know, but how do you feel about the movie?'

Further pause. Ed feeding him the lines:

Ed: 'Did you find it entertaining, engaging?'

Then Annie:

Annie: 'Dull, action packed, beautiful, dramatic?'

Then Michael:

Michael: 'S...s...s...surprising. Confusing, violent, stupid?'

Satyajit: 'Interesting, thought-provoking, intense?'

Jim: 'Too long?'

Nigel: 'Too long?'

Faces turn to Nigel, encouraging him to speak his own mind,

Nigel: 'Too short, realistic, unrealistic, touching?'

Manu: 'Predictable, different?'

Wasim: 'Original, humorous?'

Satyajit: 'Did you like the characters, the story, the relationships, the music, the pace?

So tell me, tell me, tell me...Sha-na-Boom Boom Yeah.'

All: 'Sha-na Boom Boom Yeah.'

Satyajit: 'Help me find the answer, there's something I need to know, how to make the film better, to make you the public go. Does it make you feel happy? Does it make you feel sad? Does it give you, the best feeling you've ever had?'

All: 'Sha-na-Boom Boom Yeah.'
'Sha-na-Boom Boom Yeah.'
'Sha-na-Boom Boom Yeah.'
'Sha-na-na-na-Boom Boom Yeah.'

Satyajit: 'Now just give me a sign, (won't you?)

Put your hands in the air, (you can do it.)

Let's give a count for excellent, very good, good and fair.

Does it make you feel happy?

Does it make you feel sad?

Would you tell friends and family,

	This is the best time to be had?
All:	'Sha-na-Boom Boom Yeah
	Sha-na-Boom Boom Yeah
	Sha-na-Boom Boom Yeah
	Sha-na-na-na-Boom Boom Yeah
	'There's too much blood and commotion,
	We need more love and emotion.
	Make these changes and you'll know for sure,
	We'd make a "very good" out of "poor".'
Iqbal:	'The pace is too slow.'
Dev:	'No, it's too quick for me.'
Wasim:	'Not enough jokes.'
Manu:	'The music's off key.'
Jim:	'But the pictures are pretty.' (Ed gives him a look)
Ed:	'The film has nothing to say.'
Rebecca:	'I like the lead actor.'
Dev:	'Most certainly gay.'
Iqbal:	'I'd change the ending.'
Wasim:	'Oh no, that work's a treat.'
Satyajit:	'How about the acting?'
Jim:	'Shit.'
Nigel:	'Sucks.'
Rebecca:	'Awesome.'
Ray:	'Neat.'
Iqbal:	'Not enough sex.'
Jim:	'Earthquakes.'
Nigel:	'Aliens.'
Annie:	'Well, I thought it obscene.'
Manu:	'I thought it played realistic.'
Wasim:	'Played like a dream.'
Iqbal:	'Not enough symbolism.'
Rebecca:	'But the makeup was cool.'
Dev:	'To believe that stuff, you gotta be a fool.'
All:	'Less MTV and slow it down,
	If you want to turn this,
	Struggling movie around.
	Make these changes and you'll know for sure,
	We'll make an "excellent" out of a "poor".'
	'Sha-na-Boom Boom Yeah.'
	'Sha-na-Boom Boom Yeah.'

> *'Sha-na-Boom Boom Yeah.'*
> *Sha-na-na-na-Boom Boom Yeah.'*

Satyajit: *'I feel we're really coming together,*
> *There's a connection, like we're getting so close.*
> *These notes will inspire,*
> *Our movie making hosts.'*

All: *'Does it make you feel, happy?*
> *Does it make you feel glad?*
> *You've helped make the best movie,*
> *The studios ever had.*

On the face of it, the Blumhouse model was an attractive one: creative control for the director, no executive interference, a quick in and out, financial rewards for the cast and crew if the film does well. That was how it was presented to director Iain Softley by Jason Blum no less, and that's how Iain presented it to me, when I bumped into him in Soho Square, London. Iain invited me to participate in the scam, sorry scheme, and I was, like him, hooked.

My re-cut work for StudioCanal on *L'Écume des jours*, a film by Michel Gondry was coming to an end, so the prospect of re-uniting with Iain (*Wings of the Dove*) and returning to LA was an exciting one.

L'Écume had been released in France but was perceived as inaccessible to an international audience, partly because of its length and partly because of lack of clarity; references in the film requiring some knowledge of the revered Boris Vian French novel upon which it was based. It was hoped 25 mins could be shaved off its running time of 125 mins and in the process, perhaps the narrative made simpler. Gondry, reluctantly agreeing to StudioCanal's request, re-edited the film in three days in Paris, reducing it down to 98 mins. His new edit was intended as a template for whoever took over, as understandably, he hadn't the heart to continue working on the film.

So it was left in the hands of producer Luc Bossi, and through StudioCanal, me.

His wonderfully surreal and imaginative film focuses on the romantic and tragic story of Chloe (Audrey Tautou) and Colin (Romain Duris). Stuffed full of wackiness and whimsy, Gondry

creates a weird world where inanimate objects animate, to moments of pleasure and pain: walls take on different shapes, plates come alive, a piano turns into a cocktail bar, a doorbell becomes a spider. Jam-packed with visual effects, which are deliberately low-tech and unsophisticated, the film is full of inventiveness.

With the original long cut and Gondry's cut down version as references and with extensive StudioCanal notes by my side, I worked alone on another version with some degree of freedom to do what worked for me. This was then presented to Luc Bossi, for approval and comments on Gondry's behalf and also to StudioCanal for their thoughts. I made further changes as a consequence of these viewings until both camps were happy.

Sadly, my efforts were in vain; the film was released internationally but, unfortunately, failed at the box office.

Blum's arrangement with Universal is that he can put any movie that costs $4-$5 million or less into production as long as its genre is horror, sci-fi or thriller. Universal largely stay out of the film making process (including financial arrangements with cast and crew) other than casting an eye over the script, signing off on talent and possibly giving their blessing to the choice of director. Then, with the film delivered, they decide how much they want to promote the film, or as I was to discover, not promote it at all. With so little financial risk, Universal executive Donna Langley is more than a willing participant in this suspect scheme and says, not surprisingly, "We love Jason, and we love this business."

Financial arrangements in the case of Blumhouse, is to pay everyone as little as they can get away with (union scale), the carrot being that there is a reasonable chance of cast and crew recouping their rate and possibly earning a little more.

In the case of *Curve* (the film I was asked to edit by Iain Softley), the movie had to pass $50m domestic box office gross (US), before my bonus kicked in and then more bonuses were given on a sliding scale up to a ceiling, paid out on $100m domestic box office. Along with that, there was a crew pool, which paid out on $30m box office. Nothing for International Box Office, nothing for VODs (Video on Demand) and nothing for DVD sales. For me to get back to my rate, the film would have to gross $70m domestic.

A big, big gamble but I naïvely believed the film would be given a fair shot. With an audience pleasing script (cross between

Hitcher and *Misery*) and popular cast in Julianne Hough and Teddy Sears, it was a risk worth taking. I was also keen to work with Iain again, so I agreed. As time progressed, the reality of the Blumhouse model became clear. A damning article, which appeared in the Hollywood Reporter entitled 'The Blumhouse movie morgue', aroused suspicions, but confirmed the experience I was about to have. *Curve* was one of many films (possibly ten) being made by Blumhouse at the time. Of those ten, only a few were to get Blum's TLC, the others would go to VOD, DVD or just be mothballed. As director Joe Carnahan aptly put it, "If you shotgun enough paint cans, you're going to get a Picasso," but in the Blumhouse model even unreleased films would recover their costs in other areas.

The shoot was quick, just 4 weeks, with the director's cut screening 6 weeks later and the first test screening 4 weeks after that. As usual, there were many notes from the many producers and even a session of 'brainstorming', part of the Blumhouse process, in which a group of respected writers and filmmakers gather to watch the film and give advice. All well and good, but with this barrage of thoughts it doesn't take long to lose the will to live.

Virtually, no time was allowed for sound preparation for the first test screening and the mixing room allocated was not much bigger than a broom cupboard.

Fortunately, with some string pulling, we got a larger mixing room, but a subsequent mix for the second test screening reverted to the Blumhouse no frills model. Micky Mouse conditions to make movies but relying heavily on the professional pride and ingenuity of the technicians involved to make it work. An Easy Jet[22] ride all the way. The test audiences didn't respond as well as Blumhouse had hoped, so their enthusiasm waned; this was going to be, if not a problem film, then one to be left in limbo. I was quickly and unexpectedly

[22] Budget airline based in the UK

laid off, along with my assistant and the director, until further notice.

The film was now at the mercy of Universal executives and their busy viewing schedule. Months later and while working on another film back in the UK (as was Iain), the film resurfaced and I was offered a maximum of 5 days employment (to be spread over several weeks) to oversee small picture changes (which Iain wanted) and attend the final sound mix at Shepperton Studios, still believing, as did Iain, that the film would get a release.

With no proper oversight in the intervening weeks (the film having been left in the hands of in-house Blumhouse post-production) numerous errors had been made in terms of visual FX, picture conform and sound design; errors which were ultimately fixed thanks to the good will of my US assistant Lucy Donaldson and US sound design team led by Paul Hackner (also now otherwise employed). Both I and, in particular, Iain were painstaking in trying to finish the film to a high standard but we needn't have bothered because, in truth, the film was destined for an iPhone screen and speaker. Quality isn't a high consideration in the Blumhouse model, quantity is. The film did get a showing at the London Film4 FrightFest 2015 and reviewed by journalist Alan Jones,

"CURVE is uniquely plotted, technically brilliant, and full of those directorial flourishes we knew would zing from being shown on the big screen at the Vue Leicester Square. From the moment the movie opens, throughout its shaded performances and many twists and turns, the audiences will be in the palm of a consummate filmmaker's hands. I personally think it will excite and surprise our audience and surely deserves a theatrical release."

Well-deserved praise for Iain Softley but sadly not echoed by Universal.

Jason Blum claims to be totally upfront with cast and crew regards 'the deal', as though that alone excuses this somewhat shabby, cynical and exploitative model for making himself very rich. As he says about his budgets:

"The three to five million dollar figure is not a random picked number, that amount is about what we are able to recoup on the movies if we don't get a wide release. In a worst case scenario, we

break even and maybe lose a little money but not very much, and everyone gets paid scale... That budget is reverse-engineered to thinking that if the movie isn't in wide release, at least we get our money back and can keep our doors open."

Like a church or perhaps a casino, Blumhouse keeps its doors open.

Blumhouse HQ.
Open all hours

Chapter 33

New York. Day. Conference room. The walls of the windowless room have been decorated on all four sides by large murals of a forest. Walter, Abby, Tom, Pierre, Boyd and John are seated, as before, around a large table stacked with sheets of recent test scores. Pots of tea, cups and saucers, three-tier plates of biscuits and sandwiches give it the feel of the Mad Hatter's Tea Party. Satyajit has joined them, sitting slightly apart. His peaceful expression at odds with the general edginess, despondency and weariness on display. Taking notes in the corner is the Ambitious Secretary, in appearance no longer the intern; forsaking the long-hanging hair, midi-skirt, T-shirt and Kmart cardigan for an executive power-bob, Bergdorf Goodman red pantsuit and radiant white blouse. Abby, appears more stressed than others.

Boyd: 'So to recap, the New York test scores were down on Sherman Oaks by 30% across all categories.'

Abby: 'Well obviously the film moves too fast. It's confusing. The audience is telling us it needs to be more stately and momentous. We've lost the rich epic texture of the film. It's rushed. It's like watching National Geographic or a two-hour music video! Why aren't shots held longer?'

Boyd: 'I agree, a cut every 7.35 secs would be ideal. Let's fire the editor.'

Abby: 'What happened to the camels? We loved the camels.' Ambitious Secretary refers to her notes.

John: 'Absolutely, exotic and unexpected.'

Abby: 'And the enigmatic smile, why did we lose it?'

Ambitious Sec: 'I think it was your note to lose the smile and camels, Abby.'

Abby gives her the evil executive eye, but the Ambitious Secretary is not to be intimidated.

John: 'Must put it back.'

Walter: 'We're running out of time, must get it out there for the Awards Season. What day is it?'

Tom: 'The thirteenth of March.'

Pierre: 'The fifteenth, I think, Tom.'

Tom: 'Two days wrong? I've lost sense of time.'

Abby: 'Greasing was the wrong approach. We told you Walter, butter wouldn't suit the works.'

Walter: 'I thought we all agreed? Besides it was the best butter, figuratively speaking.'

Abby: 'Well, that's as maybe, but some crumbs have got in as well. It's been spread with a bread knife, which reminds me, we have dinner with you know who tonight.'

Abby looks at her watch.

Pierre: 'Isn't it the Ides of March, today?'

The significance of the calendar date and dinner date with 'you know who', (Founder, Chairman and CEO of the global media company to whom she's answerable) hadn't registered with Abby until now. She looks at John, head down, and then at the Ambitious Secretary, who smiles back knowingly.

Abby: 'Anyone know the time? Our watch has stopped.'

Walter: 'It's late in the day I know that.'

Ambitious Sec: 'Six-fifteen. It's time you left, Abby.'

The subtext of the secretary's comment is not lost on Abby. She looks around for moral support but none is forthcoming. She gets up to leave.

Walter: 'Anyone? Thoughts?'

Satyajit: 'A headless man had a letter to write, it was read by a man who had lost his sight. The dumb repeated it word for word, and deaf was he who listened and heard.'

Walter: 'Wow, is that a treatment for a film? Sounds Swedish intellectual, Japanese horror laced with English irony. Who has the rights? I'd be in for two, three million? Four characters: black, white, brown and yellow. Two women, two men. Academy diversity. I see a black Christian, a white Muslim, a brown Buddhist and a yellow disabled Hindu. The Academy will love it. I'm excited, Tom do a budget on it.'

Tom: 'I think it's a riddle, Walter.'

Walter: 'Yeah? Really? A riddle? I love riddles.'

Abby: 'I'll leave you to play your games.'

The first time Abby uses the first person in speech. They ignore her.

Walter: 'I think I can get this one.'

Boyd: 'What exactly are we looking for, I'll Google it?'

Walter: 'It's a metaphor, Boyd. I like metaphors. I like my films to have metaphors, white notes and really big Eartha Kitts.'

Abby, now at the door, opens it to reveal a poster for 'Alice in Wonderland' on the wall opposite. There's a realisation of the absurdity of it all. She turns back to look into the room, smiles at what she sees and then, with relief, leaves. No sooner has the door closed than The Ambitious Secretary takes Abby's place at the table; no one thinks it odd. Satyajit takes one of the papers on the table and draws a letter on the blank side. Then shows it to them.

Satyajit: 'Nothing! The letter in question is the letter "O". It is zero. The man had nothing to write. The blind could read nothing. The person who was dumb

could repeat nothing. The deaf man listened and
heard nothing.'

Ambitious Sec: *'That's very curious.'*

John: *'It's been a very curious day.'*

Walter: *'What did I say, a fucking genius.' (Pause) 'What
does it mean?*

Ambitious Sec: *'Walter, he's saying we're deaf, dumb
and blind.'*

Satyajit: *'Oh no, no, no, no, no, no! It means we do
nothing. Or at least there was nothing to do. You
are looking for a problem that isn't there.*
*The film is what it is. Let us put our trust in the
tale.'*

Walter: *'The tale? Trust in the tale?'*

Satyajit: *'Yah, never trust the artist, but trust the tale.'*

Walter: *'A way with words. Fucking simple story-telling
genius.'*

Ambitious Sec: *'I think we should go with what we had,
the original cut.'*

Tom: *'Well, with the right marketing and publicity…'*

Pierre: *'Pull in a few favours, get good notices.'*

Boyd: *'Then some discrete campaigning.'*

Tom: *'Smear the opposition.'*

Pierre: *'With salacious rumours.'*

John: *'Charitable events.'*

Pierre: *'Interviews, TV shows, bit of camel time.'*

Walter: *'Goodie bags, Gucci watches. Blanket screeners.
High profile celebrity parties and the like. Could
be the springboard that we need.'*

Ambitious Sec: *'OK, we seem to be on the same page.'*

Walter: *'I still want to make that movie, though. Blind,
deaf, dumb and headless. A political satire.'*

Ambitious Sec: *'Send me a proposal.'*

Part of the director's cut on *Curve* took place in London and
whilst there I was interviewed for *Our Kind of Traitor*, a film based
on John Le Carré's book to be directed by Susanna White. In the
script, husband and wife Perry and Gail (Ewan McGregor and

Naomie Harris) are drawn into helping Russian mafia accountant Dima (Stellan Skarsgård), into defecting to the UK with the assistance of MI5 agent, Hector (Damian Lewis). Into the mix is corrupt Member of Parliament, Longrigg (Jeremy Northam).

My first time meeting with Susanna, was at the now even more dilapidated Ealing Studios and after a brief but very friendly exchange she, unconventionally, there and then, offered me the job. I returned to LA to complete *Curve* and waited for official confirmation of my appointment on *Traitor*. Weeks passed with no confirmation. Agent Mamy believed there to be some sort of financial hiccup stalling any further progress of the production (but in truth, knowing otherwise). More time passed with no news, so in frustration I emailed Susanna who informed me that the delay was as a result of having her knuckles rapped by the financiers for offering me the job and not interviewing other editors and that she was currently in the process of appeasing them by doing so. She asked me to be patient, assuring me that she had no intention of offering the job to anyone else. It isn't untypical of financiers to appoint or approve a director and then, before a frame is shot, start questioning their judgment, not only with technical staff but with the choice of actors too. The film was being financed by Film4 (Tessa Ross) and StudioCanal (Jenny Borgars); Borgars interestingly, attributing her break into films to Ross, who gave her the opportunity to script-read for her while producing a series, *The Short & Curlies*. Of the two, it appeared that the House of Borgars, the London based executive of the French company, was behind the move to have Susanna reconsider and presumably replace me. This was particularly disappointing as I thought I had had a good working relationship with Borgars, having worked on the two re-cuts, *Bel Ami* and *Mood Indigo* for Optimum and StudioCanal. Possibly, the eventual failure of both in terms of Box Office were behind her questioning my appointment; perhaps I was no longer fashionable in this fashion-conscious industry; perhaps, heaven forbid, I was just not considered good enough or, most likely, this was a display of authority to show the director who was occupying the higher ground. In any event, even more time passed with no news and eventually my agent informed me that it was now down to me and one other editor. With offer of other work and my patience at an end, I emailed Susanna to say I was passing on the film and emailed my agent, asking her to inform Tessa Ross and Jenny

Borgas that as far as I was concerned, they could go their merry way (but using expletives related to fornication). Not given to putting contentious issues in writing, my agent didn't convey my chosen words by email, perhaps just as well as Susanna asked me to reconsider; having now informed Borgars and Ross, that having gone through their process she wanted me to edit the film. They agreed, probably in the knowledge they would have their way in the end and I agreed, foolishly in hindsight, knowing that both Ross and Borgars had previous history regarding the replacement of editors.

The assembly period during the nine-week shoot was pretty routine with occasional visits to the cutting room from the producers Gale Egan, Stephen and Simon Cornwell (sons of Le Carré) and the one visit from the StudioCanal suits, including the all welcoming Jenny Borgars. My 'suits' or rather my support team were assistants, Eve Doherty and John Dwelly.

Some weeks into the 'director's cut', we had a version that was ready to show producer Gail Egan and then later the Cornwell boys. Gail, although reacting very positively had some concerns and suggestions (not unusual at this stage), which we addressed as best we could. A second screening with the Cornwells appeared to go well, superficially at least; there were mumblings that we had arrived at a viewable cut far too early and this could only have been achieved by lack of due diligence. Insulting to both Susanna and myself. Stephen Cornwell, in particular, was unhappy that we had been too faithful to his father's script and not brave and experimental enough with the structure.

However, without any further constructive thoughts, the consensus was to show the film to StudioCanal initially, and then Film4. With that in mind Susanna, Gail and I, in varying degrees of cheerfulness, trooped off to St Pancras to catch the Eurostar to Paris, where we would be joined by Simon Cornwell (Stephen Cornwell having absented himself from this screening). The studio theatre, being far from state of art that you might expect from a major player, with poor sound and an un-adjustable projector, rendered the pre-screening check pretty pointless. We waited and then the executives made their entrance along with a sprinkling of youthful office staff, presumably to see if the film had any kind of appeal to their generation.

The 2 hr 20 min film finished and was greeted with the obligatory executive silence, probably only seconds but it seemed

interminable. As is common practice with these events, the executives wait for the highest in the food chain to speak. We waited and waited. Although Ron Halpern, Executive Vice President, International Production and Acquisitions, was in attendance, he deferred to 'Jenny'. Of course, the length of silence is in direct proportion to the level of discontent, so Borgas was quite happy to let us squirm. Eventually, after a great deal of deliberation and with amazing insight, she declared, 'What a lot of locations!' Those words hung there for a while, while we all took stock. It seemed quite a surreal comment and I imagined her head swivelling 360 degrees and repeating those words in a slowed down lower register. Perhaps she thought that we had been watching an edition of *A Place in the Sun*? However, gratifyingly in a way, there was a general consensus in the room, that the locations were indeed great. A success of sorts. Typically, there was very little appreciation of the work that had been done, not just by me but the whole unit, cast and crew and particularly Susanna and Gail; the production schedule had been punishing for them. The youth present perhaps being a bit more complimentary but not to the extent of undermining the negativity of their superiors. As time was pressing (it always is for busy execs.), we agreed to make the film available to them for further corporate consideration.

We prepared for our return to Gare du Nord, eager to lick our wounds and have a good 'bitch' about the deflating screening, but were thwarted by Borgars' tactless and cost-saving decision to share the same taxi. Susanna sat in the front next to the driver, and I was sandwiched behind, between Jenny and Gail. I could have been Fredo in *The Godfather*. Jenny, picking up on the taxi vibe, acknowledged we weren't in a position to talk about her; we laughed nervously in an ambiguous sort of way, neither showing agreement nor disagreement.

Another awkward silence then followed, as each of us, heads turned to the windows, retreated into our fevered thoughts, pretending to take in the 'great locations'.

We sat in an airless bubble; someone say

something please!

"Do you come here often?"

I had broken the silence with a dance hall pick up line! Borgars responded in good faith, giving us the details of her schedule back and forth from London to Paris. I found her timetable quite riveting, probably because, unlike in the screening, her words had no emotional impact on me, but for some reason the driver wasn't quite as engaged, exhibiting signs of distress. In desperation to relieve himself or to relieve himself of the Borgars' schedule, he speeded up alarmingly, weaving through the Paris traffic at action-editing speed. On arrival at the station, shaken and stirred, we made further polite chit-chat over crisps and canopies prior to boarding the train but then, thankfully parted company to different carriages, Jenny, probably and appropriately, to a class above ours. At last, we were able to give vent to our frustrations, but being thwarted for so long and our bubble of bile having been pricked, the moment had gone. A few days later, we received the collective view of StudioCanal.

Notes from studios sometimes start with a nauseating, disingenuous and patronising, 'thank you for sharing your cut with us'. 'Thank you for sharing', being defined on one website, as a 'sarcastic remark made when someone tells something that is unpleasant, overly personal, disgusting, or otherwise annoying'.

StudioCanal's notes fell into some of these categories and continued with seven A4 sheets of written comments, some general, some specific. Much focused on the failure in the relationships department of the leading characters, Perry/Gail and Perry/Dima; a failure, if there was one, of the script and very little that could be remedied with the material at hand. Similarly, other scenes were found wanting and suggestions made, which, once again were not possible because of a lack of appropriate material. Well-used stock phrase waffle such as 'emotional clarity', 'powerful driver', 'subtle dynamic', 'set of beats' appeared along with incredibly irritating specific picture cutting notes. There was a hostile response to the Carlos Acosta ballet opening, 'rhythmically this element is setting a different pace than we want the film to follow'. The loaded use of 'we', another reminder of who was running the show and that the director and producer were, if not side-lined, being put into a supporting role. The Acosta moment was stylistically important to the director and she was reluctant to reduce its screen time.

We made changes that we felt improved the film but left others we didn't agree with or couldn't do as a consequence of not having the footage.

The screening for Film4 (now with the newer cut) was somewhat similar to the Paris experience. I hadn't met the supposedly shy, giggly, ever-so-friendly Tessa Ross before, but she reminded me of a Saint Trinian's School fourth former. First impressions aside, in 2009, The Times magazine named Ross as one of the hundred most influential people in the world. Her stewardship of Film4 has indeed led to many enormously successful films and along the way, becoming the darling of many respected directors: Danny Boyle and Mike Leigh, to name but two. Perceived as a mother figure to the British film industry, 'It's all about nurturing', she espouses the noble belief that 'Great people come out of the strangest places to make movies and great work happens when you let them do what they do'. Time would show that she didn't consider Susanna or me in the category of 'great'! So, regrettably, my Ross experience remains closer to the St Trinian's first impression.

She was also accompanied by her support staff including one, an ex-Weinstein employee, who had been at that weird missing £30,000 Weinstein breakfast jolly, but who now worked for Ross. We joked briefly at Harvey's expense… but then, doesn't everyone?

The screening response was again indifferent and the ensuing notes in executive speak, such as 'co-ordinates' and 'procedural', but largely focusing again on the Perry/Gail relationship, with 'key beats not quite landing for us'. Equally, Hector's motivation for bringing down Longrigg had 'landing' problems. Carlos Acosta suffered too with the now familiar 'doesn't quite set the pace', nor ludicrously in my opinion, the shooting of Anna, which surprise, surprise 'didn't quite land for us'. The latter being largely attributed to her performance not being strong enough. To my mind absolute hockey sticks! Other notes were equally mind-boggling for their lack of comprehension about the film and information clearly stated and which to me, reflected badly on the authors. There was more studio speak, 'character arc', 'clear arc', 'not quite tracking', 'beats', etc.; all in all, many similarities with StudioCanal's comments including, horror of horrors, hostility to the temp music which I had laid! Which suggested Ross and Borgars were two heads of the same air born monster with 'landing' problems.

Succumbing once again to childish thoughts, the two-headed dragon, Penelope and Hildegard, came to mind from the children's play *The Liberated Dragon.*

As a consequence of Film4 notes, we made further changes to the film and screened again, to both heads (naturally) and attending staff this time. The film finished and we sat once more in silence, hallucinatory smoke rising from Penelope and Hildegard's nostrils and ears. This had a comatose effect on me but I think, to some extent on Susanna and Gale too; a display of outward calm bordering on lifelessness. I was brought back to consciousness on hearing Ross saying she didn't like Anna smiling after her parents are shot, elaborating that Anna wouldn't have smiled at such a horrendous act. A very important executive point and one that needed answering. Taught with antipathy, I was emboldened to point out that Anna doesn't smile at that point but later when she thinks her life will be spared, a point rejected by Ross, supported of course by the conjoined Borgars. A ludicrously petty argument but enough to have hackles rise and produce what appeared to be an enormous sulk in Ms Ross, akin to Phyllis Nagy years before. Displaying Miss Muffet anxiety, Tessa left for the powder room, necessarily followed by Jenny; convening in their makeshift war office, no doubt to discuss battle plans. Oh to be a fly on that powder room wall!

The screening room emptied shortly afterwards.

Susanna was told later by Ross, that she felt we had ignored their notes, and that, at least in Ross' case, we had lacked respect for her. As much as Tessa Ross is admired by greater minds than mine, my sentiments are with author Douglas Adams who once said, 'it is a well-known fact that those people who must want to rule people are, *ipso facto*, those least suited to do it'.

A day or two later, the Cornwell's weighed in, or more specifically the more verbose of the two, Stephen Cornwell. He presented both Susanna and me with a lengthy list of weird and wonderful ideas in a two-hour conference call from his holiday home in the Alps, notes notable for their 'beauty' not for their usefulness; notes thankfully, later to be put in print. From experience, it is all too easy to let the mind wander during a one-way conference call, particularly when the content of the call becomes as geographically remote as the caller! It was a 'visceral' fog of a monologue equal to anything delivered by Colin Callender.

All well intentioned... I think, and delivered with mesmerising eloquence and a degree of self-deprecation, 'I do like to talk', but also delivered with the veiled threat, do something substantial to please the 'Penelope' or someone is going to lose their job and of course it won't be the director! It was truly a razzle-dazzle of notes, the kind of notes you'd expect from a film student doing a critique for their finals, and like many executive notes had little bearing on the material at hand. The effect is to make one feel inadequate; that there is a far better version of the film to be had, than the one shown. Some of his ideas were in fact very good, others bizarre. Once again we revisited the cut, tried out various things which resulted in a version Susanna was happy with and one we thought would please the authorities. But now it was open season on notes, even the very likeable and gifted DOP Anthony Dod Mantle gave me lengthy notes, similar in style to Cornwell's, something he told me he did on all his films when I expressed shock at receiving them. He was equally shocked on hearing that, in my experience, other DOPs don't give profuse notes to editors.

We showed a new cut to an approving Gale and with a two week break for me looming, I suggested this would be a good point for me to withdraw from the conflict as I sensed that Borgars, Ross and probably the Cornwell brothers were going to eat me alive; much better to resign, I thought, than be digested. Both Gale and Susanna rejected the notion, saying that we were all in this together. Within a week, we were no longer in this together.

All along this painful process, Susanna requested testing our cut with an audience and all along, she was denied. We hoped the compromise version we sent them would finally be tested. In fact, there were two versions posted: one with a temp score and one without (Stephen Cornwell suggesting a scoreless version would cause 'Penelope' and 'Hildegard' less distress). The cut was delivered to Borgars and Ross, while I was absent in LA. Within days of arriving, I received the bad news in a phone call from a very apologetic Gale Egan.

According to Egan, Borgars had summoned Susanna to head office and told to 'let me go'. Susanna, after some stout defence on my behalf, obliged, leaving a message of condolence on my UK phone, following up weeks later with emails about 'all this nonsense'. She tried once again to get an earlier cut tested, having gained an audience with StudioCanal's Chairman and CEO Olivier Courson; but presumably failed, as that was the last I heard from her for quite a while. It is difficult to know where the intriguing Cornwells (well, they are Le Carré's sons!) stood in all this but I didn't receive a 'Get Well Soon' card from them, suggesting they were very much in the Dragon's nest. Intrigue is the name of the game amongst executives and although Ross, Borgars and the Cornwells presented a united front to me, I suspect that in private it was an altogether different scenario.

I did, however, get a welcome and supportive note from Dod Mantle.

This obviously wasn't the film the financiers (nor the Cornwells) were expecting, but so much of what they wanted wasn't there to be had, rather like blaming the chef and waiter for bringing a meal, they hadn't ordered but actually had.

Previously, on *Four Feathers* and *Mrs Harris* I removed my credit on being replaced. I considered doing the same on *Traitor* but decided a pseudonym might be more appropriate and fun. After

274

canvassing opinions amongst editors in LA, there were many suggestions: Alan Smithee, well used by directors in the past, but now apparently forbidden, came to mind, then Tariq Smithee or Alan Anwar or Tariq Aswas or Richard Pull (but this was the genuine name of a genuine editor) or perhaps Gordon Bennett[23], a suggestion from Nick Hytner as we worked on The *Lady in The Van* (Gordon coincidentally being the brother of Alan Bennett the writer). Hytner suffered my tales of woe with patience, humour and typical delightful mischief, particularly with regards to Ms Ross, with whom he had become recently acquainted at the National Theatre, Nick being the outgoing Artistic Director.

Eventually, I settled on Fritz. In the *Traitor* film, Fritz is the unfortunate Alsatian stabbed in the back by the bad guys.

After appeals from White and Egan, I left my name on the film, regretting that decision later.

Tessa Ross left the film industry to run the National Theatre with Artistic Director, Rufus Norris.

Her stay there was short.

Jenny Borgars, at the time of writing, continues her Eurostar commute to Paris; timetable available on application.

Actor arriving on set

[23] Gordon Bennett, or, in Cockney slang, "Gawd 'n Bennett." is an expletive of surprise. Possibly has it's origins in religion, 'May God and Saint Benedict preserve us' or with controversial father and son, James Gordon Bennett and James Gordon Bennett Jnr., who lived in the 1800's.

Chapter 34

Several months later.

*The Intrepid Fox. Soho. Late at night. The pub is closed but Ed,
Annie, Michael, Rebecca, Nigel, Ray, Jim, Manu, Dev, Wasim and
Iqbal have gathered in reunion, to watch the Oscars, courtesy of
Mick, the publican. On the TV screen, celebrities are making their
way down the red carpet, being cheered by crowds in the bleachers
and behind barriers. TV cameras and interviewers are much in
evidence, thrusting themselves on the more-than-willing
participants. Suddenly, Satyajit is on camera talking to a female
reporter.*

Satyajit: *'So the day when my agent phoned me and said
you have, I was kind of wowed, the little boy is
excited. To be going to the Oscars again, to be
felicitated by people like Spielberg, to be meeting
them on their own terms, these are little boy
fantasies, so the little boy is having a great time
and the little boy is in awe.'*

Reporter 1: *'Well, we are so honoured to have you here. Does
Bollywood have anything like this?'*

Satyajit: *'Oh yes, but not on this scale. This is mega.'*

Reporter 1: *'Isn't this so very fun?'*

Satyajit: *'This is so very fun.'*

Annie looks at Ed.

Annie: *'So very fun?'*

Reporter 1: *'What are your chances of winning Best Director,
do you think?'*

Satyajit: *'Oh, that's not important. It's just such an honour
to be here with all these wonderful people. It isn't
about winning, it's about just being.'*

Reporter 1: *'Just being?'*

Annie: *'Just being?'*

Ed:	'Old habits.'
Satyajit:	'Just being a part of this wonderful event.'
Reporter 1:	'Thank you so much for giving us your wonderful film, it's totally amazing.'
Satyajit:	'Oh thank you, so very kind.'
Reporter 1:	'Have fun tonight. Enjoy the ride. Let's go over to Rona.'

Satyajit moves on down the carpet.

Manu:	'We are very proud of you, Sashity.'
Iqbal:	'Hear, hear.'
Dev:	'Let's charge our glasses.'

Music to sound boy ears.

Jim:	'Good timing Dev, I was coming down with Cenosillicaphobia.'
Dev:	'Is it catching?'
Jim:	'Nige has it.' (Pointing to Nigel's empty glass) 'And Ray.' (Also with empty glass)

Jim, Nigel and Ray, have Mick replenish their drinks.

Wasim:	'To our esteemed director. For he's a jolly good fellow.'
All:	'For he's a jolly good fellow, For he's a jolly good fellow, For he's a jolly good fellow, And so say all of us.'
Manu:	'God save the Queen.'
All:	'The Queen.'
Wasim:	'To the director.'
All:	'To the director.'

They all drink. On screen more razzmatazz. We catch sight of Walter with wife and mother-in-law, Tom and partner, Pierre and girlfriend, Studio Executive (Ambitious Secretary) and boyfriend.

Suddenly on screen, Walter Weisman is about to be interviewed by a female reporter.

Reporter 2:	'Douggie, thank you so much, well we're here live at the Oscars one on one with Walter Weisman. Walter this is like Groundhog Day for you isn't it, how are you feeling?'
Walter:	'Feeling good. I feel blessed to be here once again and with such a great film. It's an emotional

	moment for me and my family, I just hope I can keep it together.'
Reporter 2:	'Absolutely! Your film, Act of Courage, it was such a bold and inspired decision to go with Indian director Satyajit Krish?'
Walter:	'Not at all, I had every confidence in him, great director, great visionary. He's family, I just love the guy, and just for the record I love the Indians.'
Manu:	'Did you hear that? He loves the Indians.'
Jim:	'I think he meant the red kind.'

Ed watches the screen while the others in the pub drink and chat by the bar, having momentarily lost interest. The picture on screen changes to a catwalk of stars parading their gowns. Ed presses the remote to increase the volume but only succeeds in switching on another TV set. On this screen is the Crufts Dog Show being presented by Peter Purvis. Ed mutes the Oscar sound but watches the Oscars.

Purvis:	'I mean it'll be nerve racking for the handlers, and for people who have not been in the ring before it will be absolutely terrifying. But having said that, they are all here because they've been judged best in their groups. But there's nothing like Best in Show night here at Crufts. The atmosphere, the build-up.'

Ed, watching the Oscars with the Crufts sound. On screen, actresses stop and pose for the paparazzi. We continue hearing the Crufts commentary,

Purvis:	'Tremendous ring presence for a really big dog, really acting up to the camera. Look at the lines of this beautiful bitch, long stride and so elegant. Just look at the free economical gait and the chiselling in the face, the hair just tossed back and look at that movement. Hasn't she's got fantastic head carriage? And talking about the x factor, has she got it!'

Angel, with sunglasses, is now being interviewed by the male reporter. Ed turns off the Crufts Show and turns the Oscar sound up. The others begin to watch.

Reporter 1: 'Look who I've found everybody! Angel Hart, Angel, oh my God, you're like a kid in a candy store. You look so excited.'

Angel: 'I'm here at the Oscars, how could I not be excited?'

Angel is actually incapable of looking excited on account of possible face crack, but the interviewer persists with excitement enough for both of them:

Reporter 1: 'Your mum and dad are here, and you're presenting an award, can it get any better than this? And I must say you look stunning. I love what you're wearing. What is that?'

Angel: 'Oh, you mean the dress?'

Reporter 1: 'Yes, what is it? I mean, it's not Loehmann's.'

Angel: 'No, darling, it's Versace.'

Reporter 1: 'Well done, but you are so much more than a dress.'

Angel: 'Thank you.'

Reporter 1: 'And you smell amazing.'

The reporter fans the 'smell' towards him.

Reporter 1: 'Oh wow, thank you for sharing!'

Angel: 'Oh really, thank you.'

Reporter 1: 'Let's just talk about your film, Courage, nominated for Best Director, but sadly not for you...'

Angel: 'But that's OK. It's not about winning, I'm just so pleased to be here with all these wonderful people, in this wonderful town, in this wonderful country of ours, and to have been a small part in the success of this wonderful film with a wonderful director and a wonderful cast. And so many wonderful people have turned out, I love you all.

Angel waves to the spectators; they wave and cheer back.

I love you America.'

Reporter 1: 'Oh that's so wonderful. Thank you so much for bringing your talent to us. We love you so much too.'

Manu, slightly intoxicated, rises from his bar stool and approaches the screen to parody the interviewer. Ed turns down the sound with the remote, as Manu 'talks' to Angel.

> *'YOU'RE A PICTURE OF ELEGANCE*
> *WITH*
> *THAT SWEEPING LINE.'*
> *'THOSE GLASSES, LET ME GUESS, ARE THEY*
> *BY CALVIN KLEIN?'*

The group laugh, then Iqbal steps forward onto 'the floor':

Iqbal: 'AND THAT FRAGRANCE, IS IT CHANEL?'

And from the 'bleachers' bar stools,

Ed: 'CITRIC ACID!'

Annie: 'PARFUME GRÉS?'

Dev: 'NO, I THINK IT'S CORIANDER.'

Wasim: 'OLD SPICE?'

Together: 'NO! IT'S THE SWEET SMELL OF SUCCÉ.'

Iqbal: 'MIRREN'S IN MCQUEEN AND STREEP IN SIROP.'

Annie: 'ANN HATHAWAY'S HAIR'S A SASOONIAN MOP.'

They all laugh once again leaving their seats to join Manu and Iqbal to continue the mocking.

Together: 'BREAST LINES ARE SO BRIMMING.
AND WAISTS ARE SO THINNING,
IT'S ALL EVER SO SLIMMING,
AND NOT ABOUT WINNING?'

Rebecca: 'MCARTNEY'S JUST STELLER IN HER STRAPLESS GOWN.'

Annie: 'LOOK WALTER'S WIFE'S WEARING A DESIGNER FROWN.'

Wasim: 'NED IN NAKANISHI, AND THE MISSUS IN TOLLI,
THE GLITZ AND THE GLAMOUR,
IT'S SO ROCK AND ROLLY.'

Manu: 'EYELASHES IN MINK, AND BAGS FULL OF SWAG.'

Jim: 'WE WANT TO KNOW WHO'S STRAIGHT.'

Dev: 'AND WHO'S REALLY A FAG?'

Together: 'BREAST LINES ARE SO BRIMMING.
AND WAISTS ARE SO THINNING,

	AND NOT ABOUT WINNING?'
Michael:	'VERSACE. DE LORENZO, C...CLOONEY IN WANG.'
Together:	'WHAT WE WANT TO KNOW IS, WHICH WAY DOES HE HANG?'
Wasim:	'ALL MANNER OF JEWELS, OF MOUTH DROPPING SIZE, DIS IS DE PLACE TO.'
Together:	'ACCESSORISE. BREAST LINES ARE SO BRIMMING. AND WAISTS ARE SO THINNING, IT'S ALL EVER SO SLIMMING, AND NOT ABOUT WINNING?

Dev: (does a camp cat walk)
'MY EMPIRE WAIST IS SIMPLY A
STUNNER.'

Jim:	'LOOKS LIKE THE DESIGNER.'
Together:	'SHOULD DO A RUNNER!' (Laughter)
Iqbal:	'AND THERE'S KIRSTEN DUNST, TO THE CAMERA ZAC POSEN, AND ARNOLD SCHWARZENEGGER, IN HIS CRUSH LEDERHOSEN.' (Laughter)
Ed:	'WALTER'S TUX SUITS HIM WELL.'
Annie:	'DESIGNED BY ARMANI.'
Ed:	'RECUT BY CANALI, THEN BRIONI VENETA AND FINALLY,
All:	'CANNELLONI.'
Dev:	'STONE AND ZELLWEGER IN SHOW STOPPING SHIFTS.'
Nigel/Jim:	'CRUISE AND SYLVESTER WEARING CUCINELLI LIFTS.'
Manu/Iqbal:	'PORTA POTTIES BY BRANQUINO.'
Michael/Mick:	'BLEACHERS BY GEHRY.'
Together:	'STUPID ANSWER TO STUPID QUESTION, IT'S ALL GETTING SCARY! BREAST LINES ARE SO BRIMMING. AND WAISTS ARE SO THINNING, IT'S ALL EVER SO SLIMMING,

Later. The Best Director Award is about to be announced. On screen is a big close up of Satyajit, motionless, frozen with a fake smile.

Presenter: *'And the nominations are…'*

The camera tracks around the pub, the faces of everyone as tense as Satyajit's.

Ed in voice-over is talking to Satyajit:

> 'Keep smiling. Look at the TV guy with the hand-held camera. He knows the winner. If he stays on you, you're the man. If he scuttles off to some other nominee as the envelope is opened, at least you'll be prepared for the disappointment. Don't forget to kiss your wife when you get up, look pleased but not triumphant. Can you remember what you're going to say? Remember how humbled you are and the journey, don't forget the journey from the Bombay streets, that'll go down well. Tell everyone how much you care about everything and everyone. Applaud whatever happens, be pleased for the winner, can't be seen to be a bad loser.
>
> Oh, and if you do win, for once, thank the editor.'

Presenter: *'And the winner is…'*

Prior to my departure from *Traitor,* Nick Hytner had already offered me *The Lady in The Van*. For the second time (my untimely exit from *Fatherland* being the first), Nick was there to repair a damaged ego. This being our fifth film together and with Nick having final cut, this was an altogether more secure position than the one I had just left. The executives Tom Rothman (Sony TriStar) and Christine Langan (BBC Films) were now the Borgars and Ross of *Traitor*, Kevin Loader and Damian Jones the new Gail Egan and Cornwells, Katrina Annan my new assistant.

The budget for *Lady* was considerably smaller than *Traitor*, and as a consequence, I was informed I would have to go with Avid as opposed to the slightly more expensive Lightworks, a bit like saying Bolex to a cameraman.

The *Lady in the Van* is based on writer Alan Bennett's real experience of living alongside eccentric lady Miss Shepherd (Maggie Smith), whose not so mobile home (the van) he allows onto his drive. Miss Shepherd's 'possibly', a word she is given to ending sentences with so as not to over commit, came into regular use in the cutting rooms, as in:

'Nick, I will make all the changes you have asked for...possibly.'

The film charts their difficult and touching relationship using split screen techniques; not only to illustrate the two minds of Bennett, the 'liver' and the 'writer', both played by Alex Jennings, but also to give reality to Maggie Smith's portrayal of the piano playing Miss Shepherd, by marrying Maggie's arms with the hands of a concert pianist of similar age. Voice-over, written into the script and not an afterthought, was used to express the thoughts of Alan Bennett, the writer.

Unknown to Bennett, Shepherd is 'on the run' from the police, in particular, Officer Underwood (Jim Broadbent), believing herself to be the cause of a fatal accident many years before.

In my favour, the book and particularly the play were familiar to a lot of people including the executives, so there was little danger of the executives, on seeing the film, expecting a *Mary Poppins*. However, as with most films, the film as shot was just the starting point for a slight refashioning of the story.

The initial assembly, as viewed by Nick Hytner and myself, was faithful to the script in structure and lasted 130 mins. It was slow in the beginning (as nearly all films are), slow in the middle and although the last part worked well generally, it appeared to have too many endings.

Nick, now free of the shoot but still with National Theatre commitments, left me with thoughts and ideas to play with, before returning to the cutting room a day or two later to review my endeavours. In this first cut down, a whole scene of Alan Bennett being interviewed by an American journalist (Eleanor Matsuura) about his work, was deleted in the desire to give the film some momentum. For the same reason, a stand-alone scene of Miss Shepherd yelling at music playing children in the street was moved away from the front and placed in a later music montage, creating a tricky problem for composer, George Fenton; having to blend score with the children's rendition of Beethoven's Symphony No9

(Anthem of Europe). Following the 'snake' incident, a short scene with Mrs Vaughan Williams (Francis de la Tour) and Bennett setting up Miss Shepherd's disappearance to Broadstairs was deemed unnecessary and deleted; why be told something that becomes evident in the next shot?

After the departure of the first 'rent boy' and his confrontation with Ms Shepherd, a scene between the two Bennetts, 'having her here is not sexy' which then led on to writer Bennett expressing his desire to write a spy story, was considered repetitive and cut. Also cut: a short scene of trick-or-treaters with a bit more of Thatcher bashing and Shepherd hysteria which once again felt repetitive; Miss Shepherd leaving church, her odour effecting the other church goers – we'd made that point already; Fiona (Pandora Colin) disposing of a bag of excrement – Bennett does the same thing later. These changes with additional trimming within scenes brought the length down to 117 mins.

The first screening to producers was around this length and, thankfully, well received and appreciated. However, the consensus was that it still felt slow in the middle and that, towards the end, too much time was spent with Miss Shepherd in the Day Centre prior to playing the piano. Also, the last conversation with Bennett before her death was considered too long, and the many endings still needed to be addressed. A further point was made regarding not getting a sense of passing years.

Taking these notes on board and adding our own, we set about our next revision.

We nibbled at the two Bennetts scene following Mrs Vaughan Williams' comment, 'I planted the seed', cutting their talk of tramps being interesting and, 'Godot[24] has a lot to answer for'; Nick's concern being that if there were too many esoteric references in the film it might alienate an audience, particularly an American one. A short scene between Miss Shepherd, having returned from Broadstairs, and Bennett about to leave for Mam's house was deleted, as being once again repetitive: a repeat of her delusions in that she says, 'saw your dad hovering over the convent dressed as Queen Victoria' and a repeat of her criticism of Bennett's perceived political persuasion, 'I think it was to warn you of being a communist'.

[24] Referencing, *Waiting for Godot*, a play by Samuel Beckett

Between Miss Shepherd confronting Bennett about the possibility of 'off-street parking' and Underwood's first appearance at night, a short scene of Shepherd and Mrs Vaughan Williams requesting van parking assistance from the Convent housekeeper was also deleted. Apart from being technically poor (shot with little light), the scene didn't add a great deal to the story and had long been on the Hytner's hit list.

Following Underwood's appearance, Miss Shepherd is woken by yobs shaking her van. I had laid in a music track suggesting the shaking was part of a nightmare event connected to Underwood's visit but now we took this thought further to create the illusion that Underwood had triggered memories of the accident itself. This was achieved by extending the shot of her sleeping by repeating it (the original shot being too short for our purposes) and by manipulating the image with the visual effects (VFX) tool. The jarring movements and jump cuts that were added giving the impression of the van being hit by the motor bike. Sound effects helped complete the illusion. As a consequence of this new slant to the scene, it made sense to bring forward the confessional, which also relates to the accident. In the script, it was placed after the first rent boy but the new position worked better.

Having established her intentions to take up the offer in Bennett's drive, an amusing scene of manure being delivered for gardening purposes (another joke about smells), which largely served to re-state her intentions, seemed redundant and was also cut.

The one shot of Miss Shepherd painting her red Reliant 3-wheeler yellow, was made into two shots to give a sense of time passing; the two shots bookending other material. This was achieved by VFX once again; taking out some of the yellow paint the first time it's used. Voice over was rewritten to include reference to years going by.

The film, now at 108 mins was ready to show Tom Rothman and other Sony TriStar executives. Knowing how damaging these events can be, Nick, with admirable chutzpah, arranged to have an audience consisting of National Theatre members, a kind of Alan Bennett fan club; as close as you could get to a laughter track. It worked. There were notes of course, but the executives were as enthused by the film as was the audience. As always, pacing was an issue, the middle of the film being considered slow but there were no issues with story and establishing the two Bennetts as being the

same person; Rothman had expressed concerns at the script stage that an audience might think them twins. However, he felt there were too many English slang words (for an American audience) and moments that could be made more explicit: why, for instance, did Miss Shepherd go into a convent?; could we relate her praying in the van to the accident and could we make Bennett more curious about her past? Also, why does the brother say, 'the piano out and praying in' and why does she go to the brother anyway?

Returning to the cutting room, we reduced the two Bennetts scene following, 'I planted the seed' even more, coming out on 'fucking tame', thereby losing Miss Shepherd scaring ball kicking boys. However, the boys resurfaced as a brief point of view in a later scene. Also resurfacing was a small part of the deleted American journalist scene, which found a home in the first montage.

The middle part of the film had always been identified as a problem area and although we had tackled it, time and time again something more radical needed to be done. Central to this section of the film was a storyline of Miss Shepherd's political aspirations in forming the 'Fidelus' party and becoming Prime Minister. This narrative crossed over several scenes: starting in the market (the only remnants of this scene, 'I know who these men are...etc.' now part of a montage); at night when she complains about Bennett playing music; next day, outside a Camden café. These scenes apart from the political thread had other information that would be lost. Bennett and Shepherd at night, for instance, apart from talk of Downing Street, also served to underline her displeasure at hearing music, but as that had been pretty well established it was probably OK to lose. The café exterior, had further illustrations of her delusions, 'I saw the Virgin', but once again, we felt this had been established and little harm would be done in deleting this element of the scene. Also being lost in this area was an old-fashioned rubber motor horn she buys in the market, as an alarm should she need help. Losing it here meant also losing it from Underwood's second appearance at the van, where she uses it to bring Bennett out of the house. The shot of Miss Shepherd kneeling in prayer at a crossroads out in the country created slight geographical confusion as originally scripted; that is, it followed the Senior Citizens Club but preceded the brother's house, both in Broadstairs Town. That was remedied by putting it at the end of the sequence, along with the yellow Robin along the road (scripted as the start of her journey)

thereby making it part of her return trip. Many of Rothman's concerns about clarity were addressed by reworking the voice-over once again.

The troublesome multiple endings were remedied by music, unifying the different scenes into one. Once again, temp music played a large part in the cutting of the film, with Nick supplying me with a library of Chopin, Shostakovich, Beethoven, Schubert, etc., to play with and challenge composer George Fenton to do better!

George has scored all of Hytner's films and is the composer I have known the longest, going back to BBC's *Shoestring* and *Bergerac*. I have huge admiration for him and composers in general, not only for their musical gifts but for their passion, sensitivity and enthusiasm. I think their creativity is not only intuitive, but also comes from having great insight and their facility to articulate emotional and intellectual responses to film sequences under discussion with ease, is to be envied; they are as comfortable with words as with music manuscript.

Amusingly though, casual conversations with George can take some time, with fermata (pause/stop) notations littered all along his dialogue bar.

He can enter a trance-like state in mid-conversation, most disconcerting when on the phone.

Hello? George?

Hello?

The running time after our last round of changes was 101 mins and the film screened to a test audience of four hundred in

Wimbledon. Once again, it was well received, but with further trims, it reduced to an eventual running time of 99 mins plus credits.

Completion Guarantor[25] on set

[25] Completion guarantor companies are used by independently financed films to guarantee that films are finished and delivered on schedule and within budget. This guarantee is needed by financiers before releasing money to the production. The completion guarantor company (who take a fee), can shut down or take over a production should it be perceived to be failing.

Chapter 35

The Late Show *studio. Similar to the studio seen earlier but different. Its presenter, Humphrey Barclay, is in close shot addressing the viewers.*

Barclay: 'Good evening everyone and welcome to The Late Show. *I should say, the real* Late Show *as opposed to the one shown in the film*

Movers and Shakers the Monster Makers, *in which I made a brief and possibly forgettable appearance as myself. I have great pleasure...*

The picture widens to include two familiar faces sitting to one side of Barclay.

'In introducing our guests tonight, *the actors Mohindra Shah and Timothy Blake, who play respectively, the director and editor in the film. Welcome to you both.'*

Shah/Blake: *'Thank you.'*

Barclay: *'In your honour, Mohindra, we have the very table and props as used in the film.'*

Shah: *'Yes, it's very familiar.'*

Reaching for a glass of water,

'May I? Sharon isn't here, is she?'

Barclay: *'Not to my knowledge.'*

Shah takes a sip of water.

Barclay: *'My first question. Are you both working?'*

Both Shah and Blake laugh.

Shah: *'Absolutely yes.'*

Blake: *'Yes to that too.'*

Barclay: *'And the writer-director?'*

Shah: *'He's dead!'*

Blake: *'Mysterious circumstances, possibly an amphibious landing on the head.'*

289

They all laugh once again.

Barclay: *'Mohindra, did you base your character on anyone in particular?'*

Shah: *'Not at all. Satyajit is an amalgam of many directors, some I have worked with and others, drawn from other people's experiences. It would be highly unlikely to have one director with all those characteristics of charm, conceit, ambition, talent, innocence, fearfulness and treachery.'*

Blake: *'Similarly, the other characters, I mean, can you imagine a Walter Weisman in real life, or an Abby Spear, or a Boyd Kirstner? No, of course not. Their characters are larger than life, a gross and deliberate exaggeration, purely for comedy and dramatic effect.'*

Barclay: *'And you Blake, your own character. Where did you get your inspiration?'*

Blake: *'I guess I share the same cynicism as Ed and observation is part of an actor's tool box, so being an observer and commentator of the world around me, as Ed is in the film, came quite naturally.*

And although I've never been fired as such, as an actor I've had countless rejections, so I know the feeling.'

Thrown into this medieval society are, of course, the thespians, with their own class structure from 'A' lister to extra, trailer to tent. Actors are the most exposed, the most vulnerable, the most pandered to, and for some select few, the most overpaid. Finance for productions is largely dependent on their bankability, a reality that can lead to the collapse of many small independent productions, and large ones too, failing to attract the necessary big name. Being put on pedestals, it's easy for some 'stars' to succumb to bad behaviour and scale the heights of self-important soapboxes to deliver their thought of the day. However, well intentioned, it invariably comes across as just another performance, as damaging as it is well received (well received, in particular, by other members of this exclusive club), with possibly unfair questions of sincerity and self-

promotion. It isn't entirely their fault; the public, the media, the studios are all to blame for giving them such airtime and such a big voice.

There are so many truly fine actors scrabbling around for work but not being 'bankable', they are left to sit on the side lines to watch the bigger names monopolise the better roles, as their own careers plateau or nosedive.

For technicians, it is foolhardy to commit to a film not fully financed on this account because a commitment will probably mean rejecting other solid work. 'A' and 'B' listers are difficult to pin down on a low budget movie, taking forever to respond to sent scripts and then, more than likely rejecting them. In the meantime, producers and directors will side-step appeals for information keeping up a pretence of well-being, in fear of a team, carefully assembled … disbanding.

This was to be my experience following *Lady in the Van*. Two projects for close director friends fell by the wayside on account of casting; frustrating for me but far more so for the directors, both extremely talented and well-adjusted, having spent time and energy in developing those projects.

I then met twice with a director I have long admired, Michael Mann, for his film *Ferrari*.

I expressed my concerns about working together, based on the intensity of his gravitational field devouring all around him, particularly those in the cutting room; his last seven films amassing twenty-one credited editors. His supposed micro-management of the editing process was also a disincentive. But Mann is full of charm socially, a great filmmaker and *Ferrari* was a good script, so I was lured. However, the lead star, Christian Bale, baled and the production collapsed. Very disappointing, but perhaps I had dodged a bullet; but in this industry, it wouldn't be for long.

The Final Chapter

Barclay: *'And the decision to end the film not knowing whether Krish won the award or not, was that the way it was scripted, or a decision made in post-production?'*

Blake: *'Pretty much as scripted. It's not about the triumph, it's about the struggle, isn't it? So does it matter who won?'*

Shah: *(as Satyajit in the opening scene)*
'After all what is a man without courage and what is an artist without courage? The courage to fail. Yah, that's very good...the courage to fail.'

Barclay: *'But what about the truth?'*

Blake: *'To tell the truth is to get beaten.'*

I shudder on hearing the ping alert of my iPhone informing me of an arriving email. I hesitate to look at the iPhone screen; the same kind of hesitation I have when about to confront a hidden cockroach. I am into the eighth week of a director's cut. Since the start of production, I have received over three hundred and fifty emails from this director. My eyes squint at the screen to somehow lessen the pain of the inevitable.

Is it yet another editing note? Will this note be curt and to the point or overblown and flowery?

I know it will be written with the authority of an artist under the protective patronage of a twenty-first century medieval benefactor, the studio. In this particular instance, a gaggle of disparate independent producers, some filmmakers some not. The director I met, as Jekyll, has become Mr Hyde. His swagger and manner is one of a five-star General, his language unequivocal but curiously

these notes, however unpleasantly worded, always end with "pls" to give the false impression of a polite request, which they are definitely not.

Four months of pings. Pings during the day, pings during the night, pings at the weekend; waterboarding of a kind. I will need ping aversion therapy when this production ends.

Ping! As I write, another email; that's now three hundred and fifty-three. Written in flight from New York to Los Angeles while watching our film on a laptop (There's no escape in this modern world). This one accuses me of shortening a shot, which after some investigation, revealed I hadn't. This comment was followed by the directive, 'Don't make cuts without informing me.'

I'm sure not intended to offend, but if this director's email etiquette leaves a lot to be desired, his ornamented vocabulary and easy articulation, thereof, does not. Not that is, if you want to be treated as a man of entitlement in this medieval world. A prerequisite of his job is the gift of the gab.

His prose accompanying editing notes occasionally approach purple, with those returning levels of abstraction: 'dramatic surfacing', 'opaque stillness', 'interiority', 'walls collapsing', 'quick cuts to images of a time lost', 'the geography where code and value systems are born' and yes, 'Think, Mallick, think pastoral'.

'Interstitial' being the new 'visceral'. I reach for Google, aspirin and the sympathetic ears of my assistants.

The severity of this email is surprising, as I thought the director had left the New York cutting room a happy bunny; with a week back in LA (he didn't want to be in New York) and then returning the following week to do his final pass on the director's cut. Life seemed rosy; the cutting room was even scheduling much-needed R & R.

I respond to his email, pointing out that the shot had been shortened under his supervision. He had re-edited two or three scenes of my work with my LA assistant when I failed to understand what was required. In fairness, my lack of comprehension couldn't

have been easy for him either, but then, I could claim pretension isn't my first language. The shot in question had been part of one of those scenes. It had been that way for weeks and weeks and through many, many viewings without comment.

Ping! *He doesn't care who shortened it. Just f'ping put it back!*

The expletive is mine but could easily have been his.

As my no-nonsense Yorkshire-born uncle Cyril used to say when wrapping up an argument, "Subject's closed!"

I could read it as an admission of guilt but his confrontational tone suggests otherwise. Perhaps the production should have put him in First Class and not Business?

The director may want to close the subject but I don't. I need to take issue with him, register a protest but no time to formulate a reply because...

Ping! *Why didn't you put that beat in the scene I asked for?*

Another accusation of not following his instruction.

Perhaps he's in a pram and not a plane!

Breathe! And once again, breathe.

I sense severe anxiety, argumentative behaviour, emotional disconnectedness, delusions of grandeur, all symptoms of paranoid schizophrenia. He's spoiling for a fight, pushing me to resign or giving him cause to fire me; he's followed this path before on another film. I should back off, take the least resistance line; my wife (who is in the UK) wants to come to New York after all and I have social engagements planned with...friends...family...and of course I want to continue working with him on his film.

His note isn't unreasonable, but it reads as another scolding and what instruction anyway? I must be losing my memory. I investigate

his allegation but contrary to his claim, I did put a beat in, although perhaps not where he wanted it. A genuine misunderstanding; fifteen-all in tennis terms.

I'll put the beat where he wants it but in all honesty, the way I'm feeling now, not where I'd really like to put it! Does that make me a bad person?

Breathe.

What the director sees as guidance, I perceive as control. I try not to be too precious about it but it is difficult. Months ago I told him I didn't like being put in a straightjacket regards putting a scene together; having him choose the take, shot size and order, even occasionally, giving me the timecode frame to cut on.

I didn't like his editing with my assistant; in fact... I didn't like his editing! At times, he didn't like mine; too 'linear' he said! He was also a devotee of the Gary Gray type democratic cutting room. He was too controlling and I offered to resign, even suggesting he go back to his previous editor who I'm sure was much more accommodating than I. He rejected the notion of being controlling, *qui moi?*

'I've given you more freedom than I've given any other editor.' Having only made two previous films with three editors, a poor statistical sample and consequently not much assurance.

Being visibly distressed by my accusation of being controlling, he retired to his office to convalesce and lick his wounds.

And just to prove my point about control, *Ping!* More from Business Class JetBlue; an order from a command on high? I begin to wonder if he's now flying the plane.

He's not happy with the start of a scene and sent helpful thumbnails on shot selection and order.

Thumbnail pictures! This is like painting by numbers. I should be appreciative; he's being helpful. Perhaps this is my failing and not his. I should be living his dream as he is, day and night. We've all put the hours in though, my assistants and I, working twelve-hour lunchless days for four months and on my part, giving the production three unpaid-for Saturdays and working at 60% my normal salary. We are also two or three weeks ahead of schedule; that's pretty giving, I think, but he's like an enormous sponge absorbing all sweat in a sweatshop. My goodwill is wearing thin.

Time for retrospection. Perhaps I've never been suited to this industry after all, treating it as a hobby rather than a divine calling. My mantra should be:

I'm here to serve my transcendent leader.

I'm here to worship with blind faith and surrender… *Ping!*

He's back in LA. A new cut has been posted by us in New York. He's not happy with the quality of the download. It's unwatchable. Accuses my very experienced NY assistant of incompetence (This is his third film and her thirtieth). Wants her to phone him…

***NOW!** Pls.*

Admittedly, it is her error, or mine as Head of Department, but this is her first week as she is

taking over from the LA assistant, and excusably, not familiar with the procedure.

In any event, my assistants and I have gone home, thinking our work was done for the day. It's New York, it's Friday and after 7 pm and what's the urgency?

But in LA, it's only 4 pm. and my failure: **we should always be on Director Time!**

Ping! Ping! Ping! Where are you?

He forsakes email for the phone. Or rather has his assistant make the call. Directors do that because they have assistants to do that kind of thing. His assistant fails to get through to my assistant time and time again. The director is unravelling, about to implode from understandable frustration. Why can't I be more sympathetic?

His assistant continues to call but no answer.

He has been phoning the wrong number! Ha! Funny under different circumstances.

Actually, funny anyway.

Eventually, he gets hold of her. The director takes the phone and yells at her for her incompetence; she holds the phone away from her ear.

'If you don't know what you are doing, say you don't know; we don't have time to figure things out, this is unacceptable behaviour. I asked you to do this several times.'

That's why I can't be sympathetic.

'Unacceptable behaviour?' Does this mean time-out in her room and no TV?

She resends the edit to his satisfaction but the next day, Mr Hyde resurfaces.

He phones her again to threaten; words to the effect of "shape up or else"!

Time to talk to this bipolar man. His is *really* unacceptable behaviour. I email, suggesting a debrief on Monday morning, Director Time.

Ping! He agrees, but reading his response, I get the impression he thinks it's about his editing notes not his boorish behaviour.

Now it's Saturday

Ping! More editing notes. I don't respond.

Now it's Sunday

Ping! More editing notes. I don't respond, but then do, jokingly saying, if I do respond I'll charge a double time full day.

Ping! OK by me, says he.

Monday morning. I'm viewing an apartment I'm thinking of leasing for the remaining months of the production. Should I go ahead with it or not? It would be an upfront commitment of around $20,000 of my own money. With large productions, the production company takes on the responsibility for finding and paying for housing but with small productions, that responsibility becomes the individuals, funded by a weekly allowance given on top of a salary. But with the schizophrenic nature of my director and the possibility of being fired, alarm bells ring… as does my phone.

Ping! Many more notes. Shit! In my apartment distraction, I've missed a few pings. Heavens, he's been pinging me since dawn. This man never sleeps. He also informs me that he has arranged a viewing LA afternoon for Producer One (one of nine). Producer One is the most important. This viewing is of utmost importance to

him, in fact, this coming week is of utmost importance because he is delivering his cut to the producers. What? We all thought it was going to happen the following week.

This really is Breaking News to everyone… apart from the director…

He goes on; you must address these notes for this viewing and another surprise, a screening he's arranged for the following day at CAA (Creative Artists Agency). There's a degree of hysteria entering into his behaviour. Of course, all these deadlines are

hogwash. He had intended to disappear for the second half of the week on personal business anyway and there were still two weeks of director's cut remaining, so the importance of the week was seemingly manufactured for some ulterior purpose.

I respond, admittedly with a degree of sarcasm, that I'm returning to the cutting room forthwith and that we, the editing crew, will endeavour to carry out his instructions and endeavour not to make any more mistakes. I add that I would prefer more notice of viewings as errors can be made when work is done in haste.

Ping! Outrage! He objected to the tone of my email and anyway, hadn't he been emailing me all weekend with cutting notes and wasn't two days enough notice?

My response was brief. I didn't work the weekend.

Slightly miffed and forgetting his omnipotence, I elaborated that I had issues regarding his tirade at my assistant.

Ping! How dare I take him to task, but he didn't want to discuss it now as this was...such an important week for him don't you know! And he couldn't afford to be distracted by such trivialities. Let's discuss next week. He did, however, hold me responsible as Head of Department for the cock-up that led to his verbal abuse of my assistant

Fair comment, but then, why did he rage at her and not me?

Ping! Ping! Ping! More cutting notes throughout the day. I address them as fast as I can; as soon as I finish one note, I have another. There is a cut-off point for changes as it takes time to prepare and transfer the edit across.

Then we hear the Producer One viewing has been cancelled. Phew! But...

Ping! More notes. These are for the CAA screening now, which of course is very important. We carry on working until around 7 pm when the pinging stops. Respite. We go home thinking all's well and that any further overnight notes could be addressed in the morning; with the three hours to our advantage we could make a new edit long before CAA wakes up.

I go to dinner with friends and switch my phone to vibrate.

Ping! Ping! Ping! Ping! All on vibrate, I don't pick up.

Return to hotel and look at phone. One particular ping catches my eye.

"You left editorial tonight without informing me", it reads. "This is unethical and, disrespectful and unprofessional, especially

this week. I am delivering a cut on Friday, there's a crucial screening tomorrow. You have manufactured a raft of problems, problems that I am no longer interested in."

Reading on, it would appear that I had been sulking since the director expressed frustration at my cutting of a shot without his expressed permission. This isn't the work ethic the director requires his colleagues to exhibit and his six-time nominated last editor would have worked until 10 pm. Certainly, he wouldn't have left without seeking permission and certainly not this week.

Have I been fired? It isn't absolutely clear. I feel 'walls collapsing' and an 'opaque stillness'. I envision 'quick cuts to an image of a time lost', a deep 'interiority'.

He misreads contempt for sulking though, and the six-time nominated stuff really rankles, after all, I was nominated captain of my primary school football team.

Has my ping torture come to an end?

No, a few moments to absorb the message then, as though by wicked design…

Ping! (No 394) Here came the clarification. He was happy where the movie was or at least 90% of it, but for the last 10%, he didn't want to continue in the same fashion. He wasn't happy with the drama and misbehaviour. So he's going to make a change.

He wished me well, I had done great work and he was grateful.

The message ended with best of luck.

He might as well have added, "Love you."

His 'Best of luck', like 'pls' in earlier notes, in the 'love you' category of disingenuous parting words.

Perhaps a phone conversation would have avoided this outcome, but I suspect it would have only delayed it. This would-be King was in the altogether as far as I was concerned. My LA agent took a neutral position, simply saying with masterly understatement, 'it wasn't a good fit'. Don't you love agents? Of the nine producers, only producer six, with a momentary lapse, entertained calling the court physician, but the other producers were 'royalty' themselves, so no hope of salvation there. They closed ranks, circling the wagons around their precious charge.

I was ejected from the palace without ceremony, the doors slamming behind me.

Ex-communication from their point of view, but liberation for me.

Liberation not only from the director but liberation to write without concerns of conscience; presenting him a friendly face while having increasingly malevolent thoughts.

Perhaps, as the director had said, I had 'manufactured a raft of problems'. Perhaps as he put in subsequent emails, I was too thin-skinned and childish to have another human being in the room with ideas that were different from mine (and thereby forcing him to send emails) and that I was, in my own sheepish way, a creative bully.

Perhaps, irony of ironies, I had been controlling him all the time in order to find my final chapter.

Maybe, I too had become a monster.

Directors have to direct and most do with good grace and a genuine sense of collaboration. A few prescribe servitude, but servitude to a benign dictator is easily tolerable for short periods – in fact to a benign dictator, it doesn't feel like servitude at all. What isn't tolerable is servitude to a megalomaniac, a narcissist, a spoilt brat and playground bully whose response to any dissent is a temper tantrum and black eye.

Where have all the real producers gone, long time passing?

Too few have any creative or literary skills and too few the social skills and experience to manage a crew, let alone properly parent a problem child. Too few have an understanding of the film crafts and too few engage in the filmmaking process until it's too late. They have a financial interest, take a main credit and are largely anonymous.

Subjugation is film industry practice, I imagine it is in most businesses, but where there might be some recourse against unfair dismissal elsewhere, there is none for technicians in the film world. With the work being so transitory and the collaboration so brief, long service concerns are non-existent as are severance payments. Bad behaviour is tolerated, questionable actions excused as expedient for the well-being of the production. If a film is a success, either financially or in terms of awards, who cares what went on in the making of it?

The ruling class rule, the rest are dispensable.

Subject's closed!

At least my ping misery was truly over...

Ping!

It is now two months and two editors later. The producers want me to return. Heavens! Fired and rehired. I take it all back: the industry is full of wonderful, honourable people.

However, in an email to one of the producers, I reject the invitation with a carefully worded character assassination of the director. I get a response, not from the producer to whom it was written but from the director, to whom my email was forwarded. Ugh!

The director's vitriol, understandably, is equal to mine, but as a consequence of negative test screenings and producer disapproval, his authority has somewhat diminished. I return to New York and with minimum contact with the director, complete the film.

Kush mir in tuchus

~ The End~